NICOLAS LANCRET
1690 – 1743

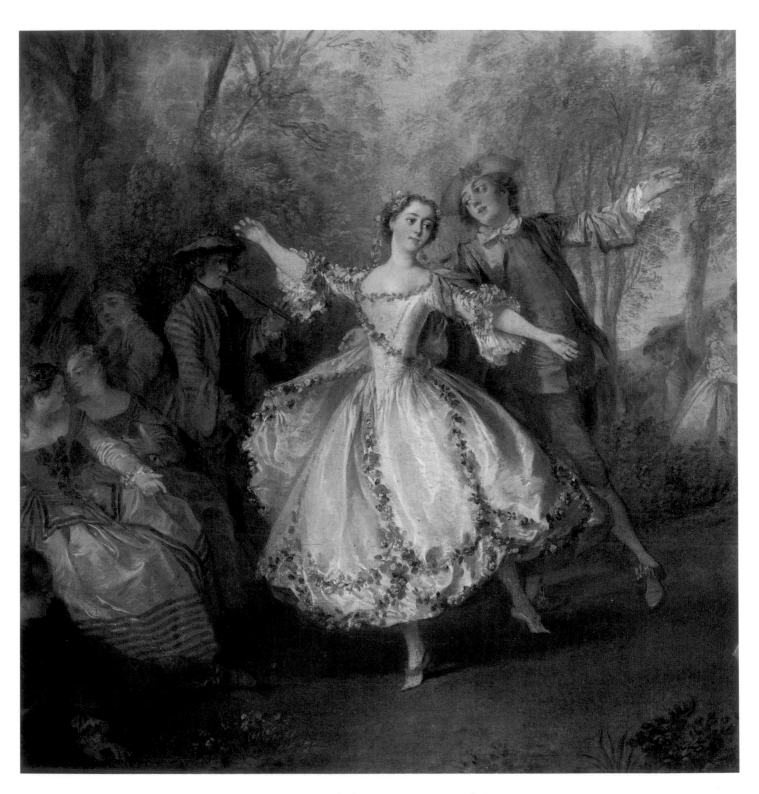

Lancret. Detail of *La Camargo Dancing* (pl. 9).

NICOLAS LANCRET
1690–1743

by Mary Tavener Holmes

edited by Joseph Focarino

Harry N. Abrams, Inc., Publishers, New York

in association with The Frick Collection

Editor: Adele Westbrook
Designer: Samuel N. Antupit

Library of Congress
Cataloging-in-Publication Data

Holmes, Mary Tavener.
 Nicolas Lancret, 1690–1743:
 by Mary Tavener Holmes;
 edited by Joseph Focarino.
 p. cm.
 Includes bibliographical
 references and index.
 ISBN 0–8109–3559–7
 1. Lancret, Nicolas,
 1690–1743 — Exhibitions.
I. Focarino, Joseph.
II. Frick Collection. III. Title.
ND553.L2293A4 1991
759.4 — dc20 91–10153
ISBN 0–8109–2491–9 (Mus. pbk.)

Published in 1991 by Harry N. Abrams,
Incorporated, New York
A Times Mirror Company

Printed and bound in Japan

To Peter, the two Shirleys, and James Rynn, with love

EXHIBITION DATES

The Frick Collection, New York
November 19, 1991 — January 12, 1992

Kimbell Art Museum, Fort Worth
February 15 — April 12, 1992

LENDERS TO THE EXHIBITION

Musée de Picardie, Amiens
Museum of Fine Arts, Boston
Krannert Art Museum
 and Kinkead Pavilion, Champaign, Illinois
The Art Institute of Chicago
Cleveland Museum of Art
Gemäldegalerie Alte Meister, Dresden
National Galleries of Scotland, Edinburgh
Indianapolis Museum of Art
The National Gallery, London
Alte Pinakothek, Munich
Robert D. Brewster, New York
The Homeland Foundation, Incorporated, New York
The Pierpont Morgan Library, New York
Mr. and Mrs. Felix G. Rohatyn, New York
Mrs. A. Alfred Taubman, New York
The Snite Museum of Art, Notre Dame
Musée du Louvre, Paris
Patrick Perrin, Paris
Virginia Museum of Fine Arts, Richmond
Bibliothèque Municipale, Rouen
The Fine Arts Museums, San Francisco
Nationalmuseum, Stockholm
National Gallery of Art, Washington, D.C.
Private collections

Contents

Introduction

During his lifetime, and through most of the eighteenth century, Nicolas Lancret was one of the most celebrated artists in France. After nearly two centuries of decline and finally rather low esteem, his reputation as a draughtsman and painter has changed considerably in recent years. The prices for both his paintings and his drawings have risen dramatically, and they have again been sought after for distinguished public and private collections. The charm and appeal of his genre paintings are once more widely recognized, yet there has not been any study of the man and his art in nearly seventy years. And there has never been a book about him in English.

This volume investigates many of the finest works of Lancret; for the first time we have a considerable number of color illustrations of his drawings and paintings, so that the reader will be better able to judge the artist. There is also a long essay which places Lancret in the context of his time and differentiates his work from that of his contemporaries, particularly that of Watteau. The Frick Collection, which has such a celebrated collection of eighteenth-century French art, has been pleased to sponsor this book. It is published in connection with an exhibition of Lancret's work held at the Collection from November 19, 1991, to January 12, 1992, and subsequently shown at the Kimbell Art Museum from February 15 until April 12, 1992.

We are indebted to Mary Tavener Holmes, who has spent many years in the study of Lancret's paintings, for writing this volume and for selecting the

works included in the exhibition. She has been helped at every turn by Edgar Munhall, Curator of The Frick Collection; and Joseph Focarino, Editor here, has worked with them in preparing this text. We have also had invaluable assistance from Joseph Baillio.

Our principal source of financial support has been ESCADA, and we are above all grateful to that international design firm for its generous grant. Benoît d'Aboville, Minister Plenipotentiary Consul General of France in New York, has been of outstanding assistance to us. Many at The Frick Collection have been concerned with the exhibition, while at the Kimbell Art Museum the Registrar, Anne Adams, has been extremely helpful, and the Director, Edmund P. Pillsbury, has shown a keen interest in presenting Lancret's work to the American public. We are deeply indebted to the lenders, representing museums and private collections throughout Europe and America, for permitting us to show such wonderful examples of Lancret's art and to reproduce them in this book. The exhibitions in New York and Fort Worth are the first entirely devoted to Lancret's drawings and paintings, and it is hoped that they will in some measure restore the acclaim that Lancret enjoyed in his own day, and which is so richly deserved.

Charles Ryskamp
Director, The Frick Collection

Acknowledgments

During the many years I have worked on Lancret, I have relied on the help and generosity of countless individuals and institutions; I thank them all. I owe a special debt of gratitude, however, to Donald Posner, who initiated my study of Lancret as a dissertation topic and shepherded that thesis with the perfect combination of academic rigor and sympathetic patience. He has been a steadfast friend and ideal mentor. I must give particular thanks, also, to Edgar Munhall, Curator of The Frick Collection, who has supported this exhibition from the outset and devoted time, energy, and hard labor to ensuring its successful appearance. I hope he finds the result worth his efforts. My editor and translator at The Frick Collection, Joseph Focarino, has my heartfelt gratitude for his keen eye, infallible blue pencil, and inexhaustible patience. Many other friends and colleagues aided my work, but I would like to mention particularly the following: Colin Bailey, Joseph Baillio, Oliver Banks, Mark Brady, the late David Carritt, the late Robert Chambers, Nicola Courtright, Craig Felton, Egbert Haverkamp-Begemann, Rebecca Rice MacGuire, Marianne Roland Michel, Pierre Rosenberg, George Shackelford, Ruth Stevenson, Paul Weis, Alison West, Eunice Williams, and Alan Wintermute.

Among the many libraries I have relied on in my work, I would like especially to acknowledge the assistance of the following: the library of the Institute of Fine Arts, New York University, under the leadership of Evelyn Samuels; the Frick Art Reference Library, New York; the library of the Metropolitan Museum of Art, New York; the Bibliothèque Nationale, Paris; the Centre de Documentation, Musée du Louvre, Paris; the Bibliothèque de l'Opéra, Paris; the Witt Library of the Courtauld Institute, London; and the library of the Victoria and Albert Museum, London.

Mary Tavener Holmes

Lancret and His Time

Nicolas Lancret (1690-1743) was one of the most important and appealing genre artists at work during the first half of the eighteenth century. His paintings graced the homes of noble families across Europe during his lifetime, and his prints remained popular long after his death.

The high regard of the eighteenth century is in stark contrast to Lancret's subsequent critical fortunes. From the Goncourt brothers' 1880 condemnation of him as a "slavish follower" who was "formed entirely by the study of Watteau's style"[1] to Levey's 1972 assertions that "Lancret perhaps deliberately modelled himself on Watteau" and that "the range of his art varied little,"[2] Lancret's role as a follower has assumed a preeminent position in the discussion of his work, and has generally been considered the most significant aspect of a not-very-interesting painter.

This narrow and pejorative focus on Lancret has had two equally damaging effects: when he is not overlooked, he is misunderstood. The label of "follower" is particularly tenacious and onerous, reducing an artist to a craftsman with no original contribution to make and, worse yet, to something of a thief. Even in recent decades, when the art of the eighteenth century has

enjoyed a resounding critical comeback, Lancret has not recovered the esteem he inspired among his contemporaries. The catalogue of the 1984 traveling Watteau exhibition, for example, insists that Lancret used "a set formula without understanding [its] poetry or originality."[3]

On the positive side, as early as 1743 Silvain Ballot de Sovot, Lancret's lawyer and friend, wrote a valuable, if biased, account of the artist's life and career. More recently, Wildenstein's 1924 monograph stands as the only serious work on the artist, aside from isolated articles and occasional exhibition-catalogue entries. Though useful, Wildenstein's book is now out of date, and it makes no attempt to discuss Lancret's work in a broad context.

Far from being a negligible figure as he is often portrayed, Lancret was a key force in the visual arts of eighteenth-century Europe. In the first half of the century, he dominated the genre scene with an enormous production of paintings and prints. He counted among his patrons many of the crowned heads of Europe, as well as major collectors among the aristocracy and in the financial community. He was the favorite genre artist of Louis XV, who commissioned decorations from him for most of the Crown residences.[4] His sole rivals in the scope and scale of commissions for royal decoration—Boucher, Lemoyne, and de Troy—made most of their contributions in the area of history painting; their genre work was a side effort. Lancret was entirely a genre artist, the only one so employed. This also sets him apart from Watteau and Chardin, the two genre painters often considered the most significant of his day; they neither sought nor gained the kind of royal patronage that Lancret won consistently.

Lancret was an important factor in the shift of perception that moved genre from the wings to center stage in French art. He had a rare opportunity, living and painting at a moment when the standards of excellence in art were changing and enlarging. History painting, hitherto foremost in esteem and patronage, no longer suited all the needs of a growing market. This provided a chance for painters of genre—scenes of everyday life—to gain wider acceptance, and Lancret's work was crucial to that effort. By the end of his career, genre ranked beneath history painting only in the minds of academics, not on the walls of patrons.

The reasons for Lancret's popularity and success are easy to appreciate. His pictures tell lively and intelligible stories, his themes are inventive and amusing, and his colors and color combinations are bright and striking. His works combine the contemporaneity of the fashion print and the humorous, anecdotal quality of the then-emerging novel with a naturalism and grace learned from the lyric

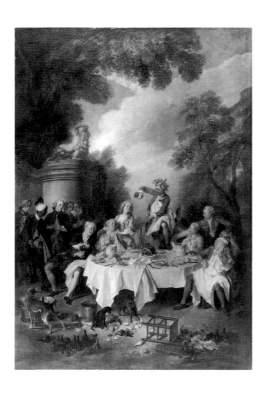

FIG. I. Lancret. *Luncheon with Ham.* 1735.
Oil on canvas. Musée Condé, Chantilly

example of Watteau. Lancret's images made the transition from decorative painting to engraving with ease, then went on to capture the popular imagination in much the same way as tasty gossip, with a rich broth of contemporary detail flavored by intimate and comic insight. His paintings are steeped in eighteenth-century life — its style, its amusements, its personalities, its secrets, and its jokes. He married convincing description to legible narrative, creating a concrete, comprehensible image. If Watteau's paintings amaze us through their transcendence of time, Lancret's charm us by their fidelity to it. Early on, Lancret abandoned Watteau's delicate ambiguity, preferring a style with the visual power and narrative coherence of history painting, one that would carry when seen above the highest doorway at Versailles. Robust faces with vivid expressions, broad gestures, and figures close to the picture plane characterize his mature work. As his art ripened, it grew more concentrated: his figures became larger in size and smaller in number.

A telling example of Lancret's characteristic manner and his prodigious success is the *Luncheon with Ham* (also known as *Luncheon Party in the Park*), which survives in two versions: the first, done for Louis XV in 1735, is now in the Museé Condé at Chantilly (fig. I), and Lancret's reduced replica, commis-

sioned by the astute connoisseur La Live de Jully, is in the Forsyth Wickes Collection at the Museum of Fine Arts, Boston (pl. 14). This boisterous work must have greatly amused the King. The actions of the jolly hunters, whose ruddy features are heightened by the removal of their wigs, are cleverly aped by the greedy satyr and hound in the sculptural group above them. The figures are close to the picture plane, and the colors, ranging from the greens and blues of the coats to the rose of the ham, are vivid and luminous. One of the most impressive features in both versions is the splendid still life of the table, which rivals the work of a specialist and is an unexpected and unheralded aspect of Lancret's abilities. The blaze of white linen, glistening silverware, and *blanc-de-chine* Saint-Cloud porcelain wine coolers brings to mind Oudry's dictum that the good still-life painter is one who can compose a work entirely of white objects and manage to give each item its due.

Lancret was, then, a strikingly successful and appealing artist who helped establish genre painting as a legitimate endeavor in France and whose prints ensured its long-lasting popularity across Europe well after his death. Ambitious and prolific, he helped secure the future for artists like Greuze, Boilly, and even Hogarth, all of whom prospered in his wake. But that is not the whole story. His visual charm and narrative strength were augmented by sophisticated imagery; among his most important contributions to the history of genre painting are his thematic ingenuity and his enlargement of the vocabulary of genre scenes. His tableaux tell their tales not only through the gestures and expressions of their characters, for he also wove into his scenes a variety of conceits and motifs—among them traditional allegory, iconographic staffage, and even persuasive colors—to enrich his narratives and make them more interesting to his sophisticated audience. If superficially they retain the appearance of genre, they are supported by an underpinning of imagery. Of course, this touch of intellectual rigor moved Lancret closer to history painting. He showed that such rigor need not accompany only themes of great moral or philosophical import; it could be put as well to the service of charm and wit.

Once it has been seen that Lancret's genre images repeatedly offer allegorical and thematic subtexts, further study reveals something equally noteworthy. The inspiration for both the themes themselves and for the compositions comes primarily from one and the same source: the seventeenth-century French popular print tradition. So consistent is Lancret's reliance on these prints as visual and iconographic sources that they form a virtual copy- or emblem-book for his work.

Among the numerous French artists involved in the engraving, editing, and

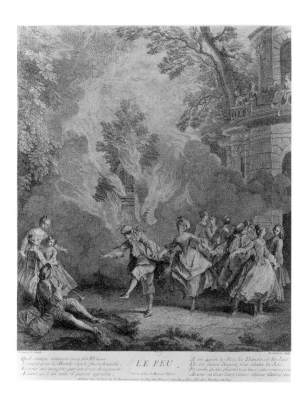

selling of prints in the seventeenth century, some of the most prolific were the celebrated Abraham Bosse, the Bonnart family, Daniel Rabel, Jean de Saint-Jean, and Claude Simpol, as well as the publishing establishments of François Langlois, André Trouvain, and the Mariette family. Their prints illustrate a wide range of themes, from religious scenes and mythologies to portraits and landscapes. Among the most popular — and, from the viewpoint of the historian of genre painting, the most interesting — are the trade scenes and fashion plates, the *gravures à la mode,* along with their offspring, the sets of fashionable figures shown in contexts representative of the Seasons, the Elements, and exotic lands.[5]

Lancret's use of such prints will be referred to repeatedly throughout this text, and many examples exist. In fact, he employed prints as the basis for the majority of his most characteristic themes, such as allegorical cycles, games, theatrical characters, and portraits. In the *Fire* scene (fig. 2) from the *Four Elements* series he painted for the Marquis de Béringhen about 1732, for instance, we can easily detect his union of genre and allegory, and his intentions in that union. As his image of Fire, Lancret makes unusual use of a *feu de joie* (a bonfire) that probably refers specifically to the St. John's Fire lit each year to commemorate the birth of John the Baptist. Jean Mariette had employed this

FIG. 3. Jean Mariette. *Summer: St. John's Fire.*
Engraving. Bibliothèque Nationale,
Paris, Cabinet des Estampes

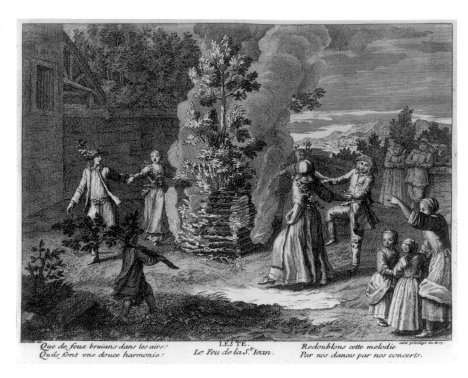

Que de feux bruians dans les airs! LESTE. *Redoublons cette melodie*
Quilz font vne douce harmonie! *Le Feu de la S.^tIean.* *Par nos dances par nos concerts.*

very image in a series of the *Seasons,*[6] the only previous instance of its use in such a set (fig. 3), and Lancret conforms to Mariette's image closely — a proximity that is typical of his borrowing from such sources. Not only was this representation of Fire appropriate because of the pyre burnt on St. John's Day, but it also had amorous associations that would have been well known to Lancret's audience. St. John's Day falls near the summer solstice, and was thus related to the traditions of midsummer. To ensure marriage to their chosen mates, couples danced around the pyre together or tossed flowers to one another through the flames. If a young woman should find a four-leaf clover on the feast day, she was guaranteed a husband. All of this is alluded to in Lancret's image, which shows couples pairing off for the dance. The couple at far right gaze at one another, while a rival suitor looks on in dismay. As the caption points out, "Love enters their hearts to light other fires." This leads to a related, but less specific, role of Fire in scenes of love. It often stood for the flame of ardor kindled in the breast by one's beloved, and is an emblem used by Lancret on several other occasions; his *Girl with a Magnifying Glass* (Charlottenburg, Berlin), for example, foretells the child's ability to provoke the heat of passion.[7]

In one of Lancret's late masterpieces, the *Fastening the Skate* in Stockholm (pl.

PLATE I. Lancret. *Fastening the Skate*. c. 1741.
Oil on canvas. Nationalmuseum, Stockholm.

1), Winter is embodied in a couple's romance, which lures them out on a cold day to participate in that most typical of Winter sports, ice-skating. Lancret adapted his image from seventeenth-century prints depicting Winter in which Eros is shown tying on a young lady's skate; many treatments of this theme exist, the closest being an anonymous print published by Trouvain in 1702 (fig. 4).[8] Lancret, needing no such obvious indications of intent, has simply replaced Eros with a more natural counterpart. Why else, after all, does one brave the cold?

Another example is the scene of *Manhood* from Lancret's series *The Four Ages of Man* in The National Gallery, London (fig. 5a). Archery is, in itself, an appropriate image of youthful maturity, when one is old enough to be skilled at a sport while still young enough to practice it. However, the two archers in *Manhood* do not simply play at sport. They are engaged in a specific type of archery competition, popular throughout France and the Netherlands since the Middle Ages, known as the *jeu de pape-guay.* The game was played by perching atop a long pole an imitation bird, usually a parrot (*perroquet* or *pappagallo,* hence the name) made of wood or paper painted green, and shooting at it. The game is a favorite subject in the popular print tradition, where it is used to exemplify a variety of themes. Though Lancret does not show the top of the pole, it is obviously this competition he is depicting: one archer is poised to shoot, his upward swing silhouetted against a break in the trees, while the other waits his turn. It is a particularly apt expression of youth, as the game was customarily played in May — when the feast day of St. Sebastian, patron saint of archers, occurs — and the warm seasons are, of course, traditionally allied with youth. Another venerable and constant symbol of youth is the sanguine temperament, and Lancret cannot resist clothing his archers in lusty red.

Many other examples could be cited, but the point is clear: Lancret had every intention of making his genre paintings as sophisticated in their imagery as they are charming in their appearance. The popular print tradition suited his needs perfectly, providing him with a stock of fashionable details and motifs that made his meaning clear to all, as well as with material suitable for retranslation into prints. It was a happy combination.

In terms of excitement, Lancret's life does not match his art. A hard-working man who virtually never left Paris, he had an even temperament quite unlike that of his mentor, Jean-Antoine Watteau (1684–1721), or of his closest friend, the tragic suicide François Lemoyne (1688–1737). Lancret was born in Paris on

FIG. 4. Anonymous. *Winter.*
Engraving published by Trouvain in 1702.
Bibliothèque Nationale, Paris,
Cabinet des Estampes

L'Hiver

January 22, 1690 — the year of Charles Le Brun's death — on the Rue Verderet in the parish of Saint-Eustache, where he was baptized two days later.[9] Ballot de Sovot, his biographer, in an affectionate attempt to place his friend in a favorable light, says he was from "an honest middle-class family," but his parents were in fact of the artisan class; his father, Robert Lancret, was a coachman, and his mother, Marie-Catherine Planterose, was the daughter and the sister of cobblers.[10]

The only artist in his immediate family was an older brother, François-Joseph, who was an engraver, and it was presumably he who arranged for Nicolas to study art, since the latter's earliest training was in engraving. Ballot writes that Lancret, in preparation for an engraver's career, was first put under a drawing master, whose name is not recorded.[11] The youth was dissatisfied, however, and asked his parents to place him with a painter, which they did.[12] It is significant that, however short-lived this engraver's apprenticeship may have been, Lancret had an early exposure to printmaking. Prints after his work were to become a large and important part of his artistic production.

Lancret himself did not make these prints, however, but followed the more common practice in eighteenth-century France of calling upon professional

FIG. 5a. Lancret. *Manhood*
(from *The Four Ages of Man*).
Before 1735. Oil on canvas.
The National Gallery, London

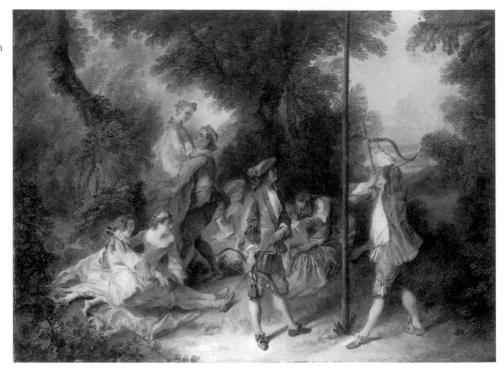

engravers to reproduce his paintings. Many of these interpreted his art through the course of his career, and even after his death. The one who did so most often, and whose name is most closely associated with Lancret's, is Nicolas IV de Larmessin (1684–1753), who engraved, among others, *The Four Times of Day, The Four Ages of Man, The Birdcage, Hide-and-Seek, The Game of Pied-de-Boeuf,* and *Mlle. Sallé.* Another well-known engraver who reproduced Lancret's paintings was Jacques-Philippe Le Bas (1707–1783), whose print of Lancret's *Conversation Galante* was his reception piece for the Académie in 1743.

Initially, Lancret followed a path leading to history painting. There is no indication in his early days — roughly 1700 to 1710 — of an inclination toward genre in general, let alone the genre of Watteau. When he asked to be apprenticed to a painter, his parents placed him — about 1707 — in the atelier of Pierre Dulin (or d'Ulin). Dulin (1669–1748), who is virtually unknown today, was moderately successful in his own time, though Dézallier d'Argenville, writing in 1762, called him only a "mediocre history painter." Twenty-one years Lancret's senior, he is found in histories of seventeenth-century French painting, listed among the legion of painters who modeled their art on that of Charles Le Brun.[13] The combination of ideal types with Baroque effects that

Lancret. *Old Age*
(from *The Four Ages of Man*).
Before 1735. Oil on canvas.
The National Gallery, London

marks his *Annunciation* in Arras[14] clearly links him to Le Brun, as does his *morceau de réception* of 1707, the *Leonidas* now at the École des Beaux-Arts, Paris. He obviously had little in common with Lancret's future manner, though Lancret must have received a sound training in his atelier. Dulin had entered a well-established painting family by marrying the daughter of the history painter Charles-Antoine Hérault, placing himself in the midst of a lively artistic circle that included Noël Coypel, Louis de Silvestre, and Jean II Bérain.[15] It must have been an exciting milieu for a young painter, and Lancret later spoke of Dulin as very important to him.[16]

The exact dates of the early episodes in Lancret's training are unknown, but presumably they fall within the first decade of the 1700s, his teenage years. Wildenstein places the lessons with the drawing master around 1703 and the entry into Dulin's studio around 1707,[17] and this must be reasonably close to the mark. The first firm date in this early period is September 28, 1708, when Lancret, already in the course of training at the Académie Royale de Peinture et de Sculpture, was expelled for three months, along with François Lemoyne and Joseph-Charles Rothiers, for having "insulted and verbally mistreated one of their colleagues."[18] Just over a week later, on October 6, the trio managed to

get themselves expelled altogether, on the grounds that they had "continued in their impertinence."[19] On January 5, 1709, after the three-month penalty expired, they were readmitted, on condition that they apologize.[20] In 1711, Lancret entered — and lost — the competition for the Prix de Rome.[21]

At some point, Lancret entered the shop of Claude Gillot (1673–1722).[22] The questions of when he did so, why he did so, for how long, and in what capacity are vexing ones, because it is this connection that first signals a change of direction in Lancret's career. Lancret's eighteenth-century biographers report merely that he joined Gillot after leaving Dulin, presumably well after Watteau had joined him.[23] Ballot, again, is our main source of information, recording that Lancret, deciding to pursue the genre of Watteau, entered Gillot's atelier, where Watteau himself had trained: "Sufficiently schooled in the general principles of art and ready to decide on a genre, he found that that of Watteau, which pleased the public greatly, pleased him as well.... As modesty and self-doubt were natural to him, moreover, he hoped to ensure himself of success in this genre by drawing from the same waters whence Watteau himself had drawn. He established himself at the studio of Gillot, Watteau's master, where he worked for several years."[24] Dézallier relates essentially the same story, emphasizing again that the genre of Watteau was then "at the height of fashion."[25] Neither source notes precisely when Lancret took this critical step. Wildenstein, stressing the importance of Lancret's disappointment over his loss of the Prix de Rome in 1711, suggests it was in 1712 or 1713.[26] Mathey believes that it coincided with Lancret's expulsion from the Académie in 1708.[27] Interestingly, speculators on this point have sought their clues in Lancret's motivation, for that, after all, is the ultimate question. What would prompt a young painter of modest financial means, already several strides along the path toward history painting, to change course by abruptly attaching himself to a studio that produced scenes of the *commedia dell'arte* and grotesque decorations? If he went to Gillot as a pupil, it certainly amounted to a serious exploration of genre painting as a career. Wildenstein's suggestion that the impelling force was the loss of the Prix de Rome does not really satisfy. History painters lost with regularity and remained history painters. Lancret's friend François Lemoyne, who took the prize that year (1711) with his *Ruth and Boaz,* had lost the previous year; Jacques-Louis David lost twice before winning with his third attempt, in 1774.[28] The selection of Lancret for the competition, which was limited to six contestants by a pretrial examination of submitted sketches, should actually have been encouraging. It is also difficult to assign much importance to his

expulsion from the Académie, which was not lengthy and, in any case, was revoked. Expulsion certainly had no such effect on Lemoyne. The only other painter to emulate Watteau or Gillot seriously at this early juncture, Jean-Baptiste Pater (1695–1736), was Watteau's fellow townsman — both artists being from Valenciennes — and he would quite naturally have sought out Watteau when he arrived in Paris in 1713. Lancret, on the other hand, began his studies in Paris amid the history painters cast in Le Brun's sturdy mold. What prompted his new aspiration?

We can only speculate. While from a historical perspective it was to prove decisive, Lancret's initial step might simply have been a practical one, and he himself might not have made the first move. It seems unlikely that Lancret, already well trained, would apprentice himself as a student again. Both Ballot and Dézallier assert that Lancret's move to Gillot was a turn toward the taste of Watteau, which was then very popular. This in itself indicates a much later date than 1708, the year of the Académie expulsion, as Watteau really cannot be considered "at the height of fashion" before about 1712, and most of his earlier production had been military or rustic scenes and arabesque decoration.[29] If we accept the basic premise of these writers, that Lancret's decision to join Gillot was a serious exploration of genre painting in general and the genre of Watteau in particular, then two factors must be noted.

First, Watteau had caused great excitement at the Académie on July 11, 1712, when he presented several paintings there, including *The Jealous Ones,* one of his earliest *commedia dell'arte* scenes done in the *fête galante* mode.[30] Lancret, then a student at the Académie, would certainly have seen that exhibition. Furthermore, there is evidence in Lancret's early work that he was directly influenced by another painting thought to have been included by Watteau in the 1712 presentation, or at least to be close to it in date: *The Foursome,* which was not engraved until 1731.[31] Watteau's depiction of Pierrot in that work, with his guitar slung behind him and his back to the viewer, is an unusual pose for Pierrot that Watteau does not use again, but it does recur in Lancret's *The Joys of the Theater,* a painting now in a private collection in the United States (previously known only through an engraving). This is perhaps the earliest painting by Lancret that survives, dating from about 1713–15.[32]

The second factor is that while history painting continued to be regarded as the highest level of artistic achievement by the Académie and the cultural bureaucracy, there was a decline in the market for it in the early eighteenth century. At the same time, genre painting was achieving a new level of

popularity and acceptance. Wealthy and influential patrons, including Louis XV, were amassing large collections of genre paintings, primarily by Netherlandish and French artists. Even the Académie, traditionally a bastion of idealism, began to accept and incorporate the lesser genres more enthusiastically.[33]

This change in outlook can easily be deduced by examining the Salon *livrets*. Prior to 1699, hardly any genre painting was exhibited.[34] While the two Salons around the turn of the century—in 1699 and 1704—do show some increase in the number of genre scenes (as well as portraits), these scenes consisted mostly of landscapes and still lifes, produced by specialists such as Forest, Fontenay, and Desportes.[35] The next Salon was not held until 1725,[36] and its *livret* indicates a real change. Many more genre paintings of various kinds can be found, and they were contributed by a wider range of artists; while still-life specialists such as Oudry and Desportes remain much in evidence, now history painters were producing genre paintings as well. Jean-François de Troy presented four gallant scenes alongside his heroic themes. Among Charles-Antoine Coypel's entries was a portrait of a boy building a house of cards, and François Lemoyne included a bather and a landscape in his display. In 1699, out of approximately 230 paintings, thirty to thirty-five could be classified as genre (excluding portraits). In 1704, with nearly 400 paintings, approximately fifty were genre. In 1725, thirty-two of the approximately seventy-four entries were genre—nearly half.

Even if Lancret's move to Gillot did not reflect in itself a commitment to genre painting, surely these factors affected his ultimate decision to take up the genre of Watteau. The inspiration of Watteau's innovation and success in 1712, and the promise of a more secure academic and financial future, prepared the way for his decision.

It is also conceivable that Lancret's entry into Gillot's shop was motivated by more immediate practical concerns. Perhaps he needed extra money and took a job as Gillot's assistant simply to augment his income. The two artists could easily have met at the Académie. Perhaps after Watteau brought popularity to the *commedia dell'arte* theme in 1712, Gillot decided to enlarge his shop in order to capitalize on the new commercial success of such scenes. Who, after all, was better prepared to make prompt use of this freshly generated enthusiasm than the artist who had introduced them to Watteau in the first place? Trained at the Académie himself, Gillot would naturally seek help there. Lancret would join him as an assistant.[37]

However and whenever Lancret entered Gillot's studio, the step was to prove definitive: in 1719 Lancret entered the Académie as a painter of *fêtes galantes,* a category that had been created for Watteau only two years earlier. Gillot was an initiator, destined to see other artists make more imaginative and successful use of what he could teach them. He influenced Lancret as he had influenced Watteau. There was by now, however, an important difference: Lancret had Watteau's example before him, as well as Gillot's.

We do not know when Lancret and Watteau first met. It may have been during Watteau's presentation at the Académie in 1712 or even before that date, but it could certainly not have occurred long after it. The first direct indication of Watteau's artistic influence on Lancret is recorded, as usual, by Ballot. Noting that the training an artist receives from his master is indispensable, Ballot nonetheless points out the risks of becoming a mere imitator. He relates that Watteau, who at first was fond of Lancret, once told him he could only lose time by staying on with a master, and that he must take his attempts further, following the master of masters: Nature. Watteau advised Lancret to go out sketching landscapes and then add some figures to create a painting. Lancret did two paintings that so pleased Watteau he embraced him when he saw them. Such was the general admiration for these creations that in 1718 Lancret was *agréé* — given preliminary acceptance into the Académie — on their basis.[38]

On March 24, 1719, Lancret was *reçu* — received as a full member of the Académie — with the *Conversation Galante* now in the Wallace Collection, London (pl. 2), or a painting resembling it but of different dimensions.[39] Some time between that year and Watteau's death on July 18, 1721, the two quarreled over two paintings Lancret had exhibited at the Exposition de la Jeunesse, which some people mistook for Watteau's work. This was to mark the end of their friendship.[40]

According to Ballot, Watteau's role toward Lancret was one of advisor and mentor. There was never a formal teacher-pupil relationship, as Watteau had shared with Pater. In 1723 the *Mercure de France* described Lancret as "pupil of the late M. Gillot and emulator of the late M. Watteau,"[41] but Watteau's influence on Lancret was demonstrably more important and lasting, far outweighing that of Gillot. We can easily see that early paintings by Lancret reflect not the stage-set interplay of Gillot's *Tomb of Maître André* now in the Louvre (fig. 6), but the parkland flirtations of Watteau's *Harlequin and Columbine* in the Wallace Collection (fig. 7).

Lancret's chief stylistic debt to Watteau is in his early production. Though

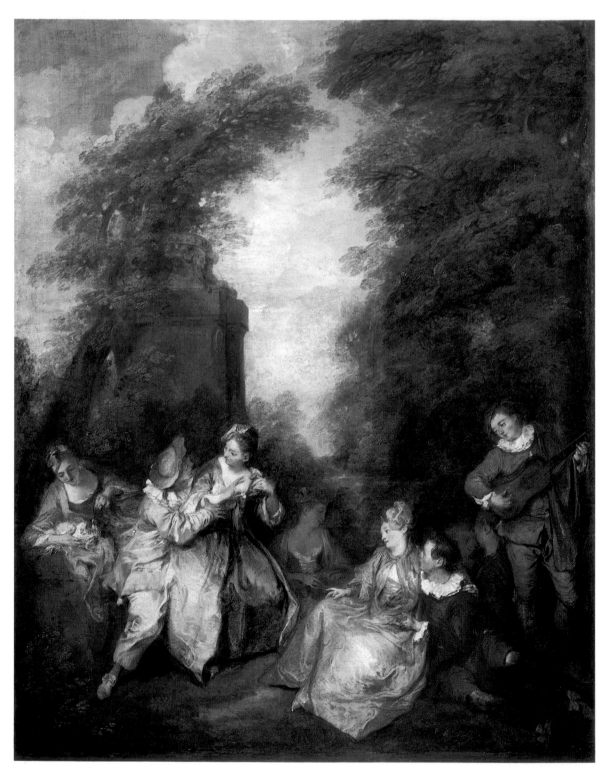

PLATE 2. Lancret. *Conversation Galante*. c. 1719.
Oil on canvas. Wallace Collection, London.

FIG. 6. Claude Gillot.
Tomb of Maître André.
Oil on canvas.
Musée du Louvre, Paris

Lancret's works are difficult to date, they do contain various chronological indicators, and one of these is the level of stylistic indebtedness to Watteau. Certain paintings from the initial stage in Lancret's development, beginning with *The Joys of the Theater,* are markedly imitative of Watteau in composition, setting, and figural style, and these are what prompted the *Mercure de France* to denote him an emulator of Watteau. They are not dated, but they surely belong to the period of Lancret's closest stylistic proximity to Watteau, which begins about 1712 and lasts several years past Watteau's death, to about 1725.

If these early works are the imitative efforts of a young painter, signs of change begin to emerge in the 1720s. Though his production retains certain derivative aspects, Lancret has gained confidence. His compositions become more spatially sophisticated and his figures more agile, as in the series *The Seasons* painted for Leriget de la Faye or *The Italian Meal* in the Charlottenburg (fig. 8). Though the figures are still small and attenuated and some of the faces still have a precious quality, other faces begin to exhibit a more robust countenance, a characteristic of Lancret's mature work. By the 1730s, Lancret has truly moved out of Watteau's stylistic orbit and into one of his own. While he retains Watteau's outdoor settings and elegant figures, he now endows them with his

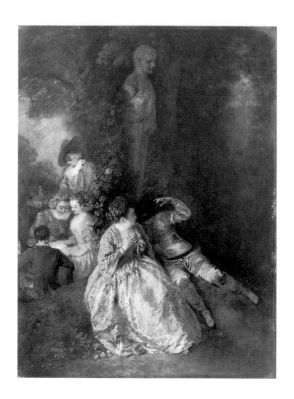

own distinctive sense of vivid color and his unique wide-eyed facial type. The narrative aspect is emphasized. The London *Four Ages of Man* (figs. 5a, 5b) belongs to this period. In the late 1730s and on into the 1740s, there is another new development: the number of figures in his paintings has decreased, and their relative size has increased. The figures have been brought forward, closer to the picture plane. While the actual size of the canvas does not necessarily grow, the figures grow within it. There is a corresponding emphasis on heightened color and luminosity. *The Cup of Chocolate* in The National Gallery, London (pl. 22), and the Stockholm *Fastening the Skate* (pl. 1) exemplify this new monumentality.

Of course, Lancret retained certain elements from Watteau throughout his career. He always preferred park settings to interiors, and he always endowed them with statues, benches, and fountains. Favorite poses continue to appear, such as the one Watteau had used in his portrait of Antoine de La Roque, which Lancret adapted for his *End of the Hunt* and *A Hunter and His Servant* (pl. 19), Watteau's ubiquitous aggressive suitor bent over his prey, who reappears in Lancret's *Bourbon-Conti Family* (pl. 16), the outdoor *Blindman's Buff,* the Wallace Collection's *Dance in a Park,* and the La Faye *Autumn* (pl. 10), or the lady being

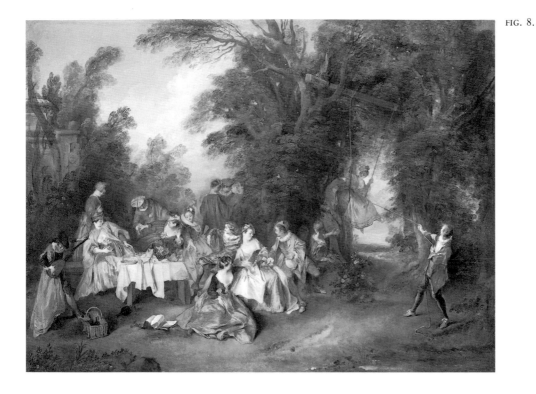

FIG. 8. Lancret. *The Italian Meal.*
Before 1738. Oil on canvas.
Charlottenburg, Berlin

helped to her feet from Watteau's Berlin *Pilgrimage to Cythera,* who is found in Lancret's 1738 *Winter.*

There are themes, as well as poses, that Lancret learned from Watteau and continued to depict with little variation throughout his career, such as large *fêtes, commedia dell'arte* scenes, and certain garden dances. While he continued to use these borrowed concepts in his mature work, he eventually did so in his own style, and with his own emphasis. When we compare Watteau's *Venetian Pleasures* in Edinburgh (fig. 9) with Lancret's *Quadrille before an Arbor* in the Charlottenburg (pl. 3), the similarity of theme and setting are obvious, and even certain motifs are shared, such as the seated bagpiper, the garden sculpture, and the impulsive suitor. However, the differences are equally obvious, and we would not mistake one painter for the other. The refined features and pearly skin tones of Watteau's figures have been replaced by blushing faces with broader features — most notably Lancret's prominent, heavy-lidded eyes. The silver glimmer of Watteau's subtle color harmonies gives way to vivid shades in striking combinations, setting the figures apart from the landscape and strengthening their visual impact. A sharp green is united with a velvet blue on one figure, red with black on another. It is Watteau's subtlety that has been

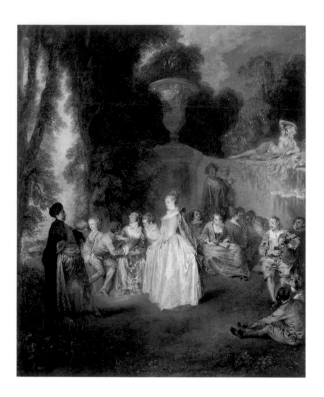

discarded, in favor of something more quickly and easily understood.

Other followers of Watteau remained much closer to him in style and theme. We must assume that Lancret's style developed from a combination of elements, of which his early experience with Watteau was only one, albeit the most important. Lancret was a professional man with an artisan family background. Throughout his career he remained aware of popular culture and the demands of his market. His more anecdotal, down-to-earth manner probably reflects his personal taste and abilities, as well as his acute sense of the taste of the time. As his decorative commissions multiplied, he must have considered a brighter, more vivid palette and the broader, more direct gestures common to history painting necessary in order to preserve the sense of his images and give them the requisite impact.

If Watteau's contribution to Lancret's art is certainly more than the sum of borrowed motifs, figures, and themes, it is still less than the total inspiration suggested by the Goncourts. Watteau provided the conceptual basis for Lancret's achievement. To clarify and measure Watteau's impact, it is instructive to compare Lancret with another contemporary genre painter who was not in Watteau's immediate orbit—for example, Jean-François de Troy (1679–1752).[42] Though de

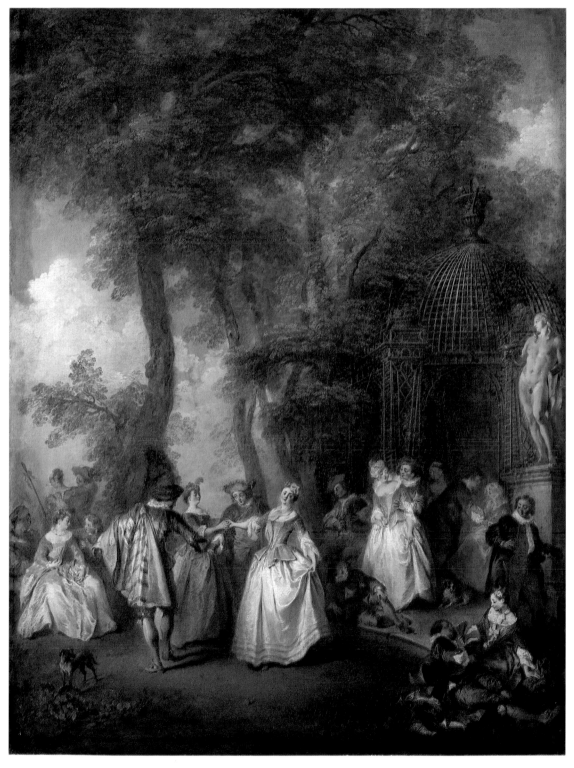

PLATE 3. Lancret. *Quadrille before an Arbor.* c. 1730–35.
Oil on canvas. Charlottenburg, Berlin.

FIG. 10. Jean-François de Troy.
The Declaration of Love. 1731.
Oil on canvas.
Charlottenburg, Berlin

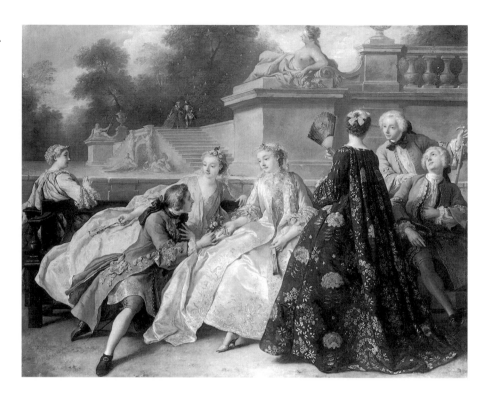

Troy was also a history painter, his opulent genre scenes are his best-known works today. His *Reading from Molière* (formerly Marchioness of Cholmondely collection) exemplifies perfectly his style of lavishly decorated, meticulously recreated interiors inhabited by wealthy people at leisure. In fact, Lancret and de Troy have much in common, especially in their emphasis on anecdote. They often used similar subject matter, and they both found inspiration in seventeenth-century costume prints. In certain works they move quite close to one another: Lancret's exquisite *Morning* (pl. 20a), for instance, leans toward de Troy's gilded settings, while the theme and outdoor placement of de Troy's *Game of Pied-de-Boeuf* reflects Lancret's livelier narratives.[43]

However, if we compare even a parkland scene by de Troy, such as his 1731 *Declaration of Love* in the Charlottenburg (fig. 10), with a painting by Lancret of about the same time, such as the *Earth* in Lugano (fig. 11), the differences are obvious. De Troy treats his parkland as if it were an interior. His figures, strung gracefully along a foreground bench, might as easily be occupying a Regency sofa. He makes no attempt to unify figures and landscape. The term *champêtre* would seem inappropriate in the title of such a painting; that the setting is outdoors is incidental, an outward extension of indoor splendors.

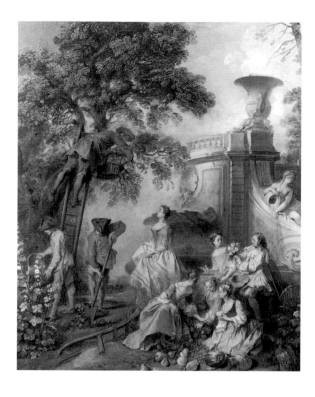

FIG. 11. Lancret. *Earth* (from *The Four Elements*). Before 1732. Oil on canvas. Thyssen-Bornemisza Collection, Lugano

The light is uniform, intended for display — far from the dappled subtleties of Lancret's parks.

The most lasting contribution Watteau made to Lancret's art is found in this comparison. Lancret will leave his imitative manner, create his own themes, develop a more anecdotal narrative, liven his palette, and provide his characters with a distinctive and unique facial type. But the ability to place his dramas in landscapes, where relationships blossom with the grace and ease of a stroll, where liaisons (present and future) are played out in the dance, where the setting is the story — all of that is Watteau's gift. The *conte* is gilded with the poetry of the *fête galante*.

After the deaths of Watteau in 1721 and Gillot in 1722, Lancret, recently granted full membership in the Académie as a painter of *fêtes galantes,* became one of the public inheritors of Watteau's mantle, with a great opportunity for success in his chosen arena. The popularity of the *goût de Watteau* among connoisseurs was by then well established. It was an exciting and lucrative new mode of expression, and Lancret was able to cater to the demand for it. While he was not the only painter to take up Watteau's manner, he was one of the first

and most significant to do so. Bonaventure de Bar had a very short career, dying in 1729.[44] The mysterious François Octavien concentrated primarily on his singing career, painting only intermittently.[45] Pierre-Antoine Quillard moved to Portugal in 1726.[46] François-Jérôme Chantereau was not born until 1710.[47] Philippe Mercier lived in England after 1716.[48] Pater alone posed a serious challenge to Lancret's virtual monopoly. After Watteau and Lancret, he was the only artist accepted by the Académie as a painter of *fêtes galantes*. Indeed, Gersaint treats Lancret and Pater as one, foreshadowing later perceptions: "Lancret and Pater were the only two painters who stumbled into the taste for fashions and for gallant subjects of which Watteau was the inventor and the model. This genre became completely extinct at their death [sic]."[49]

It was Pater who became Watteau's pupil, probably in the years from 1710 or 1711 until 1713.[50] He studied with Jean-Baptiste Guidé in Valenciennes until, according to Gersaint, his father decided he would profit from joining their compatriot in Paris. By all accounts, Watteau was not easy to work for, and Pater left him to go back home, not returning to Paris until 1718. Pater and Watteau reconciled just before Watteau's death, with the intervention of Gersaint. Pater was *agréé* by the Académie on July 28, 1725, and *reçu* on December 31, 1728, nine years after Lancret, as a painter of *fêtes galantes*.[51]

At the time of Watteau's death, both Lancret and Pater, aged thirty-one and twenty-six respectively, were only starting their careers. Though both artists founded their achievements on the art of Watteau, a comparison of their styles and their patrons shows how much closer Pater stayed to his source. While Lancret's art always revealed a profound debt to Watteau, he still was able to create an independent style and career, and to make important contributions to the art of his own time and of the future. Pater, however, seems to have been overwhelmed by Watteau's genius, and his style remained derivative. Pater's *Gathering of Italian Comedians in a Park* at Buckingham Palace (fig. 12), one of his masterpieces, bears the unmistakable stamp of Watteau in the delicate figures and faces and the pearly and subdued palette, as well as in composition and subject matter. Pater's treatment could never be confused with Lancret's stronger style. Pater seems to have been patronized especially by collectors seeking a substitute for Watteau.[52]

The *Mercure de France* described Lancret's work as "in Watteau's style" for the last time in 1728.[53] By 1730 it was praising his *Four Seasons* for Leriget de la Faye as "in a new and highly pleasing taste,"[54] and thereafter it omits mentioning Watteau altogether in its comments on Lancret's work. According to the devoted Ballot, even in his early, derivative years Lancret possessed something

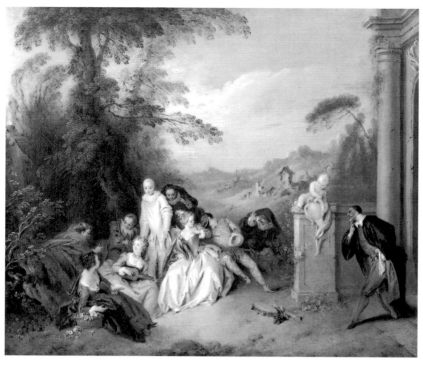

FIG. 12. Jean-Baptiste Pater. *Gathering of Italian Comedians in a Park.* Oil on canvas. Buckingham Palace, London

unique. Speaking of his 1719 reception pieces, Ballot says: "The two paintings . . . are certainly in the genre of Watteau, but in a style that M. Lancret had already created for himself; and true connoisseurs will not confuse them."[55] Pater, on the other hand, never left the shadow of the greater artist, whether in his art or in the public eye. The announcement of his death in the *Mercure* called him a "compatriot and pupil of the illustrious Antoine Watteau, in whose manner he made his reputation."[56]

A young painter anxious for wider acceptance had few chances to get his work before the public in the 1720s. Since the turn of the century, the Académie had sponsored only one official Salon, in 1704. With such scant opportunity, Lancret turned to an unofficial showing known as the Exposition de la Jeunesse to exhibit his work. The Exposition, which must have seemed a crucial opening for a young painter, was held each spring on one day only — the *Fête-Dieu,* or Feast of Corpus Christi — outdoors on the Place Dauphine and the Pont Neuf.[57] It did not carry the prestige of an Académie show, and history painters generally ignored it. The earliest record of Lancret's exhibiting there dates from 1722, but he seems to have done so at least once before Watteau's death in 1721.[58] He stopped after his work appeared in the Salon of 1725.

Lancret's 1722 entries were described by the *Mercure de France* as "various

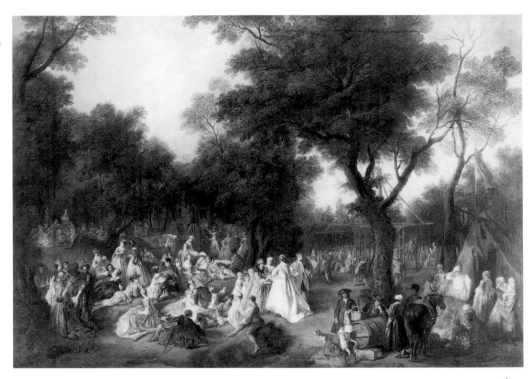

gallant subjects by M. Lancret, treated in the most graceful manner in the world." These paintings have not been identified with certainty, but one may have been the Wallace Collection's *Fête in a Wood* (fig. 13).[59]

With the paintings Lancret showed in the Exposition in 1723 we have better luck, and we are fortunate to be able to include one of those entries here: *The Lit de Justice* (pl. 5). That work's pendant, *The Conferring of the Order of the Saint-Esprit* (fig. 14), was not exhibited.[60] These two colorful, panoramic sketches, representing important events in the early reign of Louis XV, are among the rare history paintings by Lancret. We have no record of any finished versions after them nor of any commission for the sketches, and Lancret evidently held on to the pair, as they were sold with his widow's effects after her death. Two other sketches, representing concerts at the country and city homes of the immensely wealthy banker Pierre Crozat (pl. 6, fig. 23), are strikingly similar to them in style, provenance, and the treatment of contemporary events, suggesting that all four works date from this very early time. But an even more noteworthy correspondence is in their subject matter: each painting depicts an incident in the life of someone of great potential value to Lancret as a patron.

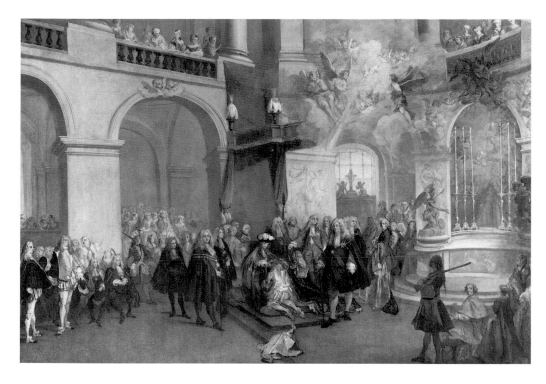

FIG. 14. Lancret. *The Conferring of the Order of the Saint-Esprit.* 1723. Oil on canvas. Musée du Louvre, Paris

There were few clear avenues to patronage at this moment in France, and, as we have seen, exhibition venues were rare. The Regency was ending and a new monarchy beginning, with unforeseeable ramifications for future art purchases or commissions. Lancret seems to have painted these four scenes from the lives of the King and Crozat on speculation, as examples of the kind of work he could do, perhaps showing them to agents of the two highly influential potential clients. The Duc d'Antin, who as Superintendent of the Bâtiments du Roi was chief advisor to the monarchy on all matters dealing with art, was an early and devoted supporter of François Lemoyne, one of Lancret's great friends. Lemoyne might easily have brought to the Duke's attention the sketches of the *Lit* and the *Saint-Esprit*. Crozat's importance should not be underestimated either. His salons were, in Crow's phrase, "shadow Académies,"[61] and during the Regency his concerts served as the best opportunity to connect potential patrons with artists, among them Watteau. Thus, Lancret seems to have shot arrows in two strategic directions, toward both the court and the financial elite, in hopes of getting something going. In fact, Crozat owned another early painting by Lancret, the *Outdoor Concert* now in the Hermitage Museum, Leningrad.

Lancret's first Crown commission followed closely upon these works of 1723.

It is questionable whether Louis XV would have been willing to sacrifice pomp to the degree that Lancret did in the recording of significant events, but when the King desired a souvenir of a humorous occasion, the Duc d'Antin turned to Lancret. (If the *Lit* and *Saint-Esprit* had been bids for history commissions, this new assignment must have had an ironic thrust.) Lancret's first Crown commission, ordered in 1725, was entitled *The Accident at Montereau.* It involved an almost burlesque incident that befell Marie Leczinska and her entourage on their way to Fontainebleau for her marriage to the King. A carriage transporting her ladies-in-waiting became stuck in mud, and the ladies were forced to continue their journey in a cart that had been covered with straw. The incident occasioned much hilarity at court, and the document granting the commission states that the ladies should be represented "as grotesquely as possible, and like calves being brought to market." All trace of the painting has been lost, but since Lancret was paid 400 livres for it in 1727, it presumably was delivered.[62]

Lancret had exhibited again in the Exposition de la Jeunesse of 1724, showing what the *Mercure de France* described as "a rather large, arched painting in which we see dancers in a landscape, with all the brilliance, novelty, and gallantry the painter was capable of bringing to the pastoral genre." Guiffrey has plausibly suggested that this is one of the paintings referred to by Mariette in his *Abécédario* entry on Lancret: "It is a full twenty-four years since he made his debut with two paintings, a *Ball* and a *Dance in a Grove,* two paintings that belonged to M. de Jullienne and then to M. le Prince de Carignan, and I recall that when they were exhibited in the Place Dauphine on the feast of Corpus Christi they earned him high praise."[63]

There were, in fact, two such paintings by "M. Nancre" in the 1743 Carignan sale. They were subsequently discussed in a well-known letter sent to Frederick II of Prussia — a devoted admirer of French eighteenth-century art in general and of Watteau and his followers in particular — by Frederick's emissary in France, Count Rothenburg, detailing the acquisition of two items by Lancret from the Carignan sale. There has been a tendency to identify these paintings with two of Lancret's most admired works, the *Quadrille before an Arbor* (pl. 3) and the *Dance in a Pavilion* (fig. 15) both now in the Charlottenburg, thereby assigning those canvases the very early dates of 1720–24. It seems more likely, however, that the Charlottenburg scenes entered the Prussian royal collection in 1753 as part of a sale of six paintings arranged by Lancret's widow, and that the

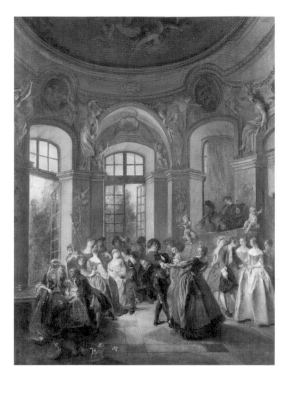

1724 works have yet to be identified. Frederick began buying French pictures in the 1730s, before his ascendancy, and his collection finally included twenty-six Lancrets. In fact, another pair of paintings in his collection seems to correspond to the early references — *The Ball* (fig. 16) and *Outdoor Fête* (fig. 17); such spacious scenes, with their multitudes of diminutive and elegant figures not unlike the less finished figures in the Louis XV and Crozat sketches, are a feature of Lancret's work in the mid 1720s. It is surely within this period that we must place the Wallace Collection's *Fête in a Wood* (fig. 13).[64] Despite obvious references in pose and theme to Watteau, the paintings of this time are far from derivative. Their striking colors, elegant clusters of figures, and increasingly distinctive facial features indicate Lancret's growing independence and maturity. On the evidence of such works, we can agree with Ballot that "true connoisseurs will not confuse them."

The Salon of 1725 provides an interesting opportunity to compare Lancret with his contemporaries, for the principals are conveniently gathered here. This "pseudo" Salon — distinct from the true Salons mainly in its duration, for it lasted just ten days rather than four weeks — was organized by the Duc d'Antin to encourage history painting, and it serves to introduce many of the

FIG. 16. Lancret. *The Ball.* c. 1724.
Oil on canvas.
Charlottenburg, Berlin

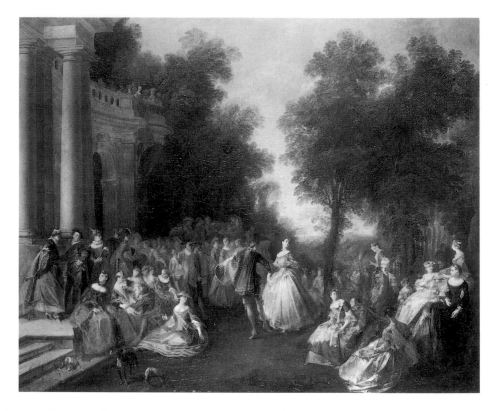

participants in the Concours of 1727.[65] (Regular Salon exhibitions did not
resume until 1737.) The 1725 showing is remembered largely as a key episode in
the battle of Jean-François de Troy and François Lemoyne for preeminence in
history painting. It was also Lancret's first opportunity to exhibit under the
Académie's prestigious aegis. The *Mercure de France* detailed his entries thus: "An
arched painting 6 1/2 feet high by 5 1/2, representing a Ball in a landscape
adorned with architecture. Return from the hunt, 4 feet wide by 3, in which we
see various horsemen and ladies in riding dress taking a meal. Women bathing.
View of the Saint-Bernard Gate, same size; Dance in a landscape, a small
painting; Portrait of M. B[allot] playing a guitar in a landscape: boldly handled
easel painting."[66]

Clearly, Lancret took the opportunity to display the full gamut of his
abilities. Indeed, a wide range of subject matter was a feature of the entire Salon,
presumably because of the dearth of exhibition opportunities. Participants had
to present the broadest possible scope within a single display. Lemoyne, for
example, showed not only the expected mythologies, such as *Hercules and
Omphale,* but also his celebrated *Woman Bathing*.[67] Of de Troy's eight entries,
two were mythologies, one was drawn from ancient history, one was from

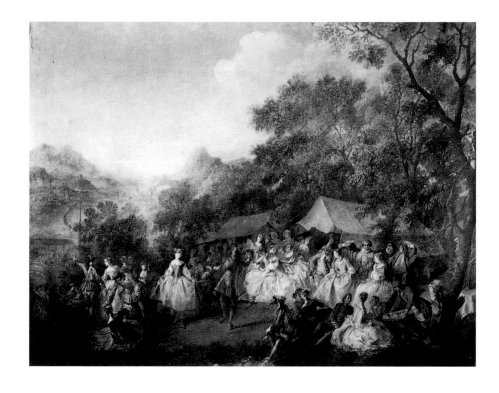

FIG. 17. Lancret. *Outdoor Fête.* c. 1724.
Oil on canvas.
Charlottenburg, Berlin

ancient literature, and four were scenes of upper-class diversions.[68]

Lancret's entries have not been positively identified, but paintings with corresponding themes from about this time survive, providing a general idea of his presentation. The Dresden *Dance between Two Fountains* (pl. 12), the *Pleasures of the Bath,* and the Sans Souci *Luncheon in the Forest,* with their small, elegant figures and their compositions revealing a continued debt to Watteau, can all be dated to the mid 1720s. Though the portrait of Ballot is lost, Lancret did a similar portrait of a man playing the cello now in a private collection (fig. 18), and its derivation from Watteau's portrait of himself with Jean de Jullienne is apparent.[69]

Lancret was now, at thirty-five, a mature, independent artist, successfully launched on his career. His developed style evinced both ease and individuality, especially in his move toward a narrative technique, characterized by liveliness of color and of facial types. He had been patronized by Crozat and the Duc d'Antin, was praised in the *Mercure de France,* and made a substantial showing at the Salon. Before 1730 he had garnered at least two (and probably three) major commissions from influential patrons, painted an immediately celebrated portrait of a famous ballerina, and begun the production of the ever-popular prints after his

FIG. 18. Lancret. *Man Playing the Cello.* c. 1725.
Oil on canvas. Private collection

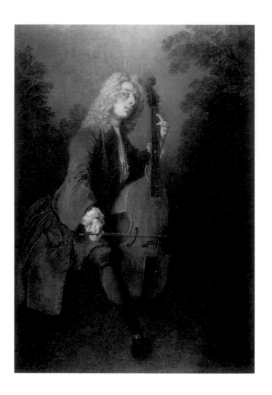

work. The two important commissions—one for the Hôtel de Boullongne, owned by Jean de Boullongne, the Controller General of Finances, and the other for Jean-François Leriget de la Faye, a prominent diplomat, collector, and poet—were for extensive decorative cycles, and they represent Lancret's largest efforts to date. Such decorative sets were henceforth to form a major part of Lancret's commissioned work, most notably those he did for Louis XV. The Leriget de la Faye paintings were engraved, and they must have assisted the spread of Lancret's popularity.

Lancret's portrait of the dancer Mlle. Camargo (pl. 9) placed him firmly in the public spotlight, for she was the most acclaimed ballerina of her time, the worthy successor to Françoise Prévost at the Opéra. Lancret did several versions of the painting, and the print after the portrait (fig. 19), authorized in August of 1730, was so successful it was promptly counterfeited. Lancret would soon provide Mlle. Camargo with a pendant: a portrait of Mlle. Sallé, who was equally celebrated in dance. The portraits of these two women, Lancret's later portrait of the actor Grandval (pl. 21), and his depictions of actual scenes from plays represent a new development in the artist's response to theatrical subjects. They are much more direct evocations of contemporary

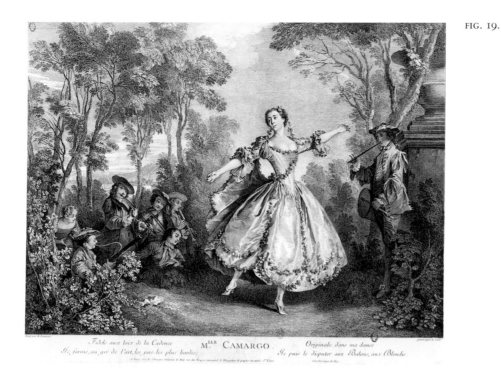

FIG. 19. Lancret. *Mlle. Camargo.* 1731.
Engraving by Laurent Cars.
Bibliothèque Nationale, Paris,
Cabinet des Estampes

Fidele aux loix de la Cadence M.^{LLE} CAMARGO. Originale dans ma danse
Je forme, au gré de l'art, les pas les plus hardis; Je puis le disputer aux Balons, aux Blondis

theater, much keener indications of Lancret's personal involvement in it, than his *commedia dell'arte* scenes, which owe their genesis more to the art of Gillot and Watteau than to the theater itself. These paintings are early instances of Lancret's move beyond the subjects of Watteau. In *La Camargo Dancing,* a sophisticated blend of fact and fantasy, of portrait and theater, marks a new stage in his art.

La Camargo brings up an important aspect of Lancret's personality: his passion for the theater in all its forms, from the marionettes and Théâtre de la Foire, to the Comédie Italienne (which had reopened in 1716), to the Comédie Française and the Opéra. He frequented them all. Ballot tells us, "This was the only vice attributed to M. Lancret."[70] Perhaps inspired — and certainly encouraged — by his associations with Gillot and Watteau, who were both conspicuous theater-lovers, Lancret's involvement with the stage colored his art as well as his life. His friend Ballot shared this preoccupation, and must surely have accompanied him to the theater often. Ballot was the legal representative for a number of theatrical figures and a regular guest at the salon of the *fermier-général* Alexandre-Joseph Le Riche de La Poupelinière, a celebrated art patron.[71] Lancret might easily have joined him, and there he could have encountered such

FIG. 20. Lancret. *Italian Comedians.* c. 1725–28.
Oil on canvas. Musée du Louvre, Paris

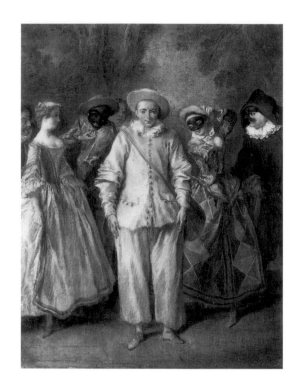

luminaries as Rameau, Voltaire, Fuzelier, La Motte, Rousseau, Jean de Jullienne, and both Mlle. Sallé and Mlle. Camargo. On one occasion Voltaire accompanied Ballot to Lancret's studio to see the portrait of Mlle. Sallé, who was his close friend; he judged her portrait superior to that of Mlle. Camargo.[72] A further connection of Lancret to the world of theater and literature was formed by his late marriage to Marie Boursault, granddaughter of the author of the stage comedies *Aesop in the City* and *Aesop at the Court.*[73]

The direct impact of the theater on Lancret's art is not hard to discern. Besides his portraits of theatrical figures and paintings of stage scenes, we find numerous characters from the *commedia dell'arte,* as in his Louvre *Italian Comedians* (fig. 20). Though he never, as far as we know, created set or costume designs, two full renditions of scenes from opera are possibly attributable to him — one painted on the inside of a harpsichord lid — and he provided two charming frontispieces for books of harpsichord works.[74]

A survey of the decade 1730–40 presents a panorama of success. Lancret's commissions multiplied. In France, he was collected by the Comtesse de Verrue, the Prince de Carignan, the Comte de Vence, M. and Mme. Gaignat, Jean de Jullienne, La Roque, Cottin, and Quentin de l'Orangère — in short, by a

solid cross-section of the major art patrons of his time.[75] As we know, La Live de Jully ordered a reduced replica of one of the works he did for Louis XV. His paintings were also extremely popular at foreign courts, and were represented in the collections of Count Brühl at Dresden, the Elector of Cologne, Catherine II of Russia, Queen Louisa Ulrica of Sweden, and, especially, Frederick II of Prussia.[76] His major patron, however, the source of steady commissions from the mid 1730s until Lancret's death, was Louis XV.[77]

Lancret provided not only decorations for the King's apartments at various royal residences — Versailles, Fontainebleau, and La Muette — but also numerous works for the quarters of the Queen and of the royal mistresses, as well as gifts for Louis' friends. Perhaps the most memorable commission, and one of the most indicative of the King's personal favor, is the *Luncheon with Ham* now at Chantilly (fig. 1). This painting — like its pendant, the *Luncheon with Oysters* by Jean-François de Troy — was commissioned in 1735 for the dining room of the *petits apartements* at Versailles, a maze of small rooms the King had had constructed in the north wing for his leisure hours. It was a mark of particular favor to be asked to provide so prominent an item in its decoration, and Lancret supplied many other works for these apartments as well.

Also in 1735, Lancret was made *conseiller* of the Académie (along with Charles Parrocel) upon the presentation of his *Dance between the Pavilion and the Fountain,* now in the Charlottenburg (pl. 4). This painting, signed and dated 1732, is singled out for praise by both Ballot and Dézallier d'Argenville, and Lancret himself must have thought highly of it to base his bid for office on it: he submitted only that one work.[78] It is a lovely example of the subtle chiaroscuro Lancret could achieve, of his ability to differentiate the glimmer of light on foliage from that on rosy skin or shining silk.

Lancret's success continued in the second half of the 1730s. After the Salon was re-established in 1737, he exhibited there regularly until his death.[79] His scenes from popular plays and his portrait of the actor Grandval (pl. 21) were shown during this period, along with many depictions of children's games. In 1736 he took over the commission for scenes from the *Tales of La Fontaine* left unfinished by Pater at his death.[80] He provided numerous decorations for the royal châteaux, including his *Four Seasons* for La Muette.

Lancret's work of the later 1730s and early 1740s exhibits another stylistic shift, one comparable in importance to his development of a characteristic facial type in the middle 1720s. Many of the works of these years — though not all; the La Muette paintings, for example, are exceptions — reveal the previously men-

Lancret. *Dance between the Pavilion and the Fountain.* 1732. Oil on canvas. Charlottenburg, Berlin.

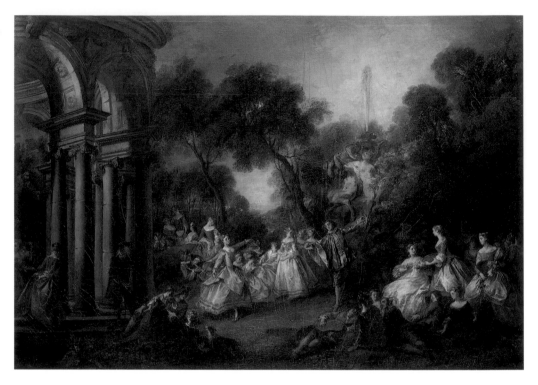

tioned increased focus on the figures: they grow larger relative to the pictorial space, and their numbers diminish. The narrative remains the central issue, but it is concentrated in fewer figures. A glance at the two masterpieces of this late style, the Stockholm *Fastening the Skate* (pl. 1) and the London *Cup of Chocolate* (pl. 22), demonstrates the new internal proportions.

Lancret's surviving oeuvre is quite large, and all of his early biographers speak of his total absorption in his work. Depending on their critical bias, they find this devotion either one of his chief virtues or characteristic of an unimaginative and pedantic outlook. Ballot treats it with respect: "Drawing and painting were preoccupations with M. Lancret. He had such a great love of work that he would have found the feast days burdensome had he not felt obliged to fill them attending to the demands of religion, which he always did until the final moment of his life."[81] Ballot adds that Lancret's hard work set a good example for the young students at the Académie, to whom, he says, Lancret was very kind. Gersaint too notes Lancret's good nature, praising "his polite, gentle, compliant, and affable temperament."[82] Mariette, however, found little to admire in Lancret's habits or his art, characterizing him thus: "He was a rather serious man, one who, going about little in society, busied himself

only with his work," though he remained, for all of that, "merely a practitioner."[83] We have only to count up the works listed in Wildenstein's catalogue to authenticate these descriptions of how Lancret spent his time. As Ballot observed, "The story of a life of labor such as Lancret's is all locked up, so to speak, in the quantity of his work that remains with us."[84] Wildenstein's catalogue includes 787 items. Even if we assume that figure to be slightly inflated, it is still an enormous production. If Lancret began painting seriously at the age of eighteen, in 1708, he would have to have turned out some twenty works a year to reach just 700.

Lancret's commercial success followed quickly upon his acceptance into the Académie in 1719. Not only were his paintings and prints popular, they soon became expensive as well. The issue of the print after his *La Camargo* was especially successful and, as noted, was quickly counterfeited; Lancret won extensive damages in his 1731 suit against the merchant involved.[85] His prints remained best-sellers.[86] The Prince de Carignan paid the tremendous sum of 10,000 livres for two paintings — of a *Ball* and a *Dance* — during the artist's lifetime.[87] As Mariette says, "He acquired in rather short order a respectable fortune."[88]

Marie Boursault, whom Lancret married in 1740, was nearly twenty years his junior.[89] She would outlive him by almost forty years. They were wed quietly — *hors de paroisse* — and neither family attended, perhaps disapproving of the disparity in their ages. They had no children, and on his death in 1743 Lancret left everything to her. The catalogue of her sale in 1782 (compiled by Rémy) consists mainly of works collected by Lancret himself, and is thus a remarkable document of his taste.[90] Roland Michel has devoted a short but illuminating study to the catalogue, and the discussion that follows is formed largely from her observations.[91]

A number of the lots in the sale represented Lancret's own work, largely comprising oil sketches and drawings. The oil-sketch technique, which we have encountered in connection with the Crozat concerts and the Louis XV history sketches, appears to have been a frequent, if not a consistent, tool of Lancret's. There are not enormous numbers of sketches, but enough exist to suggest that he employed them when the occasion demanded. Some are preparatory, while others correspond to no known finished work. Roland Michel suggests that the latter group were done either for pleasure or as lures for commissions. Over two thousand drawings are catalogued by Rémy, an abundance that should not surprise us. Ballot stressed Lancret's devotion to drawing, which Watteau had recom-

mended that he cultivate early in his career. He drew at the Académie, at the theater, in the parks and streets, everywhere. The drawings range widely, from studies for figures in paintings to academic nudes, from trees to hands and feet. They are done chiefly in black or red chalk. Though no extant academic studies had been known until recently, current scholarship has attributed some to him. As noted, Lancret also taught drawing.

Lancret's taste for the work of other artists was broad. While in national scope it was confined to Italy, France, and the Netherlands, in subject matter it covered all ground. We might expect genre themes to dominate, but such is not the case. There are just as many religious paintings, an abundance of landscapes and still lifes, and a sampling of mythologies. Lancret's choices seem to have centered on the artist, not the theme. Among the Italian school, he favored fifteenth- and sixteenth-century works, acquiring only a few Baroque examples—notably by Guido Reni. His collection of Netherlandish art, the largest group, leaned toward Rubens and his school and Teniers, followed by Rembrandt and his students, Wouwerman, Ostade, and Brouwer. In French art he again reveals no special inclination, owning two Boucher landscapes, a still life of hares by Chardin, and drawings by Natoire and Oudry. His many prints included subjects by Bernard Picart, Carle Van Loo, Charles Le Brun, François Lemoyne, and Jean Raoux.

The main surprise of Lancret's collection is the startling scarcity of works by Watteau, Pater, or Gillot. Watteau appears in a small group of fourteen assorted French prints; Lancret did not own Jullienne's album of engravings after Watteau. There is one *singerie* in the taste of Watteau or Gillot. In the words of Roland Michel, "It really seems as though Lancret had made up his mind, once and for all, to sever the chains that linked him to his first masters and models."[92]

Lancret's collection is that of a connoisseur. When he could not acquire a great master, as Roland Michel notes, he satisfied himself with work by a lesser artist of good quality, or a print. The attributions in the 1782 catalogue are done with great scrupulousness and a scholar's particularization: "Lely in the style of Van Dyck," for example. Roland Michel plausibly accords this exactitude to Lancret rather than Rémy.

Lancret's impressive connoisseurship is supported by numerous other testimonies. Ballot, for instance, records Lancret's visits with Lemoyne to Versailles to view the Old Masters: "A friend they had in common asked to join them; and it is from him that we have the comparison—if we dare to make use of it—of those two men visiting that immense and precious collection with two pilgrims whom we might encounter in the holy places: rapt, overwhelmed,

lifting up their exclamations and prayers to heaven. They would not part without promising that before they died, they would each paint a copy of Van Dyck's *Christ* and make a gift of it to the other."[93]

Ballot also relates the story of Lancret's most famous display of connoisseurship: "M. de la Faye, who took pleasure in testing those who claim they can distinguish an original from a copy without ever going wrong, had commissioned a Flemish artist to paint, on an old canvas, a full-sized copy of the lovely *Nativity* by Rembrandt that he owned, and had substituted this copy for the original, hanging it in the same frame and in the same place. M. Lancret, accompanied by one of his friends, went to visit like the others, proceeded through the rooms, and stopped before the painting. M. de la Faye was ready to set off the trap, but he did not snare him like those who had come before; for M. Lancret cried out to his friend, 'We've been deceived. Surely this is not the original. This is not the one that I've seen.' M. de la Faye asked him on what he based his judgment. M. Lancret pointed out a false brushstroke on the arm of the Child. The original was brought out. M. de la Faye was enlightened and instructed, and paid homage, so to speak, to the astuteness of M. Lancret, who alone among several qualified people had spotted that difference."[94]

Lancret died on September 14, 1743, apparently of pneumonia. Ballot, always the affectionate friend, says he expired while painting the only work that ever completely pleased him. This painting, or a close variant of it, is included here (pl. 25). "He conceived some time before his death," Ballot writes, "an idea for a painting he said he wanted to do for his own pleasure and enjoyment. Its subject is a man showing curiosities in a village, accompanied by little girls with marmots and surrounded by onlookers. To that effect he shut himself up, wishing to see no one. This prompted two of his friends to try to penetrate the mystery, and what they discovered in his studio was a scene out of a comedy, surprising him amid a troop of little marmots whose grotesque attitudes contrasted so strikingly with the gravity of his brush. Close to finishing the work, he admitted, for the first time in his life, that when he looked it over he was pleased with himself. This expression of self-esteem, which was so foreign to him, seemed to signal his end. He had only to add the final touches to the painting when he was suddenly struck with an inflammation of the lungs, which carried him off in two times twenty-four hours."[95]

Nicolas Lancret exerted a widespread and important influence on the art of the eighteenth century. His special talent lay in developing themes in which to

couch his narrative, iconography to elaborate on it, and compositions, figure styles, and colors to express it most clearly. His intimate and humorous anecdotes differ markedly from the quiet scenes of Watteau or Chardin, in which very little happens. After painting his stories, Lancret returned them to the print world: the vast majority of his paintings were engraved, and these prints were purchased throughout Europe, throughout the century. Copies after his engravings turn up regularly in the work of minor English painters.

In order to define properly Lancret's influence, we must return to the point where most examinations of Lancret begin: the relationship of his art to that of Watteau. Scholars have long insisted on the primacy of Watteau in the history of eighteenth-century painting.[96] However, contemporary studies, most notably Posner's 1984 Watteau monograph, have challenged this view, asserting that Watteau remained largely outside the artistic mainstream; indeed Posner concludes that Watteau's influence on the development of eighteenth-century art "was relatively limited."[97] Lancret brought Watteau's achievement back into the mainstream of popular culture. Lancret's focus on contemporary realities — definable and particular — made him more accessible. If Watteau's poetic evocations remained outside the grasp, or the aims, of many eighteenth-century genre painters, Lancret's prose adaptations did not. Lancret used many elements from the *fête galante,* such as the placement of graceful figures in parks or elegant structures, the blend of fantasy and theater with contemporary fashion, and the expression of relationships through composition and iconography. However, where Watteau is timeless, presenting love as a constant of human behavior, using anachronistic costumes, depicting ambiguous settings and generalized activities, Lancret is contemporary, illustrating love stories of eighteenth-century individuals, elaborating them with appropriate details of dress and specific settings, and providing them with particular undertakings. Lancret's images are rooted in their time, and the narrative is paramount.

Posner's comparison of Watteau's *Halt during the Hunt* in the Wallace Collection with Lancret's *Picnic after the Hunt* in the National Gallery, Washington (pl. 13), demonstrates this contrast clearly. Watteau, even treating so specific a subject, remains allusive and vague about the figures and their actions. The "hunt" aspect of the painting is manifestly secondary. The figures do not wear appropriate hunting dress, the dogs are languid, the catch is meager. As Posner notes, ". . . Watteau was not comfortable with the actuality of the hunting scene, and, characteristically, he tried to preserve his allusive poetry by undermining the naturalistic content of the imagery he was introducing."[98] Not so

Lancret. His scene is rich with the staffage of the hunt—the colorful hunting costumes, the straining hounds, the clustered horses. It is no surprise that it was Lancret who most successfully combined the *fête galante* with portraiture, in his theatrical portraits and conversation pieces. An air of contemporary reality was never absent from his paintings. The images of daily life created by many other eighteenth-century French artists, such as Boucher, Carle Van Loo, or Gravelot, reflect not the ageless and subtle glories of Watteau's scenes, but the contemporary narratives of Lancret.

Lancret's influence on eighteenth-century genre painting was twofold: he developed specific themes that, in their use of images from daily life, became important sources for other genre painters; and, more generally, he advanced a style of painting that focused on the relationships and anecdotes contained within a scene, on its particular humanity. Lancret was the great storyteller of the early eighteenth century, and this aspect of his art provided a stimulus for the continuing traditions of narrative painting in France, including the art of Greuze and Boilly. It is not difficult to trace the progress of Lancret's themes during the later 1700s. They recur frequently, both in France and abroad.

Perhaps the most obvious example of Lancret's impact is on the narrative genre scenes of François Boucher (1703–1770), which are few in number but striking and important works nevertheless. The great majority of Boucher's allegorical compositions employ putti or mythological motifs. In 1746, however, he undertook a set of *The Four Times of Day* for the Queen of Sweden, Louisa Ulrica. Only *The Milliner: Morning,* still in Stockholm (fig. 21), was completed, but the entire projected set is described in a letter of October 27, 1745, to the Queen's emissary in Paris, Count Tessin, from his secretary, Carl Reinhold Berch: "Morning will be a woman who has just had her hair done, still wearing her dressing gown, amusing herself looking over some baubles being displayed by a milliner. Noon, a conversation at the Palais-Royal between a lady and a wit. . . . Afternoon or Evening . . . invitations are brought for a rendezvous. . . . Night represented perhaps by some giddy women in ball gowns making fun of a person who has fallen asleep. . . ."[99]

The debt to Lancret is obvious. It was Lancret who conceived of combining the fashionable appeal of the costume print and the allegorical conceits used to vary its staffage with the multi-figured genre painting. His own set of *The Four Times of Day,* now in London (pl. 20a-d), engravings of which were published in 1741, is the self-evident and solitary prototype for Boucher's projected set, and Boucher's *Morning* echoes Lancret's directly, especially in the

FIG. 21. François Boucher. *The Milliner: Morning.* 1746.
Engraving by R. Gaillard. Bibliothèque Nationale,
Paris, Cabinet des Estampes

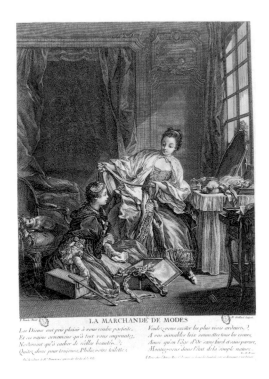

pose and costume of the central character: each lady sits facing the viewer with a
dressing table beside her, each wears a short morning cape tied at the neck, and
in each painting one tiny foot pokes from beneath the lady's skirt. It is likely
that Boucher also followed Lancret's lead for the source of the ribbon-seller
motif, as it is borrowed from seventeenth-century prints such as Henri Bon-
nart's *January* (fig. 22).[100] Boucher's 1742 *Lady at Her Toilet* (Thyssen-Bor-
nemisza collection, Lugano), though not part of a set, again reflects knowledge
of Lancret's *Morning.* The frontal pose of the main figure, the dressing table, and
the tea table are there, and the maid holding the lady's lace cap is a direct
quotation. Boucher has also made expanded use of the sexually enticing
quality inherent in a *toilette,* which Lancret conveyed only through the revealing
disarray of his lady's costume and the resulting confusion of her visiting prelate.
There is naïveté in Lancret's scene. Boucher abandons pretense. The lifted skirt
of the woman affirms her availability, and the cat between her spread legs toying
with a ball leaves no doubt as to the reason for her *toilette:* she is a courtesan
preparing for a lover.

Other examples of Lancret's direct influence throughout the century could
easily be cited. To mention but two, Antoine Pesne's *Portrait of La Barbarina*

FIG. 22. Henri Bonnart. *January.*
Engraving by R. Gaillard. Bibliothèque Nationale,
Paris, Cabinet des Estampes

(Charlottenburg), done around 1745, and Gainsborough's 1782 *Portrait of Giovanna Bacelli* (The Tate Gallery, London) are obviously based on Lancret's well-known portraits of Mlle. Sallé and Mlle. Camargo.

Lancret's misfortune is all too common in the history of art: to be born in the shadow of a genius, and to share enough affinity with that genius to invite constant comparison. It is a fate that has plagued the critical reputations of many fine artists, such as Masolino, Van Dyck, or Aert de Gelder. Indeed, a recent exhibition of Jan Lievens' work was entitled "In the Shadow of Rembrandt." If this circumstance had not obscured the gaze of nineteenth- and twentieth-century viewers, perhaps they would have seen what Lancret's contemporaries saw and admired in his art: its unique beauty — ideal for the decoration of eighteenth-century interiors — and its narrative sophistication. Rather than remaining imprisoned in a style so easy for him to emulate yet impossible for him to perfect, Lancret moved away from Watteau to develop his own special talent for narrative — storytelling that is at once subtle and sophisticated, yet ingenuous and folkloric. The narrative tradition in European art was strong and continuous, as indicated by a few of its most famous adherents, Hogarth and Greuze. To those names should be added that of Lancret.

The Paintings

PLATE 5 CATALOGUE NUMBER I

The Lit de Justice at the Majority of Louis XV.

1723. Oil on canvas, 56 x 81.5 cm.
Musée du Louvre, Paris, R. F. 1949–32.
Provenance: Mme. Lancret sale, Paris,
April 5, 1782, lot 9; Chevin; Coupry-Dupré
sale, February 21, 1811, lot 21; Cailleux,
Paris.
Bibliography: *Mercure de France,* June 1723,
p. 1175; Wildenstein, nos. 628–629;
J. de Cayeux, "Deux Peintures historiques
par Lancret," *Bulletin de la Société de l'Histoire
de l'Art français,* 1947–48, pp. 61–64;
M. Florisoone, "Deux Esquisses histo-
riques de Lancret," *Musées de France,* VI,
1950, pp. 129–46; Roland Michel, 1969.

Before Salon exhibitions reopened in 1725, Lancret used the annual Exposition de la Jeunesse to show his work, beginning at least as early as 1722. The following year, the *Mercure de France* described his entries as follows: "From M. Lancret, pupil of the late M. Gillot and emulator of the late M. Watteau, a painting with small figures representing the Lit de Justice held by the Parlement at the coming of age of the King. Several other small paintings by the same, in a thoroughly gallant manner."

The *Lit de Justice* and its pendant of the same size, the *Conferring of the Order of the Saint-Esprit at Versailles on June 3, 1724* (fig. 14; not in the 1723 exhibition), seem to have been aimed at attracting royal attention and patronage. Painted in a thin and sketchy technique, the pendants remained in Lancret's collection, appearing in the sale of his widow's effects as *"esquisses terminées,"* suggesting that they were pre-paratory works. In technique, provenance, and subject (the portrayal of actual events was very rare in Lancret), they are strikingly similar to a pair of paintings depicting concerts at the country and city homes of Pierre Crozat (pl. 6, fig. 23).

The *Lit de Justice* and the *Saint-Esprit* present colorful panoramic displays of two important events in the early reign of Louis XV. The Lit de Justice of February 22, 1723, a ceremony of the Parlement held to register legally the majority of the thirteen-year-old King, marked the official end to the Regency, just as the Lit de Justice of September 12, 1715, had begun it. Such gatherings were held in the Great Hall of the Parlement in the Palais de Justice, which Lancret depicted faithfully, even to the inclusion of the *Crucifixion* retable that hung there (now in the Louvre). The King, dressed in mourning for the death of his governess, Mme. de Ventadour, is in the far corner, slightly to the right of center, seated between the Peers and the Princes of the Blood.

Both ceremonies, and their attendant functions, were popular subjects for artists. Several depicted the Lit de Justice of 1715 — for example, a scene by Dumesnil at Versailles — and all work with the basic elements we find here: the Great Hall, the retable, the rows of officials, and the small figure of the King. The conferring of the Order of the Saint-Esprit had previously been represented twice by Philippe de Champaigne, and it would later be taken up by Subleyras. Such images belong to a tradition in French painting, repeated frequently during the reign of Louis XIV, of representing ceremonial and military events in the life of the sov-ereign. The series called *The History of King Louis XIV,* begun by Charles Le Brun, produced a stream of such scenes that were woven into tapestries at the Gobelins, making ideal propagandistic gifts to foreign nations. Lancret's early teacher Pierre Dulin provided the *Establishment of the Invalides* to this series, and even Watteau contributed a painting of Louis XIV giving the Cordon-Bleu to the infant Duc de Bourgogne, though it was never woven.

It was Dulin who provided Lancret with his closest precedent, and it is possible that Lancret actually did these two sketches for his master. In 1722 Dulin began a set of engravings that culminated in 1731 with the publication of *The Crowning of Louis XV,* commemorating the coronation.[1] Perhaps a larger set, of which Lancret's scenes could be a part, was planned but later abandoned. Or perhaps Dulin's concentration on these historical scenes at just this moment moved Lancret to attempt similar themes. Since Dulin's work exhibits the same panoramic view-

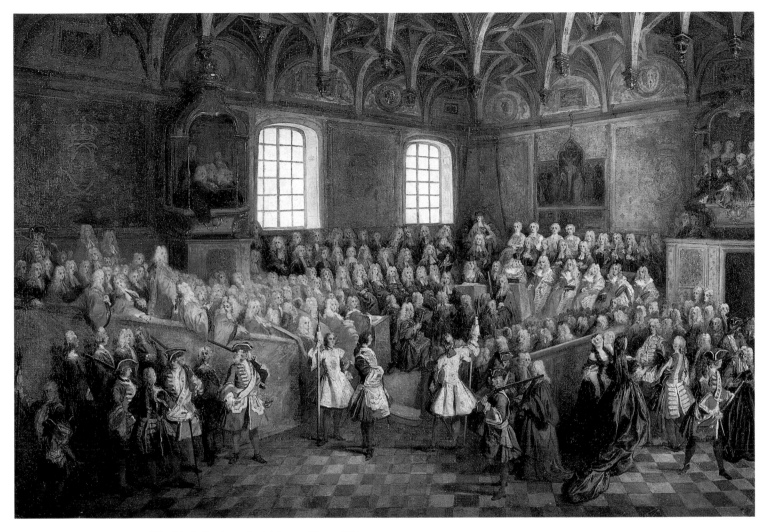

PLATE 5. Lancret. *The Lit de Justice at the Majority of Louis XV.*

point, small, elegant figures with little facial detail, and wealth of peripheral events found in Lancret's versions, his style must surely have affected Lancret's.

But Lancret did much to enliven the pictorial format, making what had often been pompous subjects distinctly his. Shifting the vantage point so that the viewer sees the room on a diagonal axis provides more interest than the usual square or rectangular format, and the panoramic treatment allows the clusters of figures to sparkle, though it sacrifices traditional portrait values. Such a technique is more suitable to *fêtes,* and it does give both of the pendants a festive air. One scholar has noted that Lancret was more a teller of anecdotes than a historian, remarking of this work, "In a few moments the masked ball will begin."[2]

PLATE 6 CATALOGUE NUMBER 2

Concert in a Salon with Architectural Decoration.

c. 1720–24. Oil on canvas, 38 x 48 cm.
Robert D. Brewster, New York.
Provenance: Mme. Lancret sale, Paris,
April 5, 1782, lot 12; Cailleux, Paris
(in 1969).
Bibliography: Wildenstein, nos. 86–88;
G. Henriot, *Collection David Weill,* Paris,
1928, II, p. 219; Roland Michel, 1969;
Colnaghi, New York, 1990, *Claude to
Corot,* under no. 20.

FIG. 23.

Lancret. *Concert at the Home of Crozat.* c. 1720–24.
Oil on canvas. Alte Pinakothek, Munich

Brilliantly evoking the cultured leisure enjoyed by wealthy individuals in eighteenth-century France, this early oil sketch shows a concert of six musicians accompanying a singer who sits at a table, her sheet music spread before her. Listening to the concert, or ignoring it, is a company of elegant ladies and gentlemen scattered around an oval salon. Large arched windows open onto a garden in which a fountain is visible.

Gallet has convincingly identified this impressive room decorated with statuary and columns as the salon of Pierre Crozat's country home at Montmorency. As he notes, "The architecture is strongly reminiscent of the oval salon in the Italianate style which was the central room of the château. It opened out to the park through three arches. It is known to have possessed a niche in the bay where Lancret inserts a niche, enclosing a statue."[1]

Lancret's pendant to this painting, the *Concert at the Home of Crozat* now in Munich (fig. 23), depicts, according to Gallet, the *grande galerie* in Crozat's Paris hôtel on the Rue de Richelieu. Roland Michel believes that Crozat himself is depicted in the Munich work — presumably the man facing outward in the group of spectators to the left.[2] The identification of the two rooms with actual sites is made all the more plausible when we compare these paintings with two contemporary works by Lancret very similar to them in style, the *Lit de Justice* (pl. 5) and the *Conferring of the Saint-Esprit* (fig. 14), in which specific locations are very closely described.

Both of Crozat's homes were built for him by Jean-Silvain Cartaud (1675–1758). The Montmorency property, acquired by Crozat in 1702, had once been the home of Charles Le Brun, and its gardens were by André Le Nôtre; the garden pavilion there appears in Watteau's *The Perspective* (Museum of Fine Arts, Boston). The oval salon shown in Lancret's painting had *trompe l'œil* decoration by Charles de la Fosse, who also did the ceiling of the *grande galerie* of the Paris hôtel. The latter building, begun in 1704, was later inherited by the Duc de Choiseul, and its interiors are depicted on the famous Choiseul gold box.[3]

The concerts given by the wealthy financier and art patron Crozat are celebrated. He held them once a month in his Paris residence, and many prominent musicians performed there. Watteau went and drew the players, and Rosalba Carriera recorded her attendance in her diary. The present sketch and its pendant, both thinly and loosely painted with preparatory lines visible, must have been done to catch the attention of this important connoisseur. Though both sketches remained in Lancret's collection and finished works were never commissioned, Crozat did own at least one early painting by Lancret, the *Outdoor Concert* now in the Hermitage, Leningrad.

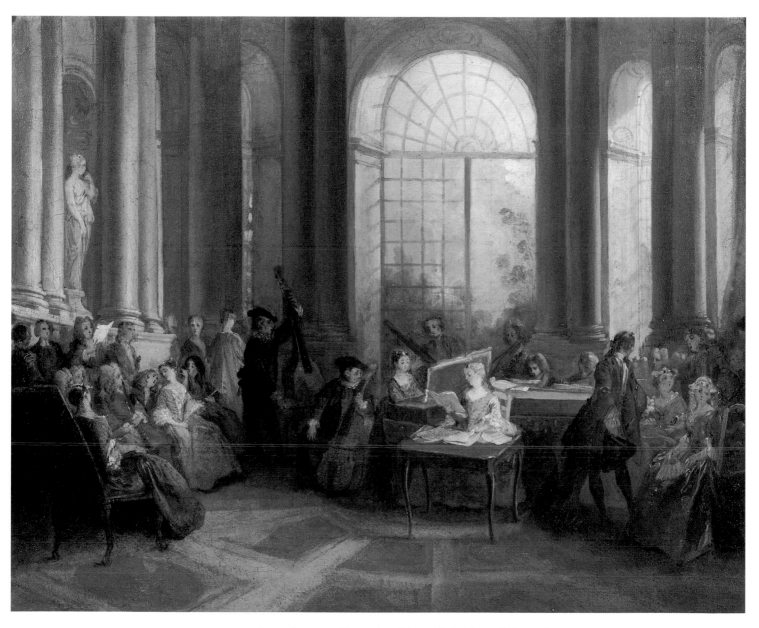

PLATE 6. Lancret. *Concert in a Salon with Architectural Decoration.*

PLATE 7 CATALOGUE NUMBER 3

Five Decorative Panels.

c. 1723. Oil on canvas: a) *The Seesaw,*
150.7 x 89.5 cm.; b) *The Swing,* 151.1 x 90.2
cm.; c) *The Gardener,* 151.1 x 36.8 cm.;
d) *Horticulture,* 151.1 x 36.8 cm.; e) *The
Vintage,* 149.8 x 82.5 cm. Cleveland
Museum of Art, gift of the Louis Dudley
Beaumont Foundation, nos. 48.176–48.180.
Provenance: Vicomte Pierre de Chézelles;
Duveen, London, by 1926; Commodore
and Mrs. Louis Dudley Beaumont, Cap
d'Antibes, c. 1935–36.
Bibliography: H. S. Francis, "A Gift of the
Louis Dudley Beaumont Foundation,"
Bulletin of the Cleveland Museum of Art,
XXXV, 1948, pp. 221–24; Cleveland
Museum of Art, *Catalogue of Paintings Part 3
–European Paintings of the 16th, 17th and 18th
Centuries,* 1982, nos. 35 a–e, pp. 86–87.

Some of Lancret's first commissions were for room decorations. In the eighteenth century such decorations were either done on canvas and then set into carved woodwork especially designed to hold them, or painted directly onto the paneled walls of rooms. These treatments covered more of a room than easel paintings, almost forming a wallpaper decoration. The ensemble usually included paintings to be mounted over the doors and mirrors, often the size of easel paintings but irregularly shaped, and long, narrow paintings to cover the walls down to the chair rail. The figural scenes were frequently surrounded by arabesque designs that complemented them. The five long canvases from Cleveland no doubt formed the wall pieces for just such a room. The overdoors and overmirrors from the same room, representing *The Four Seasons,* are now in a private collection.[1]

Claude III Audran and Watteau, both artists with close ties to Lancret, popularized this style of room decoration, and Lancret's adoption of it is not surprising. In fact, Audran probably painted the arabesques for Lancret's best-known room decoration, done about 1728–29 for the Hôtel de Boullongne and now in the Musée des Arts Décoratifs, Paris. Predating that set are two series dating from about 1723–27: the Cleveland canvases, and another ensemble of which the overdoors and overmirrors, also representing *The Four Seasons,* are in a private collection in France.

The five Cleveland panels have the pastoral themes favored by Lancret in room decoration. The scenes are all set in the countryside and enacted by slim adolescents. The three wider canvases show pastoral duets, while the narrower ones of *The Gardener* and *Horticulture* each depict a single emblematic figure. Their themes, involving the relationship of man to nature, are found in other decorative schemes by Lancret: a group resembling *The Swing,* for instance, appears in the Hôtel de Boullongne decoration, and *The Vintage* is echoed in the abovementioned *Four Seasons* group in France. The Cleveland ensemble probably was intended, like the set of *The Four Elements* Lancret did for the Marquis de Béringhen, for a garden salon, where its themes would harmonize with the views of nature visible outside. The Cleveland set is traditionally thought to have been painted for a house at 28 Place Royale (now Place des Vosges) and may have been commissioned by the family of the Dukes of Melun, who owned the house from 1721.

It was Watteau, as Posner has pointed out, who increased the emphasis on the image set within an ornamental surround, making it not merely a symbol or ornament but a scene with characters and naturalism.[2] In his hands the arabesque elements became light and airy and incorporated natural forms in their designs. Following Watteau's lead, Lancret created what are plainly easel paintings in decorative surrounds, playfully mingling natural and abstract forms. The arabesques seem part of the vegetation, providing perches for squirrels and birds or, in *The Vintage,* intertwining with the grapevines.

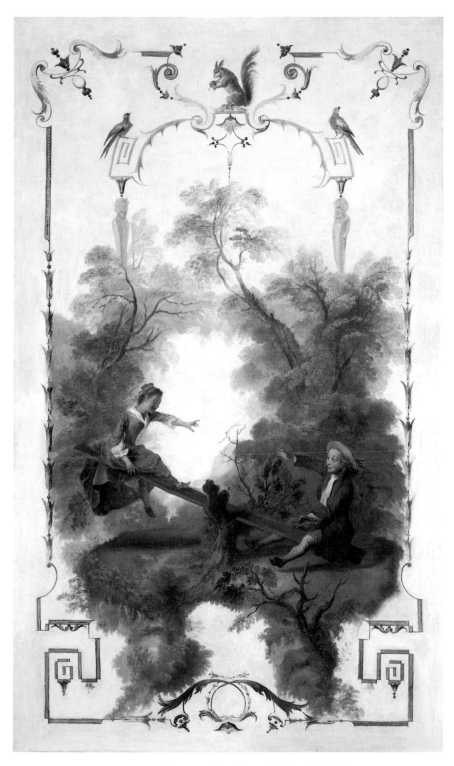

PLATE 7a. Lancret. *Five Decorative Panels: The Seesaw.*

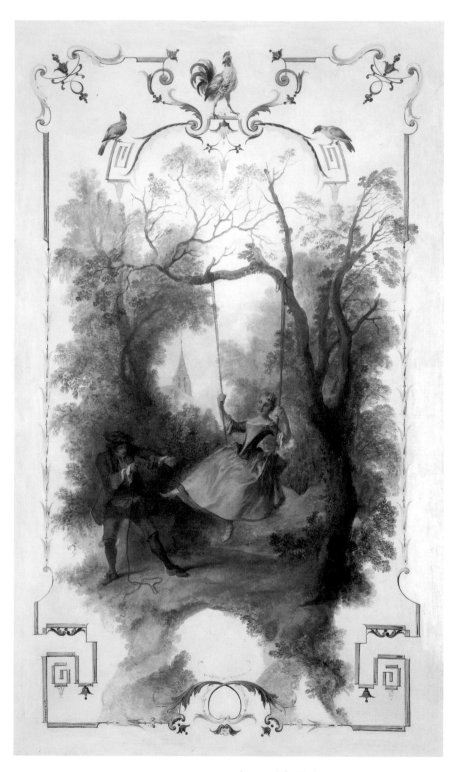

PLATE 7b. *The Swing.*

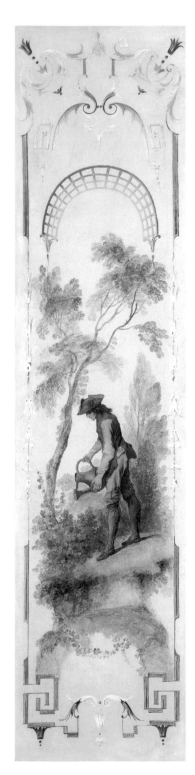

PLATE 7c. *The Gardener.*

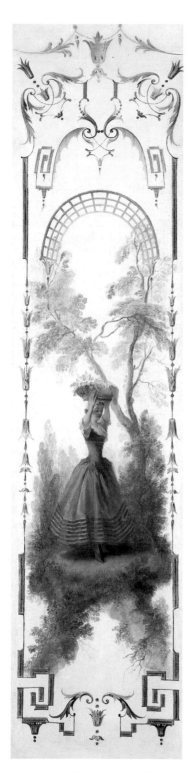

PLATE 7d. *Horticulture.*

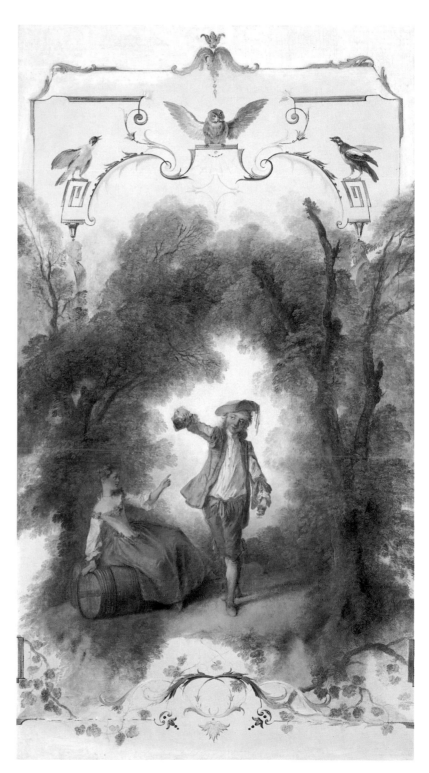

PLATE 7e. *The Vintage.*

PLATE 8 CATALOGUE NUMBER 4

Outdoor Concert with the Beautiful Greek and the Amorous Turk.

c. 1728. Oil on canvas (oval), 59 x 75 cm.
Mr. and Mrs. Felix G. Rohatyn, New York.
Provenance: Le Doux sale, Paris, April 14,
1775, lot 55 (together with an oval pendant
showing a shepherd, shepherdess, and ten
other figures, possibly Wildenstein no.
142); private collection, Switzerland;
Colnaghi, New York.
Bibliography: Wildenstein, no. 708.

At first glance this painting, with its musicians and amorous couples, might seem to be a simple *fête galante,* a common subject in Lancret's oeuvre. Indeed, the concert group to the left can be found in another Lancret painting, the *Outdoor Concert* now in the Hermitage (once owned by Pierre Crozat). The small heads and delicate features in both works date them prior to 1730. However, there is something unusual here: the inclusion of a couple who are markedly different in demeanor and costume from the other participants, and who appear to have taken center stage. They are a familiar sight in Lancret's work, the Beautiful Greek and the Amorous Turk, he identifiable by his blue-and-pink costume and his guitar, she by her elegant gown trimmed in fur. The concert we see is an accompaniment for the play-acting of the exotic pair. The similarity in concept between such a scene — the inclusion of theatrical figures in a *fête galante,* as if they had strolled naturally into the party — and Lancret's portraits of famous ballerinas in outdoor settings (see pl. 9) is obvious. In this instance, the audacious blending of picture types simply serves to heighten the magical quality of the pastoral, with no need to elaborate.

As with his portraits of La Camargo, Lancret did numerous versions of the Turk and the Greek. They appear both as single, portrait-like figures in costume, engaged in their theatrical trade, and as participants in *fêtes galantes.* Unlike the characters he used from the *commedia dell'arte,* Lancret did not integrate the Turk and Greek into the action of these scenes: their theatrical nature sets them apart. Lancret usually depicted them as single figures in pendant paintings. There the Turk is seen in the same blue-and-pink costume, carrying his guitar, standing solitary and dashing against a landscape background. The Greek, also alone against a garden landscape, usually wears a vivid cherry-colored gown trimmed in dark fur, with a small toque of matching material — the same costume our Greek wears but in a different color; she too has a proud demeanor, and an operatic bearing.

The Beautiful Greek appears by herself in another *fête galante, The Ball* in Berlin (fig. 16), where she is seated on a step, and again with two musicians, but no Turk, in a painting in the Fitzwilliam Museum, Cambridge. A preparatory drawing for both the standing Greek in the Rohatyn painting and the seated one in Cambridge is in Washington (pl. 32). The woman in the Stockholm *Fastening the Skate* (pl. 1) is dressed similarly to the Greek, in a gown trimmed in fur, hers being gold lined in red. In what may be the earliest appearance of either character, the Turk is among the figures in Lancret's painted decoration for the salon of the Hôtel de Boullongne, a set of five long panels, four overdoors, one overmirror, and three double-door ensembles that was completed in time for a 1731 housewarming. It was Lancret's first large decorative commission, and the Turk is found on one of the long panels; the Greek is not shown, and there is no single unifying theme.

No specific theatrical source for these characters has been found. The mysterious East had been a popular factor in French literature and visual art since the sixteenth century, and countless theater pieces had Oriental settings and figures. By the eighteenth century the fashion was quite widespread and had even reached the *commedia dell'arte* and the fair plays. Indeed, one such play, *Polichinelle the Grand Turk,* may have been authored by one of Lancret's early employers, Claude Gillot.[1] Typically, the pieces tell of a noble Turk freeing his love, often a Greek woman, from

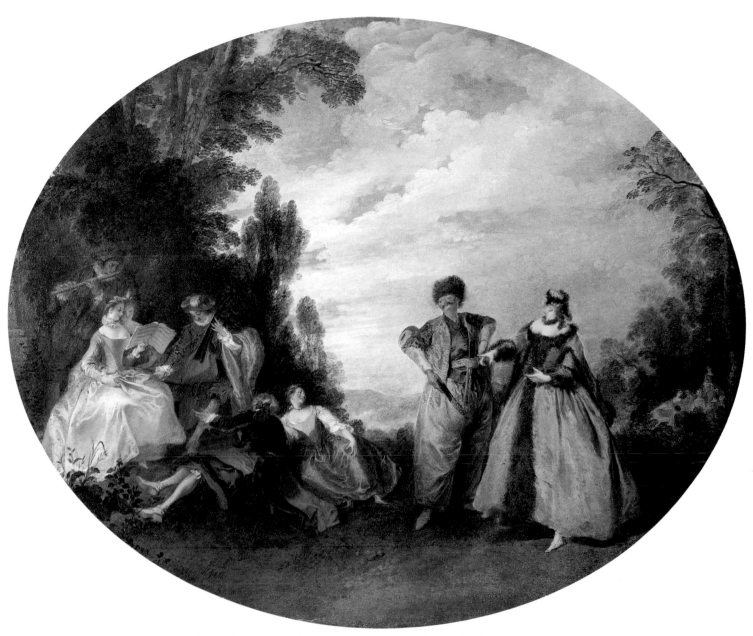

PLATE 8. Lancret. *Outdoor Concert with the Beautiful Greek and the Amorous Turk.*

the seraglio. Lancret's two figures reflect this tradition. The inscription on an engraving after one of Lancret's paintings of the Beautiful Greek calls her a "young slave." In Lancret's time the profound impact of the East on the arts was further augmented by the official visit of the Turkish ambassador to France in 1721, which was faithfully recorded in paintings as well as in the *Mercure de France*. The popularity of portraits *à la turque* was widespread, prompting such examples as Nattier's *Mlle. Clermont* of 1733 in the Wallace Collection, Carle Van Loo's *Mme. de Pompadour as a Sultana,* and Aved's 1743 *The Marquise de Saint-Maure as a Sultana*. Oriental figures can also be found in theater scenes, such as Gillot's turbaned Turk in an Italian comedy scene in the Musée des Beaux-Arts at Angers.

In the popular print tradition, the portrayal of theatrical characters enacting familiar parts had long been the province of "role pictures," known in France since the sixteenth century. They consisted of a single costumed theatrical figure, usually from the *commedia* troupe, against a blank or rudimentary background. In the seventeenth century, such plates were created not only anonymously or by relatively minor printmakers like the Bonnarts, but by such major artists as Jacques Callot, Stefano della Bella, and Claude Gillot. Callot's set of *Three Italian Comedians* is a good example of the genre. It has been noted that later creations by Watteau, such as *The Indifferent One* and *Gilles,* have their roots here, and Lancret would certainly have been aware of such a popular tradition. His image of the Beautiful Greek clearly recalls Watteau's engraving *The Polish Woman* or his painting *The Dreamer* (which was once attributed to Lancret). The role pictures are not portraits, though occasionally — especially in prints — the actor playing a character might be identified, as in Gillot's *Quinson as Pierrot*. The make-believe character is the focus. As Posner has noted, such works function as the "portrait of a special professional aspect of a person, rather than of what one might call his 'true' self."[2] This is certainly the case with Watteau's *Mezzetin,* which some have suggested is a portrait of Angelo Constantini, the creator of the role, and it is so again with Lancret's Turk and Greek: they are not portraits but characters.

Lancret's characters reflect not only role prints in general, but specific prints devoted to the popular Eastern culture. Many series of prints existed on this subject, but the most widespread, going through three Paris editions, was Jean-Baptiste van Mour's *Set of One Hundred Prints Representing Various Nations of the Levant,* which van Mour painted in 1707–08 and Cochin engraved in 1712. Such collections were composed essentially in the familiar genre of the costume plate, but with a change of setting. It is here that we find Lancret's Turk. A survey of the images he had at his disposal indicates that he knew the distinguishing appearance of a young Turkish gallant. The beardless Turk in trousers with a cloth belt is usually a guard or Janissary in the costume books; only the older sages and viziers wore beards, while the "young Turks" wore brave moustaches. In fact, van Mour's book includes just such an Amorous Turk, the image of a Janissary who, having removed turban and coat, opens a vein in his right arm to show his imprisoned beloved the depth of his affection (fig. 24). Lancret dispensed with the bloodletting, but the image lies behind his achievement.

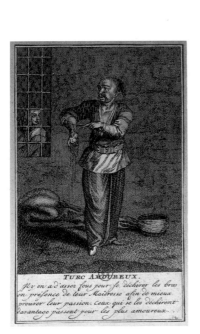

FIG. 24.

Jean-Baptiste van Mour. *The Amorous Turk.* 1712. Engraving by Charles-Nicolas Cochin *père*. Bibliothèque Nationale, Paris, Cabinet des Estampes

PLATE 9 CATALOGUE NUMBER 5

La Camargo Dancing.

c. 1729–30. Oil on canvas, 76 x 107 cm.
National Gallery of Art, Washington,
D.C., Andrew W. Mellon Collection,
no. 1937.1.89.
Provenance: Frederick II, Potsdam.
Bibliography: Oesterreich, Nouveau Palais
no. 114; E. Dacier, "Mlle. Camargo dans les
portraits de Lancret," *Les Vieilles Années,*
1910, pp. 31–36; Wildenstein, no. 585;
L. Einstein, "Looking at French Pictures in
Washington," *Gazette des Beaux-Arts,*
XLVII, 1956, pp. 213–50.

Marie-Anne Cuppi de Camargo (1710–1770) was one of the most famous balle-
rinas of the eighteenth century, and it is thus that Lancret depicts her, in a
composition that places him among the masters of French portraiture. She is shown
poised in a dance step, supported by a partner whose salmon costume is the perfect
foil for her shining silver gown with salmon trim. Their *pas de deux* is performed in
a shady clearing in a garden, with a fountain playing to the right and a term in the
middle distance. Circling this "stage," in the shadows of the trees, are the familiar
characters of the *fête galante* — musicians, lovers, children — costumed in luminous
silks. One man wears the gaudy ribbons of a performer. While there is no
indication, beyond her costume and the pastoral setting, that Mlle. Camargo is
portrayed in a specific ballet, it has been suggested that her companion here is the
choreographer Laval, one of her frequent partners.

Lancret painted at least three other versions of Mlle. Camargo dancing, and
their order is debatable — though they all seem quite close in date. Three of them are
very similar (compare fig. 19), the main difference being the color of the dress. The
Washington painting is the most elaborate, surrounding the dancer with a larger
garden and more spectators. Only in this example is she partnered, and only here
does Lancret include what appears to be a self-portrait: the long-nosed gentleman in
stripes looking out from the foreground at left bears a close resemblance to the
engraved portrait of him by Aubert. The addition of a partner and a self-portrait
make it likely that this is Lancret's last version of the painting, a final embellishment
on his most famous early achievement.[1] The first is probably the one in the Wallace
Collection, London, and the others are in Nantes and Leningrad.[2]

Some of the attention that Lancret's portraits of Camargo received was no
doubt due to reflected glory. Born in Brussels to a dance master and brought to
Paris by the Princesse de Ligne to study with Mlle. Prévost, Mlle. Camargo became
one of the most celebrated dancers at the Paris Opéra. As famous for her private life
as for her art, she counted many noblemen among her lovers and many prominent
writers and musicians among her friends. In dance, she was renowned for the
athletic energy of her steps, her quicksilver virtuosity, and her strong leaps. She
shortened and simplified the cumbersome ballet skirt, so that audiences could see
her flying feet. One contemporary observer said she "danced like a man."
Camargo's style was in marked contrast to that of the demure and graceful Mlle.
Sallé, her contemporary rival. Lancret's pendant portrait of Sallé, formerly known
only through an engraving by Larmessin but recently rediscovered,[3] shows her
displayed elegantly in a park glade, before a Temple of Diana and accompanied by
three dancing Graces. Lancret's portraits reveal the two dancers' contrasting styles.
Here and in the other versions, Camargo is shown on balance, in an energetic step
that sends her dress flaring and swinging; Sallé is all quiet poise like her protectress,
the cool and virginal Diana. As Voltaire, who introduced Lancret to Sallé, wrote:
"Ah, Camargo, how brilliant you are, but, great gods, how ravishing is Sallé! How
light your steps, and how soft hers! She is inimitable, you are original. The nymphs
leap like you, but the Graces dance like her."[4]

Lancret's triumph here, in a painting that is one of his finest as well as an
unforgettable glimpse of eighteenth-century theater, is his masterful blend of

the portrait with the *fête galante*. This combination, hinted at in Watteau's *Portrait of Antoine de la Roque* and Raoux's *Mlle. Prévost,* had never before been so naturally and gracefully achieved. Camargo's profession, in which such a large element of fiction predominates, makes Lancret's fiction — that his subject has wandered into a glade peopled by lovers and musicians and has started to dance — entirely believable and even appropriate. Did she not, after all, do much the same thing every night on stage? The overtly artificial world of the stage set has been abandoned for the more subtle fiction of the *fête galante*. The potential awkwardness of such a fabrication is avoided, there is a "willing suspension of disbelief." Camargo's dance finds its rightful place in the immortal glades of Cythera.

Lancret's portraits of Camargo and Sallé were referred to as "historiated portraits" in the *Mercure de France*.[5] His ingenious and compelling mixture of genres resulted in a brilliant device, as he could depict his subject not merely in feature but in character as well. This achievement did not go unnoticed by other artists faced with portraying dancers, and Pesne's *Portrait of La Barbarina* and Gainsborough's *Giovanna Bacelli* clearly find their source in Lancret.

Lancret based both the pose and the setting of the Camargo and Sallé portraits on costume prints, which were among his favorite sources. His format drew heavily on a very common image in the print repertory: that of dancers in elaborately modish dress performing a step against a simple background — usually a terrace — that is obviously a set. The dancer is often identified, as in *Mademoiselle Subligny Dancing at the Opéra* (fig. 25). The similarity to Lancret's image is unmistakable. We even find Camargo's balancing step — in the 1702 *M. de Lestang in Spanish Dress Dancing at the Opéra*.[6] Lancret transforms such rigid, manifestly theatrical images into scenes of graceful and convincing illusion.

As noted in connection with the *Outdoor Concert with the Beautiful Greek and the Amorous Turk* (pl. 8), images of theatrical figures in costume abounded in the French print tradition. While most of these pictures are not portraits, it was natural that famous performers, in commissioning a portrait, might ask a painter to show them in a well-known role, or that a painter might choose to do so. Not unlike the portrayal of an aristocrat as a mythological figure, the reference to a famous role would illuminate and glorify the actor. Largillière's *Mme. Duclos as Ariadne* (Comédie-Française, Paris) and Raoux's 1723 *Mlle. Prévost as a Bacchante* (Musée des Beaux-Arts, Tours) come to mind. But Lancret moves his depictions of dancers away from one specific role to their greater role: that of Dancer.

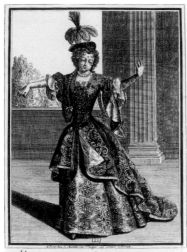

FIG. 25.

Anonymous. *Mademoiselle Subligny Dancing at the Opéra.*
Engraving published by Jean Mariette.
Bibliothèque Nationale, Paris,
Cabinet des Estampes

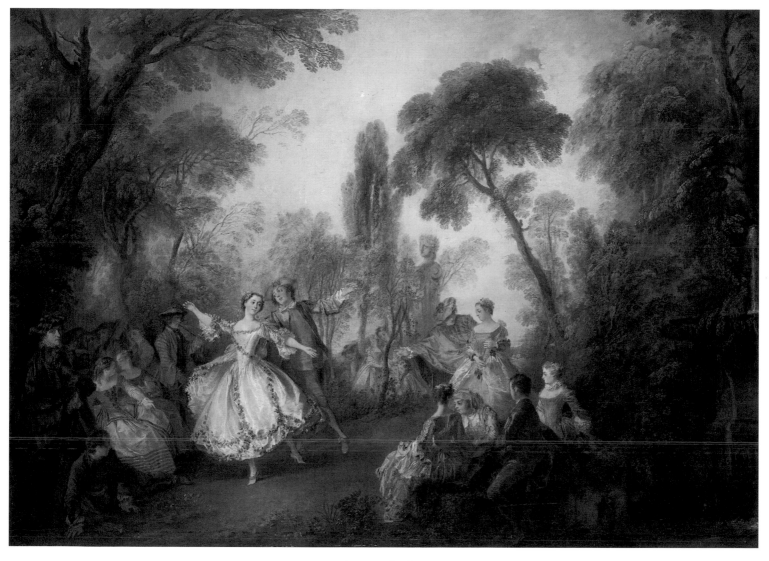

PLATE 9. Lancret. *La Camargo Dancing.*

PLATE 10 CATALOGUE NUMBER 6

Autumn.

Before 1730. Oil on canvas, 113 x 94 cm.
The Homeland Foundation, Incorporated,
New York.
Provenance: Leriget de la Faye sale,
September 26, 1731, lot 87; the architect
Vigny; his sale, Paris, August 1, 1773, lot
100; Baron Edmond de Rothschild, 1924;
Alexandrine de Rothschild sale, Sotheby's,
London, June 30, 1941, lot 15; Rosenberg
and Stiebel, New York.
Bibliography: *Mercure de France,* June 1730,
p. 1184; Ballot de Sovot, pp. 19–20; *Affiches,
annonces, avis divers,* Paris, 1753, p. 92,
described as for sale; Dézallier d'Argenville,
p. 290; Bocher, IV, nos. 13, 31, 40, 64;
E. Dacier, "A propos du portrait de la
Camargo, par Lancret, au Musée de
Nantes," *Musées de France,* III, 1911, p. 44,
note 2; Wildenstein, pp. 12, 49, nos. 7–10;
Grasselli, 1986, pp. 378–89.

Autumn is a magnificent painting and, like the portraits of *La Camargo Dancing,* among the early masterpieces that undoubtedly helped establish Lancret's name. Though still tied closely to the art of Watteau — compare the *Venetian Pleasures* in the National Gallery of Scotland, Edinburgh (fig. 9) — Lancret was already forming an independent style, more forceful and decorative than that of the older artist. The small heads and delicate features mark *Autumn* as a work of the early 1720s (Grasselli dates it as early as 1719–21), yet the figures already have the clarity and presence that will distinguish Lancret's mature style. In a lush garden on a fine day, with the trees changing from green to red, a group of picnickers dance, flirt, and feast on the harvest of grapes. Mingled with the ordinary participants are two characters from the *commedia dell'arte:* we see Gilles, all in white, embracing a woman on a bench, while mocking him is the disdainful Harlequin. This is, in fact, a classic *fête galante* composition of the sort created by Watteau only a decade before, with elegant people taking their leisure outdoors, mingling with actors from a *commedia* troupe.

The painting belongs to a cycle of *The Four Seasons* commissioned by Jean-François Leriget de la Faye. Engravings after them were published in 1730.[1] *Spring* and *Summer* are together today in the Hermitage, Leningrad, while *Winter* is known only in the engraving.[2] Lancret exemplified each season by its effect on human pleasure and merrymaking, showing the different forms of entertainment they offered: savoring grapes and wine in Autumn, birdcatching in Spring, bathing in Summer, and playing cards by a cozy fire in Winter.

The Four Seasons was one of the most significant commissions of Lancret's career, owing both to the importance of his patron and to the success of his results. Leriget de la Faye (1674–1731) was, from all accounts, a Renaissance man: a military leader, a diplomat, a connoisseur of music, ballet, and theater, a voracious collector, and a poet with enough merit to claim a seat at the Académie Française. After years of service to the Crown he returned to Paris, to a house on the Rue de Sèvres, where, according to one biographer: "He assembled a rich collection of paintings, engraved stones, bronzes, marbles, porcelains, and a valuable library. His collections were accessible to all, to the curiosity-seeker as well as to scholars."[3]

D'Alembert, in his biographies of the members of the Académie, asserts that Leriget was a true "man of taste," preferring "the masterpieces of a virtually unknown painter to a mediocre painting by a celebrated artist"[4] — an interesting comment in light of his early sponsorship of Lancret. Voltaire characterized him thus: "He received two gifts from the gods, the most charming they can bestow: one was the talent to please; the other, the secret of being happy."[5]

Ballot de Savot relates the impact the first two paintings of *The Four Seasons* had on Leriget: "When M. Lancret had the second painting brought to M. de la Faye, he was so moved by his progress that he canceled the original terms and gave him double the price they had agreed on. Would a Medici have done better?"[6]

Leriget shared Lancret's passion for theater and ballet, and it has been suggested that he was one of La Camargo's lovers. He certainly was the first owner of one of Lancret's portraits of her, and he provided the verses for the print made from it (fig. 19). He owned two other Lancret paintings as well.

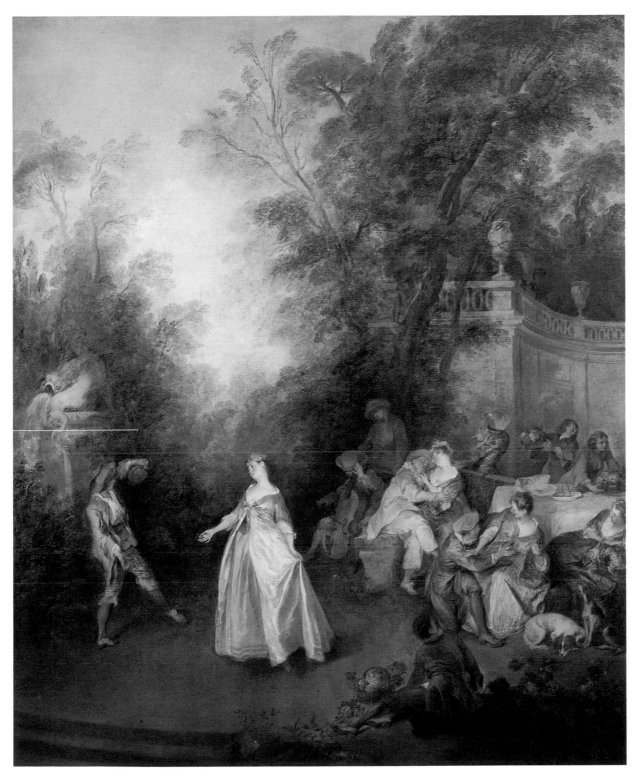

PLATE 10. Lancret. *Autumn.*

Blindman's Buff.

c. 1728. Oil on canvas, 37 x 47 cm.
Nationalmuseum, Stockholm, NM 844.
Provenance: Count Tessin, 1728; Queen
Louisa Ulrica, 1750.
Bibliography: J. E. Staley, *Watteau and his
School,* London, 1902, pp. 92–98; G. Gothe,
*Notice des tableaux du Musée National de
Stockholm,* Stockholm, 1910, no. 844; Lady
Dilke, *French Painters of the XVIIIth Century,*
n.d., p. 104; P. Lespinasse, "L'Art français et
la Suède de 1686 à 1816," *Bulletin de la Société
de l'Histoire de l'Art français,* 1912, pp. 221,
225, 226; Wildenstein, no. 229; F. Boucher,
"L'Exposition de la Vie parisienne au
XVIIIe siècle au Musée Carnavalet,"
Gazette des Beaux-Arts, CXXI, 1928,
pp. 194–95; C. D. Moselius, "Gustav III
Och Konsten Med En Inledning Om
Tessin Och Lovisa Ulrika," *Nationalmusei
Arsbok,* 1939, p. 95; P. Bjurstrom, *French
Paintings: Eighteenth Century,* Stockholm,
1982, no. 1001.

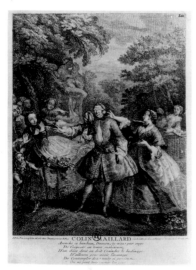

Games, with their inherent opportunities to mimic and mock human behavior, were an ideal theme for Lancret, who loved to capture through a gesture or glance the desires, follies, and disappointments of his subjects. In the Stockholm *Blindman's Buff,* one of his finest early works,[1] the game is played in an elegant oval salon similar to that in the scene of *Youth* from Lancret's *Four Ages of Man* in London. The artist's favorite architectural interior, the oval room, effectively arranges the spectators here around the two main figures, the blindfolded young man and his charming tormentor, whom the others watch with interest; even the two bust portraits high on the wall seem intent on the outcome.

Though the origin of the French term for the game — *colin-maillard* — is unknown, the interpretation of blindman's buff as a parable of the folly of love and marriage has a long tradition. Brueghel made use of it in his *Children's Games,* as did Jacob Cats in his poem *Kinderspiel.* In Charles Sorel's 1642 treatise *The House of Games,* blindman's buff is described as the "Game of Love," with the following interpretation: "It must be understood that binding the lovers' eyes is meant to represent their blindness and the confusion of the various passions and affections that are excited by love, which is commonly the mistress and the most absolute of passions." Two depictions very close in time to Lancret's offer graphically clear instances of this interpretation: a 1737 engraving by Jacques-Philippe Le Bas (fig. 26), and a painting by Pater. The foolishness of the blinded young man in the Le Bas print is exaggerated by those who point at him, mock him, and steal his wig as he gropes toward a young woman. The object and alternative outcomes of his search are clear from two background details: a statue of Pan entwined with a nymph and an amorous couple in the distance at right, the man grasping the breast of a disinterested woman. Pater also stresses the erotic quality of the game, explaining and embroidering it with elaborate allegorical embellishments. The blinded player, here a female, has made her choice and peeks to see whom she has tagged. Eros discards the young man's implements of battle as no longer necessary, for Venus has won over Mars; the youth's spear lies on the ground, pointing to directly beneath the girl's skirt, and putti above the couple bear the torch and flowers of Amor Victorious. Even the garden sculpture is brought into play, as the Three Graces adorn a term of Priapus and a putto riding a dolphin in the fountain foretells the onrush of love. In the Stockholm painting Lancret needs use no such emphatic devices, for the image is quite clear. The young woman teases a gallant, cajoling his attention and pursuit, as society attends the outcome. A mother points out the scene to her daughter as if to instruct her by it.[2]

FIG. 26.
Jacques-Philippe Le Bas. *Blindman's Buff.*
1737. Engraving. Bibliothèque Nationale,
Paris, Cabinet des Estampes

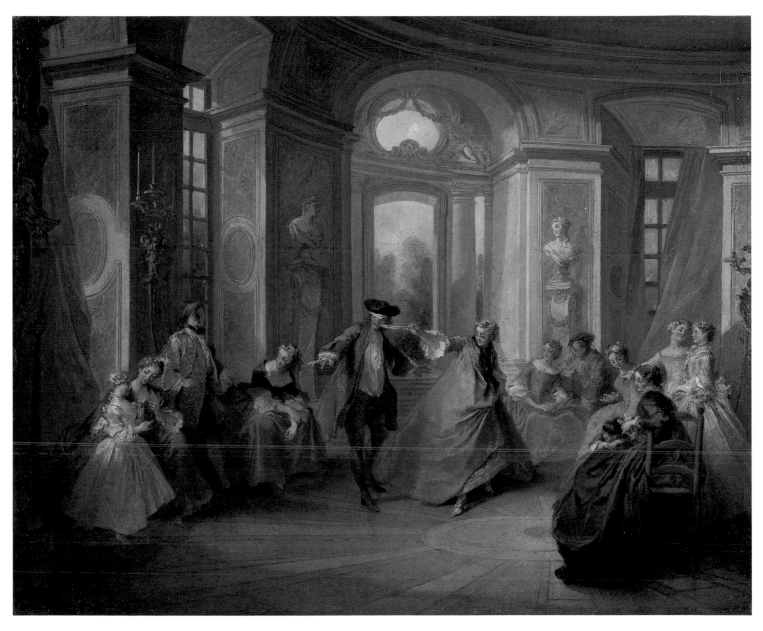

PLATE II. Lancret. *Blindman's Buff.*

PLATE 12 CATALOGUE NUMBER 8

The Dance between Two Fountains.

c. 1725. Oil on canvas, 207 x 230 cm.
Gemäldegalerie Alte Meister, Dresden.
Provenance: Dresden since 1754
(inventory of 1754, II, 723).
Bibliography: Wildenstein, no. 143;
Staatliche Kunstsammlungen, Dresden,
*Gemäldegalerie Altemeister Dresden: Katalog
der ausgestellen Werke,* 1979, no. 784.

The Dance between Two Fountains is one of Lancret's most ambitious early works, dating from around 1725 and possibly exhibited in the Salon of that year. His dancing couple is poised in mid-step, perfectly balanced between arching trees and fountains in a handsome garden, while around them others play music, flirt, or simply watch. A bagpipe lies abandoned on the ground. Two enchanting little girls, not yet old enough to join in such adult play, watch the grownups from an oval space in the foreground; Lancret's drawing for them is pl. 36.

Lancret's gardens, like Watteau's, exemplify the sort of orderly nature that Alexander Pope admired and so perfectly described in *Windsor Forest:* "Where Order in Variety we see, And where, tho' all things differ, all agree." This early painting finds Lancret much in the thrall of Watteau, both in the use of the *fête galante* theme and in the delicate figural style. The Dresden *Dance* has the same basic elements as Watteau's *Pleasures of the Ball* in the Dulwich Picture Gallery, London: a dancing couple surrounded by a charming assembly of lovers, musicians, children, and pets, the whole set before a garden where nature and artifice peacefully coexist. However, the differences between the two artists are already becoming apparent. Lancret's colors are stronger and brighter, and his figures are more defined. His vision will always be more down-to-earth.

The two fountains in the Dresden *Dance* were favorite types of Lancret; the niched and columned version on the left is also found in the *Quadrille before a Fountain* in the Alain de Rothschild collection, Paris, and the freestanding bowl held up by river gods and nymphs at right was used in the *Italian Comedians by a Fountain* in the Wallace Collection. Their inclusion here shows Lancret following Watteau in yet another respect, as the latter's garden scenes typically included fountains, urns, statues, lattice or stone pavilions, benches, and other decorative paraphernalia. This staffage, easily traceable to depictions of Love Gardens and to seventeenth-century Northern outdoor pleasure scenes by Rubens, Gonzales Coques, and others, is an identifying characteristic of the *fête galante* composition as it developed in France.

Lancret generally positioned such architectural and sculptural elements prominently within his garden scenes, using them to frame the characters, emphasize their actions, and accent the story. His curving sculptural forms and rococo architecture and decoration owe much to Gilles-Marie Oppenort (1672–1742) and Jacques de Lajoue (1686–1761). The fountain on the right in the Dresden painting is taken directly from an Oppenort design, and another Oppenort creation became the splendid fountain in the *Winter* scene for *The Four Seasons* at Louis XV's hunting lodge of La Muette.[1] Lancret clearly found the graceful and curving forms of such fountains perfect foils for his elegant figures. His garden sculpture, always striking in appearance, seems almost alive in its grisaille tones and animated configurations.

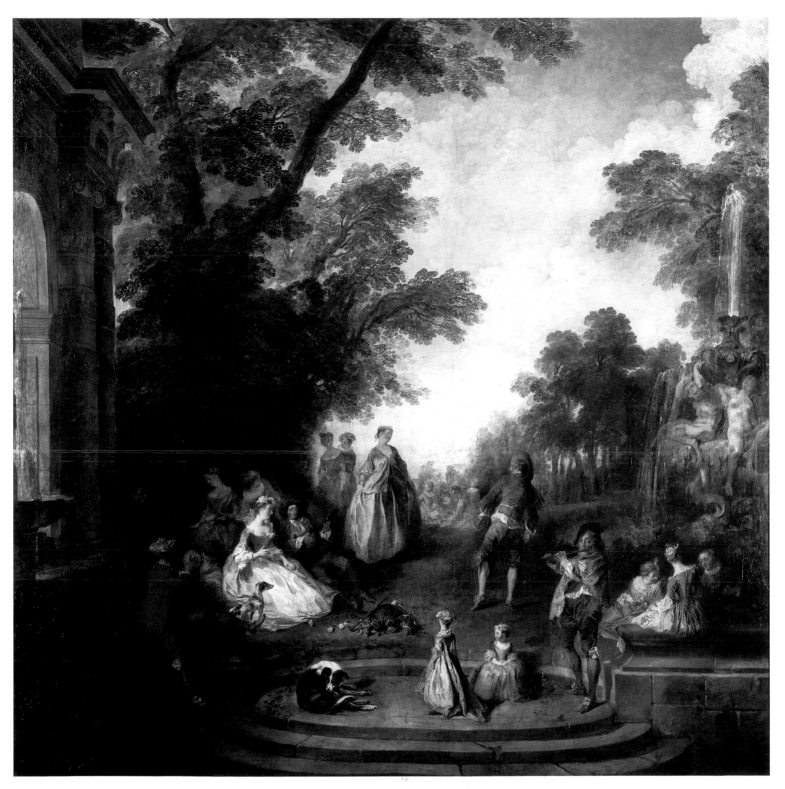

PLATE 12. Lancret. *The Dance between Two Fountains.*

PLATE 13 CATALOGUE NUMBER 9

The Picnic after the Hunt.

c. 1740. Oil on canvas, 61.5 x 74.8 cm.
National Gallery of Art, Washington, D.C.,
Samuel H. Kress Collection, 1952.2.22.
Provenance: Frederick II (acquired by him
or Prince August Wilhelm); House of
Hohenzollern, Neues Palais, Potsdam;
purchased from Kaiser Wilhelm II, Doorn,
The Netherlands; Wildenstein, 1923.
Bibliography: Oesterreich, p. 109; Bocher,
IV, no. 556; Wildenstein, no. 444; C. Eisler,
*Paintings from the Samuel H. Kress Collection:
European Paintings excluding Italian,* 1977,
no. K1420, pp. 307–08.

If any artistic theme can be said to epitomize the reign of Louis XV, the hunt picnic is that theme. It was virtually invented in response to the King's obsession with hunting — he being the patron who most often commissioned such paintings — and the form it took in the first half of the eighteenth century is resoundingly contemporary in costume and detail. The royal hunts were notorious for their length, exhausting other hunters as well as horses and dogs, and Louis is said to have had more conversation with Lansmate (or Landsmath), his first huntsman, than with most members of the court. At one point, a close advisor cautioned the King to curtail the hours spent hunting in order to broaden his interests, but this counsel was ignored.

Lancret's many scenes of hunt picnics capture all the color, excitement, and luxury attendant on this courtly pastime,[1] and the opulent detail that characterizes them is nowhere rendered more beautifully than in the Washington example. The waistcoat of the lady in yellow and silver is delicately embroidered with flowers in peach and blue, protected by a crisp linen napkin. Her fellow huntress wears brilliant red, much like the color we associate with modern hunting coats. A bowl of peaches, a frothy confection, and bottles of wine are being produced. Such attention to detail can be found in other works by Lancret: the table in the *Luncheon with Ham* (fig. 1) and *Luncheon Party in the Park* (pl. 14) is set with Saint-Cloud wine coolers, patterned porcelain plates, glistening silver, and snowy linen; the hunt picnic painted for the Marquis de Béringhen, recently acquired by the Louvre, shows a meal that is spread out on the ground but no less luxurious. Lancret's painstaking detail gives these paintings a striking immediacy, leading inevitably to the suggestion that they include portraits.[2] However, while individual likenesses certainly are possible, the portrait intention is not uppermost.

Though he did so more than others, Lancret was not the only artist to employ the hunt picnic. Carle Van Loo painted a large hunt meal for Fontainebleau in 1737 (now in the Louvre), Jean-François de Troy did another one for Fontainebleau that same year, and François Lemoyne painted one in 1723 (Museu de Arte de São Paolo, São Paolo).

The Washington canvas was formerly in the collection of Frederick the Great, one of Lancret's most ardent admirers. Frederick in fact owned twenty-six paintings by Lancret, including another hunt picnic as well as *The Peepshow Man* (pl. 25).

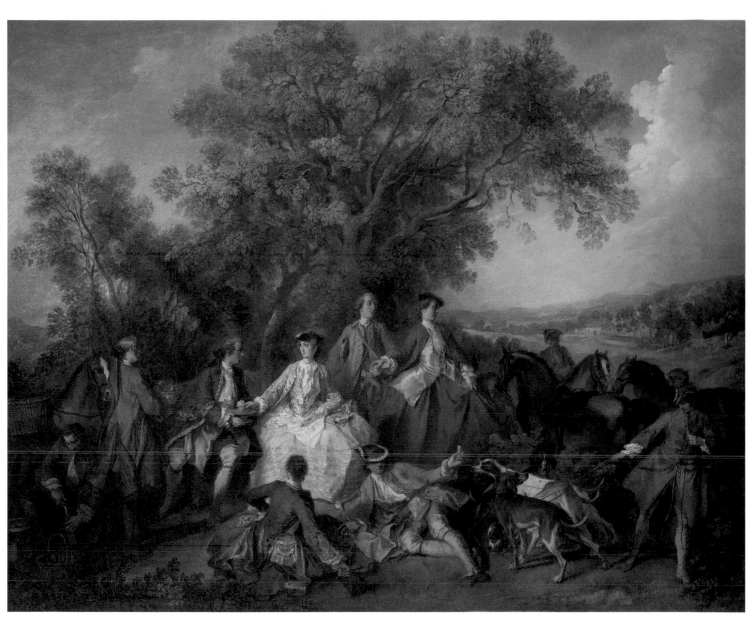

PLATE 13. Lancret. *The Picnic after the Hunt.*

PLATE 14 CATALOGUE NUMBER 10

Luncheon Party in the Park.

1735. Oil on canvas, 55.7 x 46 cm.
Museum of Fine Arts, Boston,
Forsyth Wickes Collection, 65.2649.
Provenance: La Live de Jully sale, March 5,
1770, lot 79; Marquis de la Rochefoucauld-
Bayers; David Weill, Paris.
Bibliography: *Dictionnaire pittoresque et histo-
rique,* Paris, 1766, I, p. 122; Bocher, IV,
no. 57; Wildenstein, nos. 73–74;
P. T. Rathbone, *The Forsyth Wickes
Collection,* Museum of Fine Arts, Boston,
1968, p. 18.

In this elegant small painting Lancret replicated one of his most famous and important works, the *Luncheon with Ham* now at the Musée Condé, Chantilly (fig. 1), which he had done for Louis XV. The replica, smaller than the original, was commissioned by a leading art patron of the eighteenth century, Ange-Laurent de La Live de Jully, who still had it in 1766 when a visitor saw it in the "small study facing the courtyard" of his Paris hôtel. Lancret's practice of repeating his work is well established. However, he did make minor changes: the statue of the satyr in the Chantilly painting is replaced by an urn in the Boston work, the plates in Chantilly show a pattern — possibly Kakiemon — rather that the simple filet on the Boston plates, and the oval table in Chantilly is a rectangular one in Boston. La Live's replica was engraved by Pierre-Étienne Moitte in 1756.

The original *Luncheon with Ham* and its pendant, a *Luncheon with Oysters* by Jean-François de Troy now also at Chantilly, were painted in 1735 for the King's private dining room at Versailles, the center of activity in his *petits cabinets,* or private quarters. The Duc de Luynes, who dined there often, tells us that the room was used almost exclusively for meals after the hunt. "These suppers usually lasted until around midnight," he reports, adding that "the honor of dining in the room was considered equal to that of riding in the State carriages."[1]

The two pendants, framed in carved emblems of the chase, were clearly meant to echo in their subjects the post-hunt revelry that took place in the room, with one painting focusing on city roistering, the other on country. Lancret's lively and colorful scene, with its hilarious wigless hunters, mimicking statuary, and the profusion of empty bottles on the ground, must have delighted the King, as well as La Live.

The increased informality at the French court in the eighteenth century, and the King's desire to secure a measure of privacy and comfort amid the pomp of his daily life, have been widely noted. Much of his leisure was devoted to his two favorite hobbies: the hunt and his succession of mistresses. These passions, matched by a penchant for construction, culminated in the creation at Versailles of the *petits cabinets du roi.* Begun in 1722, and known disparagingly as "pretty rats' nests," the Versailles *cabinets* were located in the upper stories of the north wing. Reached by private stairway, they gave the King a suite of rooms in which to relax with friends and pursue his personal interests. There were a library, a game room, a map room, a workroom with a lathe, a small laboratory, even a kitchen where the King could cook — and the rooms changed all the time. In the dining rooms, *tables servantes* were installed to reduce the need for servants. The apartments of the mistresses, though not precisely incorporated into the *cabinets,* were adjacent to them — the famous stairway to Mme. de Pompadour could be entered from there. Scaled and decorated to suit the King's taste, the rooms were small and featured hunt and animal themes, as well as informal genre scenes.

It must have been a particular honor to assist in their decoration, as the King reserved these rooms for favorite people, pleasures, and objects. Lancret received many royal commissions, including some for the Queen's apartments, but his work in the *petits cabinets* and the apartments of the mistresses is the core of his contribution, and a striking emblem of his success.

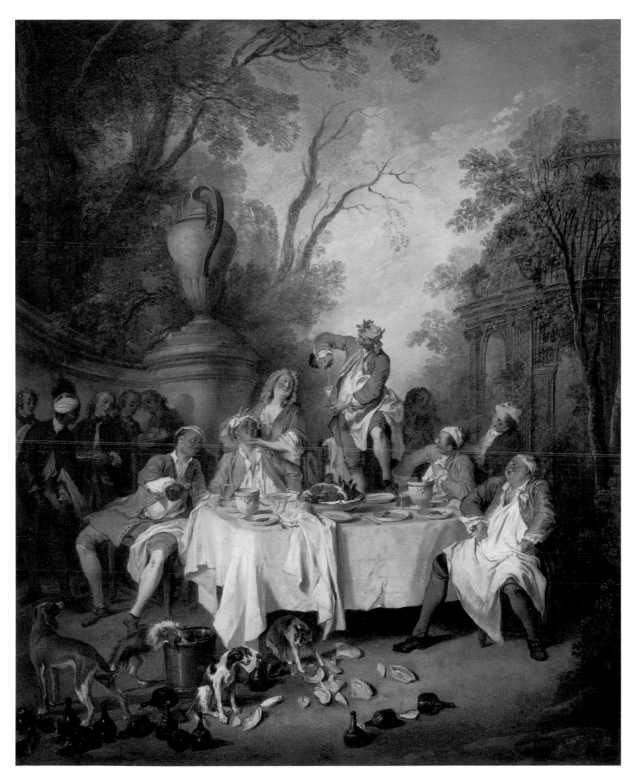

PLATE 14. Lancret. *Luncheon Party in the Park.*

PLATE 15 CATALOGUE NUMBER II

The Tiger Hunt.

1736. Oil on canvas, 177 x 129 cm.
Musée de Picardie, Amiens, inv. 2088.
Provenance: Commissioned in 1736 by
Louis XV for Versailles.
Bibliography: Holmes, 1985, pp. 24–31.

Another of the numerous commissions given to Lancret by Louis XV, *The Tiger Hunt* was part of a series of exotic hunt scenes painted by different artists for the *petite galerie* of the King's private apartments at Versailles. Bruzen de la Martinière visited the room in 1741 and gives us the following description of its splendors: "Nothing is gilded except the mirror moldings, the mantelpiece decoration, that of the pier glasses, and the frames of several pictures. All the rest of the wall surface is painted in various soft colors applied in an unusual varnish, especially made, which is polished and rendered brilliant by a blend of eight or ten coats applied one over the other.... In the room that serves as a gallery, there are six [paintings] representing different hunts of fierce exotic animals, like the lion, the tiger, the panther, the elephant, the wild bull, and the boar. These paintings have issued from the brushes of de Troy, Van Loo, who did two of them, Parrocel, and Lancret.... One also notes other small [paintings] that serve to ornament different areas of the apartments, in which it is easy to recognize the gay character of Lancret."[1]

This *petite galerie* was next to the dining room where Lancret's 1735 *Luncheon with Ham* (see fig. 1, pl. 14) was hung. The *galerie,* like the dining room, was dedicated in theme to the King's favorite pastime, the hunt. Long and narrow, it had elaborate *boiseries* by the famous carver Jacques Verberckt and furniture upholstered in green damask.

In 1736, the King commissioned six paintings of exotic hunts to be installed there, each by a different painter: Lancret, Pater, Boucher, Carle Van Loo, Charles Parrocel, and Jean-François de Troy. It is an odd assembly, and only one of the painters, Parrocel, had previously produced the kind of scene the King had in mind. For these were not to be the more sedate contemporary hunts of the sort provided by Oudry for the King, the chase of the roebuck through French forests. They would be savage hunts after dangerous beasts in strange lands. Lancret's *Tiger Hunt* would be accompanied by an *Elephant Hunt* (Parrocel), a *Bear Hunt* (Van Loo), a *Leopard Hunt* (Boucher), a *Lion Hunt* (de Troy), and a truly odd *Chinese Hunt* (by Pater far beyond his depth), each painting characterized by action, blood, exotic costumes, and evocative settings. Three more canvases were ordered in 1738: Parrocel's *Wild Boar Hunt,* Van Loo's *Ostrich Hunt,* and Boucher's *Crocodile Hunt.* All are now together in Amiens. It has been plausibly suggested that the project had an overseer to coordinate the images, probably Parrocel, who may have guided the choice of source material as well; most of the scenes were drawn from prints of hunts by Antonio Tempesta and Jan van der Straet.[2]

Lancret rarely attempted explosive action or violent motion, and this commission demanded both. His mustached and turbanned Turks — some astride plunging horses, some on the ground, some in trees — converge on and spear a struggling tiger. Its defeated mate lies to one side. Lancret attains a sense of powerful movement through the diagonal lines of the composition that focus on the writhing tiger, a baroque device of great effect. The dynamic action is in contrast to the tight and smooth — even hidden — brushstrokes, which render fabric and animal skin in beautiful detail. Lancret's hunt lacks the ferocity and bravura of those by Boucher or de Troy, both of whom bring a Rubensian vigor to their scenes, but his sumptuous and precise treatment gives his image a wonderful exotic richness. An oil sketch for this painting, which appeared in Mme. Lancret's sale, is in a private collection.

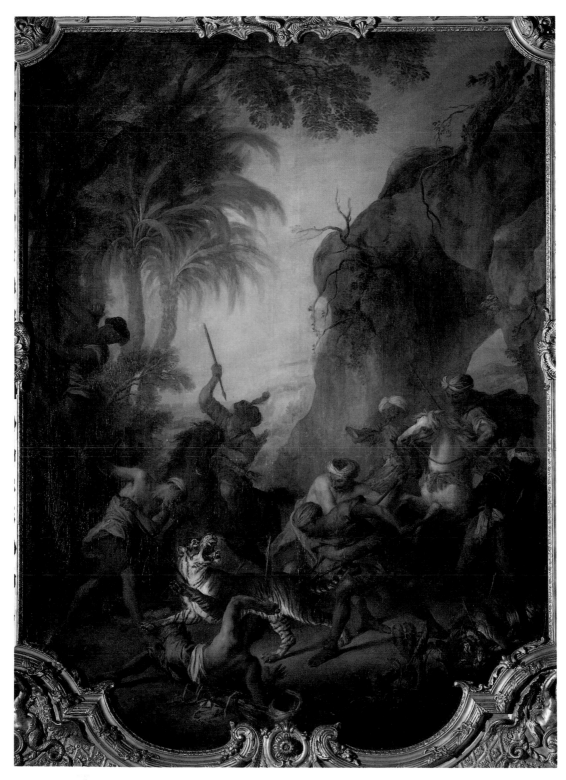

PLATE 15. Lancret. *The Tiger Hunt.*

PLATE 16 CATALOGUE NUMBER 12

The Bourbon-Conti Family.

c. 1737. Oil on canvas, 49.3 x 66.7 cm. The Krannert Art Museum and Kinkead Pavilion, Champaign, Illinois, no. 67–3–5. Provenance: Bourbon-Conti family (?); Comtesse d'Hautpol, descendant of the Bourbon-Conti family; her sale, Hôtel Drouot, Paris, June 29, 1905, lot 44; Duveen, London, 1906; Cailleux, Paris, 1930; Timary de Binkum; Cailleux, Paris. Bibliography: Wildenstein, no. 562; P. Jarry, "La Deuxième Exposition de Bagatelle: 'Le Dix-Huitième Siècle aux Champs,'" *Le Gaulois Artistique,* July 25, 1929, p. 367; Roland Michel, 1968, under no. 96; S. Sitwell, "The Pleasures of the Senses," *Apollo,* LXXXVII, February 1968, p. 137; R. Melville, "Miss O'Murphy and the Satyrs," *Architectural Review,* CXLIII, no. 855, May 1968, pp. 381–82; "College Museum Notes," *Art Journal,* XXVII, Summer 1968, pp. 406–08; J. T. Butler, "The American Way with Art," *Connoisseur,* May 1968, pp. 64–67; M. Roland Michel, *Lajoue et l'Art rocaille,* 1984, p. 77 and under no. P256; Colnaghi, New York, 1990, *Claude to Corot,* no. 24.

The Bourbon-Conti Family and *The Luxembourg Family* belong to a small but important group of paintings within Lancret's oeuvre, his family portraits. Five of these survive: the present two works; *The Saint-Martin Family;* and two unidentified family portraits. Another painting, of *M. and Mme. Gaignat,* is known from a *livret* drawing by Gabriel de Saint-Aubin.

The Bourbon-Conti Family includes four female members of this household — or, more accurately, of some unidentified household, as it seems impossible that the painting could depict the Bourbon-Conti family at that time. They are shown at their leisure in the shade of a row of trees, one young girl with her pet, another with a flower, and one of the older ladies with a fan. A tiny yapping dog leads the viewer's eye to the couple to the right of center, a girl in green and gold and a man in ruby red (his blue cloak and hat have been discarded) who tries to embrace her. A sleeping dog at right and a flock of sheep tended by a relaxed shepherd and shepherdess in the background complete a picture of pastoral ease.

Elegant outdoor recreation is again a motif in *The Luxembourg Family,* which shows a young girl ready to collect flowers as her mother fishes in a thoroughly unconcerned and stately manner. The young man between them could ostensibly be a family member, as contemporary portraits of the upper class sometimes showed a bagpiper — for example, Drouais' 1750 *Portrait of the Marquis de Sourches and His Family,* or Rigaud's 1737 *Portrait of Gaspard de Gueidau* — and the playing of pipes would be an appropriately rustic activity to accompany fishing and flower-gathering; however, an eighteenth-century sale catalogue entry describing a copy of this painting calls him merely *"un paysan."* The women are beautifully gowned and coiffed.

These two paintings and the others mentioned above have a number of things in common: each is modest in size, with the figures much smaller than life; each shows the subjects relating to one another, whether by glance or by gesture; and in each the figures are engaged in activity that suggests leisure and intimacy, not formality. In the tradition of portraiture, such paintings belong to the specific type known as the conversation piece. This style of portrait is closely allied to the personal lives and social aspirations of its sitters. For this reason, many authors have stressed the essentially bourgeois nature of the form, a notion that is supported by the milieus in which the conversation piece has been most popular: seventeenth-century Holland and eighteenth-century England, times and places that saw great power and prosperity shifting to the middle class. The conversation piece enters the home or garden of its sitters, showing their hobbies, pets, domestic furnishings, toys, and treasures. We might also find these elements in a genre scene, but never with such specific and personal application. The conversation piece was not popular in France, where the magic of the full-size portrait retained its appeal. Lancret was one of the few French artists to attempt it, certainly owing to its similarity to the *fête galante.*

The activities and relationships among the sitters in Lancret's conversation pieces often suggest their roles within the family and in society, as well as their stages of life. In the Bourbon-Conti painting, the ages of the sitters are reflected in the colors of their dresses: the two guardian matrons wear cool, harmonious tones,

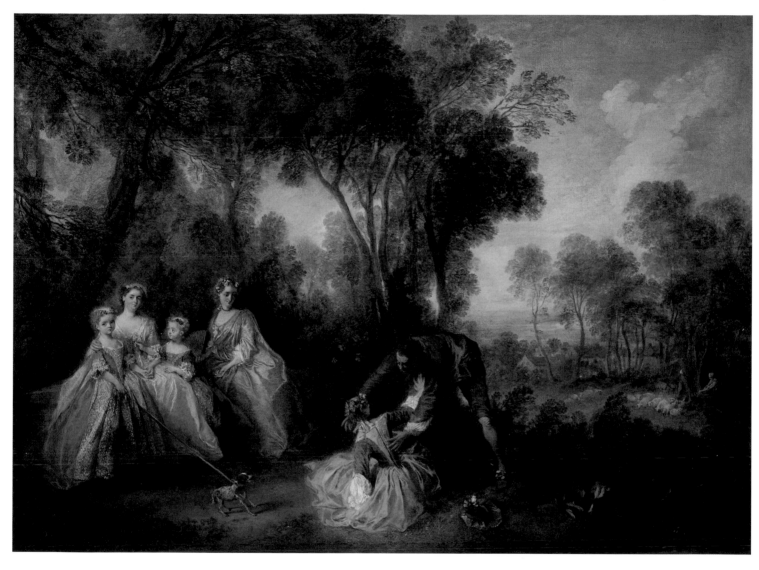

PLATE 16. Lancret. *The Bourbon-Conti Family.*

PLATE 17 CATALOGUE NUMBER 13

The Luxembourg Family.

c. 1735. Oil on canvas, 58.4 x 73.7 cm.
Virginia Museum of Fine Arts, Richmond,
The Adolph D. and Wilkins C. Williams
Fund, no. 57.37.
Provenance: Choiseul sale, March 15, 1839,
lot 136; John W. Wilson sale, Paris, March
15–16, 1881; Comte Edmond de Pourtalès;
Comtesse de Pourtalès, 1924;
Mme. Elizabeth Wildenstein, 1935.
Bibliography: Wildenstein, nos. 565
(oil sketch for the painting), 566; Roland
Michel, 1968, p. iii (oil sketch).

while their prepubescent charges wear the unblemished pastels of Spring flowers. The older girl to the right wears vivid Summer green and yellow, her lusty suitor sanguine red. The inclusion of this couple is also designed to enrich the context provided for the sitters. The pair are set apart by their position in the painting, their shepherd garb, and their more active poses. They are clearly not meant as portraits — indeed, their faces cannot really be seen. They are included as a reference to the awakening of desire in the older of the two girls to the left, to characterize her quickly approaching puberty. Her yapping dog, a frequent herald of carnal appetites, tries to pull her toward them, and is barely restrained: it is not yet time. The smaller child, with no notion of the coming of age of her sister, offers her the innocent flower of youth; she ignores the amorous couple.

This blend of different painting genres — portrait and allegory — recalls Lancret's achievement in *La Camargo Dancing* (pl. 9). The other conversation pieces also illuminate the context of their sitters with recognizable signals. The head of the Saint-Martin family is in hunting dress, a sign of his upper-class position; his older daughter holds a bird in a cage, an emblem of innocence used repeatedly in the eighteenth century (compare pl. 23). The young girls in Lancret's portrait of an unidentified family in the Palazzo Barberini, Rome, have been gathering flowers, a time-honored activity of the young and innocent. The pastoral quality of *The Luxembourg Family* belongs in the fashionable tradition of portraits *à la bergère,* so popular in the seventeenth-century Netherlands and eighteenth-century France. Fishing, like hunting, can be used to imply class distinction and is often found in images of nobility at leisure. Again, we find a child about to gather her blossoms before they fade.

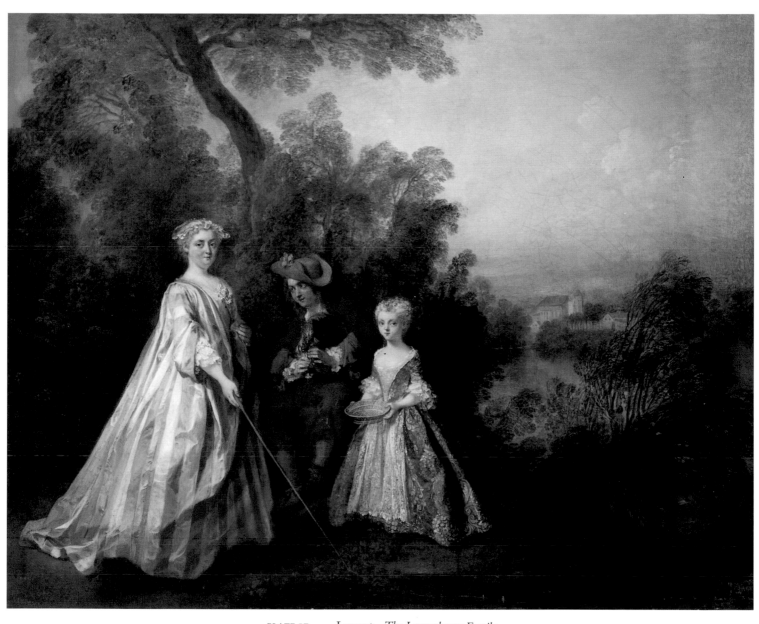

PLATE 17. Lancret. *The Luxembourg Family.*

PLATE 18 CATALOGUE NUMBER 14

The Toy Windmill.

c. 1731. Oil on canvas (circular),
diam. 52.3 cm. National Galleries of
Scotland, Edinburgh, no. 440.
Provenance: Fortier sale, April 2, 1770,
lot 36; anonymous sale, December 15,
1777, lot 107; Baron de Saint-Julien sale,
June 21, 1784, lot 62; Devouges; Baron
de Saint-Julien sale, February 14, 1785,
lot 86; H. D. sale, January 30, 1845, lot 15;
Lady Murray.
Bibliography: Edinburgh,
Catalogue of the National Gallery of Scotland,
1946, p. 206; Wildenstein, no. 245.

Edinburgh's *Toy Windmill* portrays a boy and girl playing with a pinwheel. That the toy was as familiar then as now is evident from the pinwheel vendors in the *Cries of Paris* engravings and from Rabelais' extensive list of games in *Gargantua.* The mechanism is, of course, very simple: a wooden stick mounted at the top with a cross of wings that spin in response to wind or breath. It is the child's reduced version of the adult's windmill, much as hobbyhorses and pullcarts are variants on grown-up modes of transportation.

The circular shape and high color of Lancret's small painting have great charm, as does the comic depiction of the girl's efforts. She puffs and strains to spin the pinwheel, but to no avail. Has the boy tampered with it to tease her? He wears cherry red, which exactly matches the red color of her inflated cheeks. She wears another of Lancret's inspired color combinations, yellow and blue, with red shoes to further link her to the boy.

Lancret's paintings of children at play fall into two groups. Most show active games — such as hide-and-seek or skittles — being played by several children, and were intended to be made into engravings and sold as sets. Such engravings belong to a rich tradition in printmaking that includes games not often seen in paintings; examples can be found in Guillaume Le Bé's *Set of Thirty-Six Plates Showing All the Games Ever Invented Being Played by Children,* Claudine Stella's *Children's Games and Pleasures,* and Augustin de Saint-Aubin's *These Are the Different Games of the Urchins of Paris.* Lancret's second group comprises a small number of paintings like *The Toy Windmill.* The games in these scenes demand fewer players (usually one to three children), are less physical, are much more static, and often include some kind of toy. These pastimes all suggest flirtatious teasing. Lancret's *Girl with a Magnifying Glass* (Charlottenburg, Berlin), for example, shows a girl kindling a flame in a small pyre of sticks — undoubtedly referring to her future ability to enflame hearts. In *Mischief* (National Gallery, Dublin), a young girl who has fallen asleep over her book is being teased by a boy who blows smoke in her face. Similar images exist in works by Claude Duflos and Charles-Nicolas Cochin.

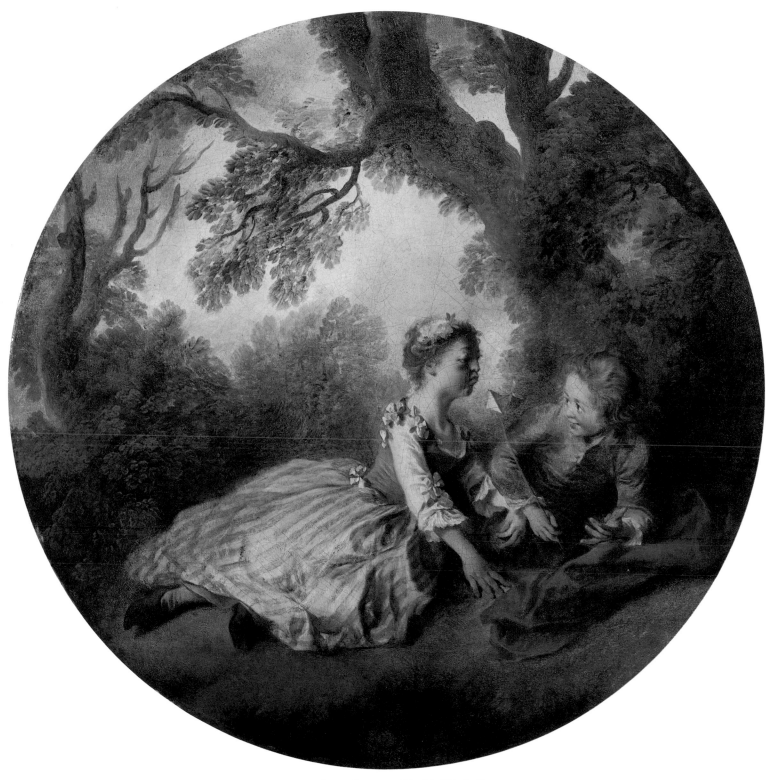

PLATE 18. Lancret. *The Toy Windmill.*

PLATE 19 CATALOGUE NUMBER 15

A Hunter and His Servant.

c. 1737–40. Oil on canvas, 82.5 x 65 cm.
Private collection.
Provenance: Collection of a nobleman,
Great Britain.
Bibliography: None.

Lancret painted few formal portraits. The requirements of the pose and the relatively restricted spatial arrangement were fundamentally alien to his proven specialty, the setting of small, elegant, lively figures within a rich and spacious landscape or a pavilion. When he did venture into portraiture, it was usually in a manner that allowed him to use the devices familiar from his genre scenes. The *Hunter and His Servant* is a rare attempt at more formal portraiture, and so successful is it that we wonder why Lancret did not do others.

Though not life-size, the figures have a stature and dignity unusual in Lancret's portraits, which are usually so intimate and informal. The painting is a masterly example of the artist's brilliant use of brush and color, the tonal range restricted to muted earth tones appropriate to the subject and the creamy brushstrokes visible throughout, especially on the hunter's shirt front. Interestingly, both master and servant, though clearly individuals, retain Lancret's signature enlarged eyes and elongated fingers.

Of course, the hunt theme recurs often in Lancret's work, frequently in paintings of hunt meals. He also used hunting costumes in at least two other portraits: one, quite like this painting but with a more elongated horizontal format, is now in a private collection, Switzerland, and the other is the figure of the father in *The Saint-Martin Family*. The placement of the sitter here, and of the hunter in the Swiss example, immediately recalls Watteau's portrait of Antoine de la Roque, which Lancret certainly knew as he reproduced it in a drawing (Eliot Hodkins estate) and may even have collaborated on painting its background.[1] Watteau provided a still closer precedent in a painting, known only from an engraving by Audran, of the *Return from the Hunt,* in which a woman in hunting clothes sits on a knoll beneath a tree, some game hanging beside her. However, Watteau was not the only source — and perhaps not even the most important one — available to Lancret. Alexandre-François Desportes' 1699 *Self-Portrait as a Hunter* (Louvre) and Nicolas de Largillière's 1729 *Portrait of a Man in Hunting Dress* (Staatliche Kunsthalle, Karlsruhe) are closer to the present painting in the sitter's graceful pose and easy inhabiting of the landscape, as well as in their tonal richness. The hunting theme is a portrait device with a long tradition, useful for depicting the upper class. Hunting was regal and expensive, and thus a flattering portrait guise.

Lancret's work had an important impact on English art of the eighteenth and nineteenth centuries, and it is tempting to suggest that the present painting, which has a British provenance, formed part of that influence. The abundant art traffic between France and England in the eighteenth century has often been noted. Not only did paintings and engravings cross the Channel regularly, but so did artists — among them Philippe Mercier, the engraver Hubert-François Gravelot, and even Watteau (in 1719). Hogarth visited France in 1743. Lancret was well-known in England, and eighteenth-century English copies after his work exist. Francis Hayman, for example, copied his *Morning* (pl. 20a) and used Lancret's children's games as models for his Vauxhall decorations of 1743. Thomas Gainsborough may conceivably have borrowed from the present work for his 1750 *Philip Thicknesse* (City Art Museum, Saint Louis) or his 1762 *William Poyntz* (Earl of Spencer, Althorp House).

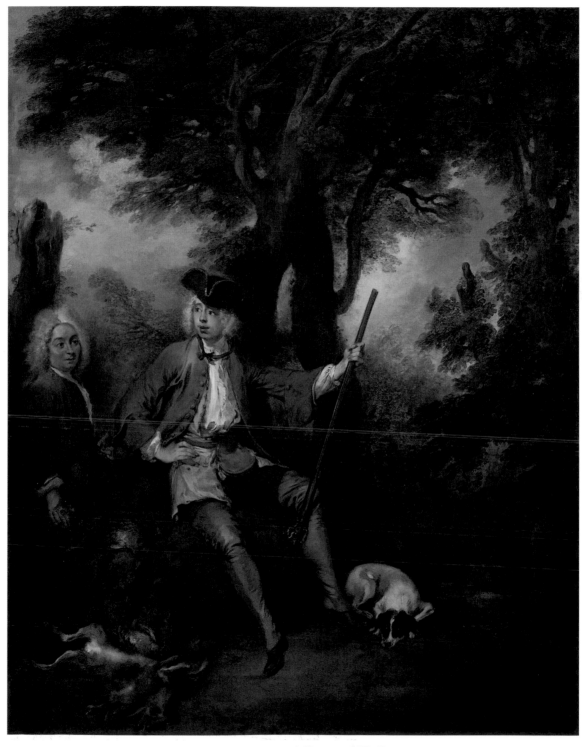

PLATE 19. Lancret. *A Hunter and His Servant.*

PLATE 20 CATALOGUE NUMBER 16

The Four Times of Day.

c. 1739. Oil on copper, all 29 x 37 cm:
a) *Morning;* b) *Midday;* c) *Afternoon;*
d) *Evening.* The Trustees of The National
Gallery, London, nos. 5867–5870.
Provenance: Marquess of Bute sale, June 7,
1822, lot 60 (?); Sir Godfrey Macdonald,
Thorpe Hall, Rudston; his sale, Christie's,
London, February 22, 1935, lot 18, to
Vicars; bequeathed by Sir Bernard
Eckstein, 1948.
Bibliography: Chevalier de Neufville de
Brunabois Montador, *Description raisonnée
des tableaux exposés au Louvre, 1739, Lettre à
Mme la Marquise de S.P.R.,* Bibliothèque
Nationale, Collection Deloynes, pp. 9–10;
Bocher, IV, nos. 10, 49, 50, 74; Wildenstein,
nos. 34–37; M. Davies, *National Gallery
Catalogues: French School,* London, 1957,
nos. 5867–5870; A.C.R. Carter, "Forth-
coming Sales: Lancret at Last," *Burlington
Magazine,* LXVI, February 1935, supp.
p. xiii.

FIG. 27.
Gabriel Le Brun. *Morning*
(from *Pursuits of a Man of Quality*).
Engraving. Bibliothèque Nationale,
Paris, Cabinet des Estampes

Lancret's *Four Times of Day* are among his rare works on copper. Small, sump-
tuous, and highly civilized, they draw on a rich popular print tradition, which they
enrich in turn. The set forms a brief lesson in how to spend one's day at leisure
and pleasure.

In the first painting, *Morning,* a lovely lady wearing a salmon dress trimmed
with silver receives a prelate for morning tea as she completes her *toilette* with the
help of a maid; the setting is her boudoir, a beautifully detailed interior that is one of
Lancret's few essays into the territory of Jean-François de Troy. It is this scene that is
so devastatingly mocked by Hogarth in his *toilette* scene from the *Marriage à la Mode*
(also The National Gallery, London), his satire made all the more biting in light of
the tradition that inspired it. Lancret's disheveled lady believes her visitor is either
beyond temptation or, more likely, susceptible to it. As one observer at the Salon of
1739 pointed out: "This young person, with her bodice nonchalantly open and her
dressing gown thrown back... pours tea into a cup that M. l'Abbé holds out to her
with a distracted air; because he is attentive only to this beauty's disarray. A maid
takes it all in, smiling slyly."

In *Midday,* a party of elegant folk, out picking flowers in a garden, pause to
check their watches against a sundial mounted on a fountain. In *Afternoon,* what
appear to be the same participants, now dressed in more subdued tones of silver,
gold, and pink, aid their digestion by playing backgammon on an elegant lacquer
table they have had moved outdoors to take advantage of the fine weather. For
Evening, Lancret turned to a theme he painted independently many times, that of
bathers; to fit the present cycle, the women bathe by moonlight.

As he did so often, Lancret relied here on the seventeenth-century popular print
tradition for both theme and composition, producing a narrative cycle of great
charm and equally great influence. Before the seventeenth century, the Times of
Day were portrayed mainly in terms of personifications and mythology. The
development of genre-based Times of Day undoubtedly followed seventeenth-
century advances in clock mechanisms and manufacture, most notably the spiral
balance spring for the pocketwatch. Better watches and more of them increased the
number of people able to calibrate time and willing to let their activities be governed
by the hour and minute hands. Lancret included timepieces in both *Morning* and
Midday. Genre depictions of the Times of Day soon adhered to a standard pattern:
Morning, a toilette; Midday, a luncheon, a scene with a sundial, or both; Afternoon,
either games or an easy domestic activity such as sewing; Evening, perhaps
attendance at a ball, cardplaying, or slumber. The elaborate consistency of these
scenes calls to mind that the rigid custom of the King's public *levée* and *couchée*
persisted through most of the eighteenth century. Women usually dominated such
scenes, but a very attractive set by Gabriel Le Brun (Charles' brother, b. 1625) details
the activities of a young man — his *Pursuits of a Man of Quality* (see fig. 27).

Lancret led the way in translating the printed images of the Times of Day into
paint, and the development proved very popular. As noted, the present set certainly
inspired the *Four Times of Day* planned by Boucher for Louisa Ulrica of Sweden, of
which only *The Milliner: Morning* was completed (see fig. 21). Lancret's *Times of
Day,* combining fashion, etiquette, intimacy, and allegory, were ideal fuel both for

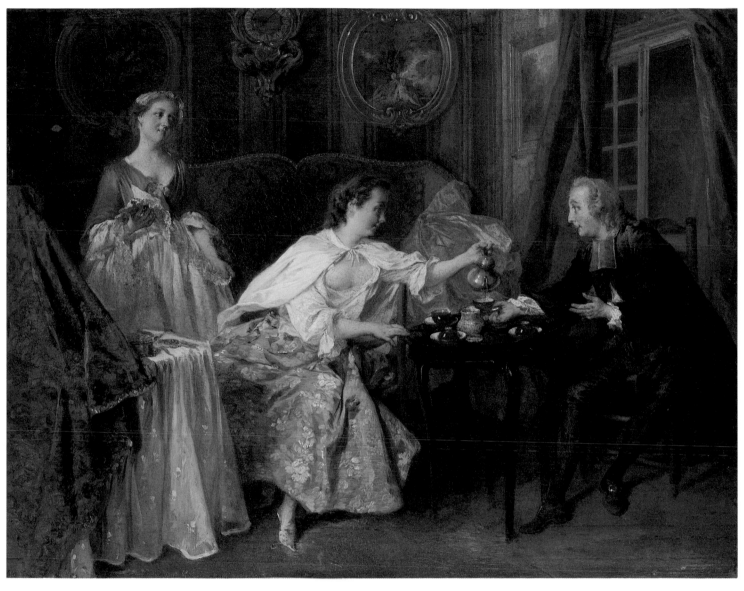

Lancret. *The Four Times of Day: Morning.*

narrative genre painting and for portraits of fashion leaders. Time, the focus of these images, has been stripped of its malevolence, its character as the thief of beauty and life. Like its yardstick, the pocketwatch, Time has become instead an excuse for changing one's clothes, varying one's recreation, ordering one's existence according to a system of constraints and propriety.

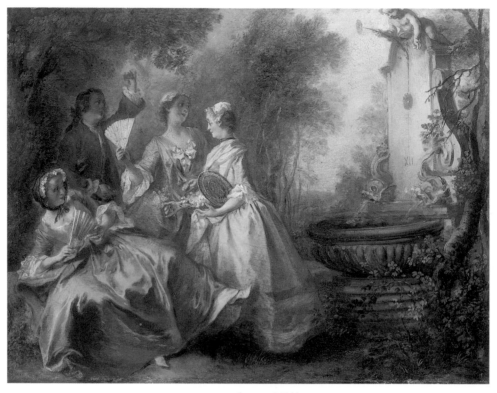

PLATE 20b. *Midday.*

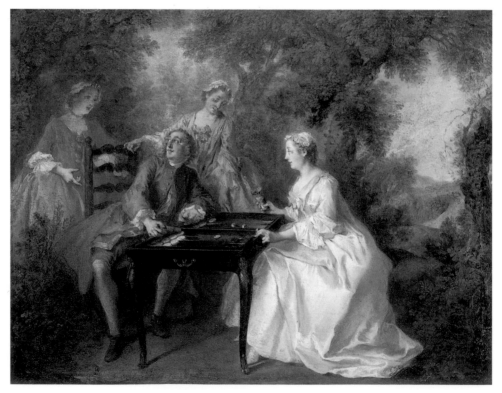

PLATE 20c. *Afternoon.*

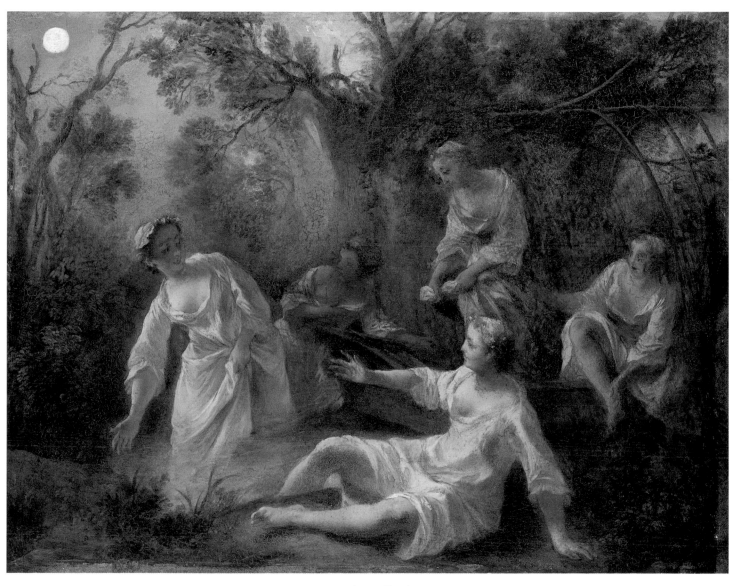

PLATE 20d. *Evening.*

Portrait of the Actor Grandval.

c. 1742. Oil on canvas, 68.5 x 85 cm. Indianapolis Museum of Art, gift of Mr. and Mrs. Herman C. Krannert, no. 60.247. Provenance: Comte d'Artlet sale, Paris, January 4, 1815, lot 235; Vicomte de Suleau; anonymous sale, Hôtel Drouot, Paris, January 14, 1880, lot 82; Camille Groult, Paris; Wildenstein, New York, until 1960. Bibliography: Wildenstein, no. 592; *Gazette des Beaux-Arts,* February 1961, supp. p. 36, no. 110.

Lancret is not especially known as a portraitist, yet his surviving portraits prove him remarkably creative at the form. One of his most inventive conceits was the blending of fact and fantasy in portraiture—placing a real individual in a fictional setting. This worked especially well in his portraits of contemporary theatrical figures, subjects whose daily lives were distinguished by a strong element of make-believe. Such is the case in his likenesses of the celebrated ballerinas Mlles. Camargo (pl. 9) and Sallé, and such is the case here in his portrait of the actor Grandval.

Charles-François-Nicolas-Racot de Grandval (1710–84), a leading performer of the eighteenth century, played both tragedy and comedy in Paris for thirty years. He appeared in eighty-eight plays, including Molière's *Misanthrope* and Voltaire's *Zaïre,* before retiring in 1768. In a painting exhibited at the Salon of 1739, Lancret depicted him in his role from Destouches' *Le Glorieux.* He exhibited another portrait of the actor at the Salon of 1742 (no. 19), where it was described as "M. Grandval in a garden ornamented with flowers, vases, and statues of Melpomene and Thalia." In keeping with Lancret's practice of replicating his own work—the two versions of the *Luncheon with Ham* (fig. 1, pl. 14), for example, or the four of *La Camargo Dancing* —the Indianapolis painting can be identified as a reduced replica of the one exhibited in 1742; the Salon *livret* gives its dimensions as "4 feet by 3 and half wide," or about 129 x 113 cm—much larger than the Indianapolis picture.

As in the portraits of Mlles. Camargo and Sallé, Lancret has placed his sitter in an imaginary garden, and the garden itself tells us something about Grandval's mastery of his craft—much as the Temple of Diana in the portrait of Sallé suggested the virginal purity of her dance style. Here a putto holds a symbolic mask, and the statuary group depicting Thalia, Muse of Comedy, and Melpomene, Muse of Tragedy, alludes to Grandval's celebrated ability to play roles high and low. As Camargo and Sallé take dance steps, so Grandval holds a rhetorical pose, ready for his next line. Like the two dancers, he is not engaged in a particular role; he merely wears the costume of Gentleman, with an especially handsome waistcoat.

The engravings of the Grandval, Camargo, and Sallé portraits were made to the same size, as noted in the *Mercure de France* of April 1755 in its announcement of LeBas' print after Grandval, and could be purchased as a "gallery of the theater."

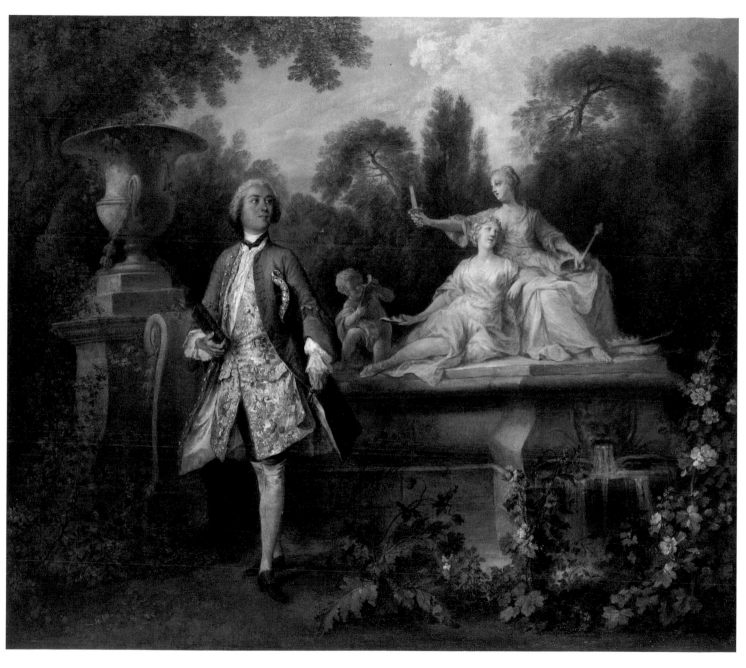

PLATE 21. Lancret. *Portrait of the Actor Grandval.*

PLATE 22 CATALOGUE NUMBER 18

A Lady and Gentleman with Two Girls in a Garden (The Cup of Chocolate).

c. 1742. Oil on canvas, 88.9 x 97.8 cm.
The Trustees of The National Gallery,
London, no. 6422.
Provenance: Lady Wantage, London.
Bibliography: Salon of 1742, no. 50;
Royal Academy of Art, London, *France
in the Eighteenth Century,* 1968, no. 383;
Wildenstein, no. 621.

Perhaps no painting so clearly illustrates the unjustness of Lancret's dismissal by succeeding generations as *The Cup of Chocolate*. This sensitive and moving portrayal of family life has few equals in eighteenth-century art, and it ranks Lancret among the leaders of his time.

It is, in fact, strikingly similar to Boucher's justly-acclaimed *Breakfast* of 1739, now in the Louvre. Each painting catches a family in a moment of informal domesticity, at morning coffee. (The traditional title of Lancret's work is a misnomer, as the silver utensil the servant holds is a high-spouted coffee pot.) Lancret's group includes father and mother, two daughters, and a manservant, while Boucher's shows two women, two little girls, and a manservant; the subject is essentially the same. The paintings also share a charming freshness in the children, the touchingly maternal gesture of feeding a child with a spoon, and the comfortable inclusion of dolls and toys. Boucher usually preferred elaborate interiors for his genre scenes, while Lancret, with a nod to Watteau, favored the garden, but the delicate description of intimate domestic ritual remains similar. Boucher's painting is roughly contemporary with Lancret's, and both are in part the fruit of Lancret's earlier achievements — in particular, his fashionable narrative genre scenes and conversation-piece portraits. Lancret's talents coalesce in the late *Cup of Chocolate*, his telling sense of anecdote now directed at portraying familial intimacy, his grace and ease now at the service of a mother and her children, and his garden landscape, so often before a glamorous setting for dance and seduction, now an extension of the family home.

It is no wonder the painting is sometimes called a conversation piece. The relationships are so expressive that they give a portrait-like quality to the group. This does not seem to be the case, however, as the Salon *livret* for 1742, the year the work was exhibited, calls it simply "a lady in a garden taking coffee with children." Boucher's painting has created similar confusion, often being misidentified as a portrait of the artist and his family.

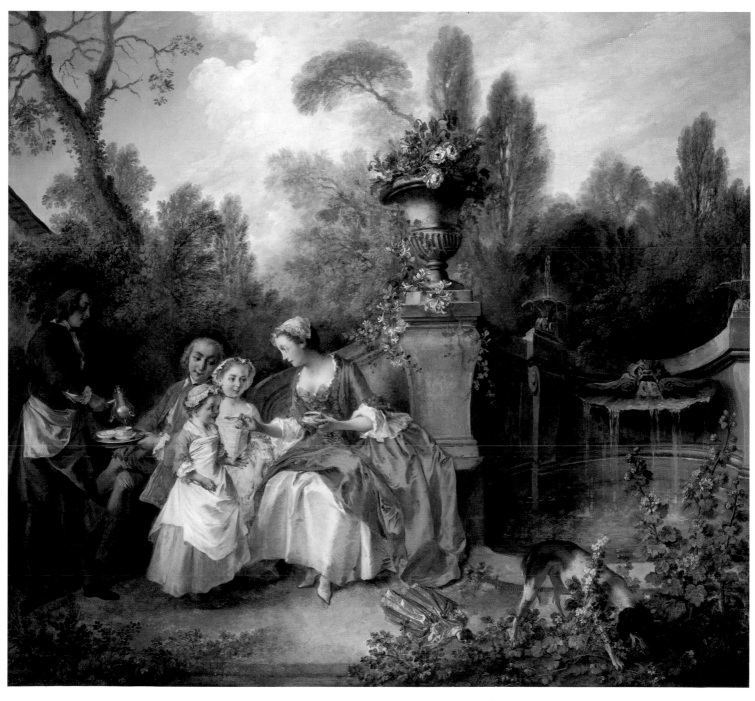

PLATE 22. Lancret. *A Lady and Gentleman with Two Girls in a Garden (The Cup of Chocolate).*

PLATE 23 CATALOGUE NUMBER 19

The Birdcage.

c. 1735. Oil on canvas, 44 x 48 cm.
Bayerische Staatsgemäldesammlungen,
Alte Pinakothek, Munich, no. HuW 4.
Provenance: Frederick II; Neues Palais,
Potsdam, until 1923; Wildenstein,
New York.
Bibliography: *Mercure de France,* January
1736, p. 135; Oesterreich, no. 80;
R. Dohme, "Die Austellung von
Gemälden," *Jahrbuch der preussischen
Kunstsammlungen,* IV, 1883, no. 19; Bocher,
IV, no. 8; Wildenstein, no. 455; W. King,
"A Watteau Subject in English Porcelain,"
Apollo, January 1935, pp. 31ff.; F. J. B.
Watson, "Dix-huitième and settecento at
Munich," *Burlington Magazine,* CX, 1968,
p. 351; Alte Pinakothek, Munich, *Katalog
IV: Französische und spanische Malerei,* 1972,
p. 33.

One of Lancret's most popular works, *The Birdcage* has been reproduced on porcelain, picture puzzles, and even chocolate boxes. It is a fine example of a theme that was a constant in Lancret's art and, indeed, in art throughout the first half of the eighteenth century: the bucolic loves of elegant shepherds and shepherdesses symbolized by the snaring and releasing of birds. Watteau used the motif, and it was a particular favorite of Boucher's. A bird that has escaped from a cage or is about to is a recurring symbol of the loss, or potential loss, of virginity. This is certainly the meaning of Lancret's caged bird here. The girl at right leans across the shepherd's lap, tempting and toying with the bird. The youth's shirt has fallen open. Bird and boy are teased simultaneously. Two voyeurs in the bushes at far right await the outcome.

Lancret's fascination with this theme began early; we find it, for example, in his scene of *Spring* from *The Four Seasons* for Leriget de la Faye.[1] *The Birdcage* is a work of the artist's maturity, in which he has adopted some aspects of history painting—in particular the monumental figural style and triangular composition—to give the scene greater visual importance. The color combinations are striking and unusual, with one shepherdess in salmon and blue, the other in sea green and yellow.

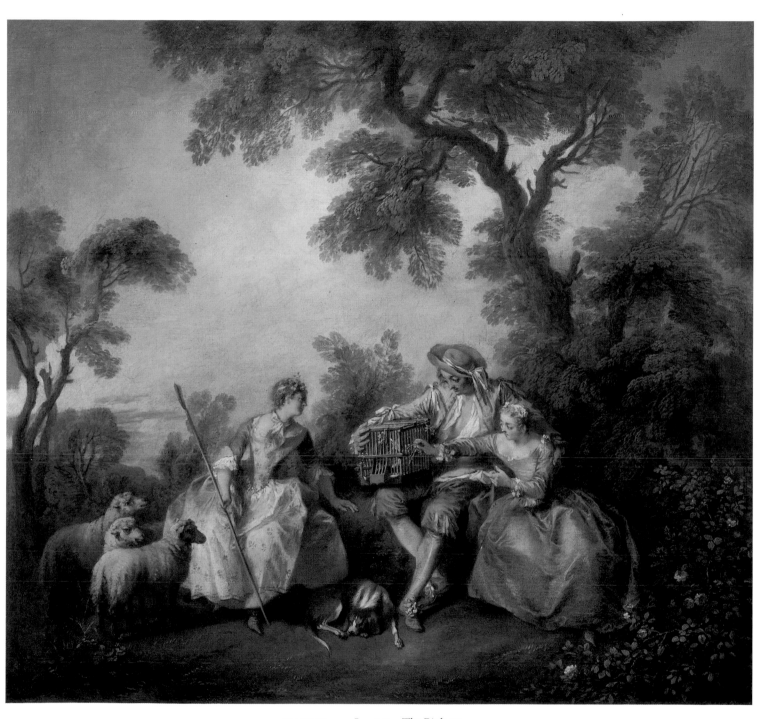

PLATE 23. Lancret. *The Birdcage*.

PLATE 24 CATALOGUE NUMBER 20

a) *The Game of Pied-de-Boeuf* and b) *The Outdoor Concert.*

c. 1743. Oil on canvas, both 81.5 x 106.5 cm. Private collection.
Provenance: Possibly commissioned by Louis XV for the apartment of Mme. de la Tournelle at Versailles; François-Marius Granet, Aix-en-Provence and Paris; his sale, January 28, 1853, lot 77 or 83(?); Duc de Vicence, by 1866.
Bibliography: Engerand, pp. 264–66; Wildenstein, nos. 105, 406; Wildenstein, New York, 1948, *French XVIIIth Century Paintings,* nos. 24, 25; Holmes, 1985, pp. 28–29, 31, note 11.

FIG. 28.
Lancet. *The Game of Pied-de-Boeuf.* 1739. Engraving by Nicolas de Larmessin. Bibliothèque Nationale, Paris, Cabinet des Estampes

Lancret's *The Game of Pied-de-Boeuf* and its pendant, *The Outdoor Concert,* are among the masterpieces of his late style and probably date to about 1743, the year he died. Elegant in treatment and ravishing in color — their lemon yellows are paired with jade greens, their cornflower blues with the palest peach — these images would have held their strength when seen above the highest doorway, and were no doubt designed to showcase the artist's skill. Though they are not commonly associated with a particular commission or patron, the author suggests that the paintings were meant to decorate one of nine attic rooms at Versailles, near the *petits cabinets,* that Louis XV gave in 1742 to Mme. de la Tournelle, later Duchesse de Châteauroux (daughter of the Marquis de Nesle), his current mistress. She had succeeded her two sisters, Mme. de Mailly and the Marquise de Vintimille, to that post, and when she in her turn was ousted, her successor, Mme. de Pompadour, claimed the apartments.

It is known that Lancret was commissioned by the Crown in 1743 to provide "five irregularly shaped paintings representing different gallant outdoor subjects," probably for these rooms. There is some debate over which five paintings they were; only the Louvre's *The Flute Lesson* is securely located there, thanks to the inscription on an engraving made of it. *The Game of Pied-de-Boeuf* and *The Outdoor Concert,* originally irregular in shape but filled out to form rectangles, together with the Louvre's *Innocence* and *The Music Lesson,* probably formed the other four. All fit the size and shape requirements and the cited motifs, all share highly idealized pastoral costumes of rich and brilliant silks, and all but one allude to music-making. Another group of four that has been proposed — the *Shepherdess Crowned* and *Sleeping Shepherdess* in Tours, together with two scenes from La Fontaine — do not fit together convincingly as a group.

The Outdoor Concert represents a favorite pastoral subject of Lancret's: a man wooing three girls with his song, much as in the Louvre *Music Lesson.* The pendant portrays a theme of great importance to Lancret in his role as thematic innovator: the game called *pied-de-boeuf,* the origin of which is unknown. Lancret depicted this game several times, notably in a version now in the Charlottenburg that was exhibited in the Salon of 1739 and later engraved (fig. 28). The game was started by having the first player place his hand on the knee of a seated person, and counting "one." The next player's hand went atop the first, that player counting "two," and so on; as they moved up, and all hands were engaged, the hand on the bottom of the pile was drawn out and slapped the hand on the top. The first player to reach nine quickly grabbed the unengaged hand of another player, saying "Nine! I've got my pied-de-boeuf." He then demanded a forfeit. "Pied-de-boeuf, will you do one of three things for me?" To which the captive answered, "Yes, if I wish to and if I can." The winner then asked for two things that were impossible; one historian of games notes they were likely to be along the lines of "bring me the moon, or go to the opposite sides of the earth."[1] The third request, the one that really counted, was traditionally a kiss.

In the Charlottenburg *Pied-de-Boeuf,* Lancret chose the climax of the game, when the boy has caught the hand of his chosen captive, a lovely girl in blue and yellow, and is demanding his forfeit. Judging from the two fingers held up by the

100

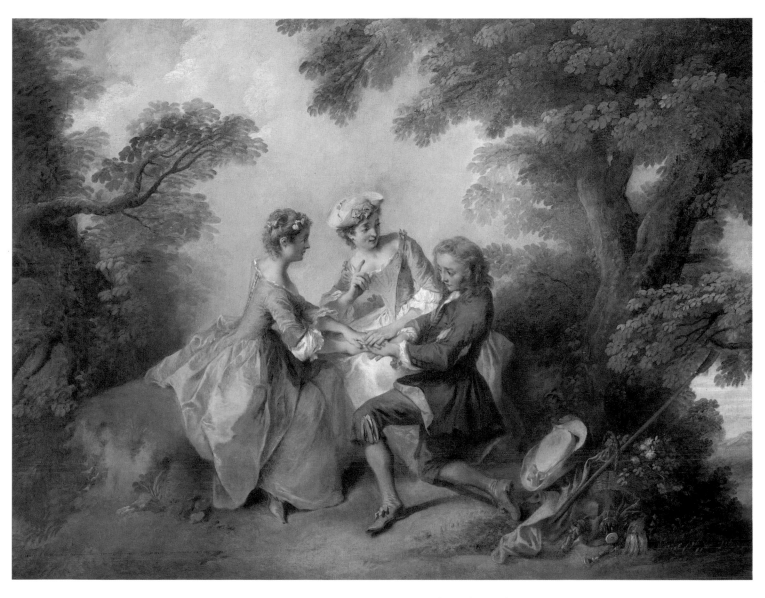

PLATE 24a. Lancret. *The Game of Pied-de-Boeuf.*

boy behind them, he seems to have reached the second question. In the present painting, Lancret depicts the moment just before the game has begun, when a young referee, stilling the eager hands on her knee, details the rules.

Lancret's favorite games are those with potential for flirtation, such as this one or, more patently, hide-and-seek, where an object is hidden on one player's person and another player searches for it. The children (or adolescents) playing these games are mimicking the courtship activities of adults, a common and traditional function of scenes of children in European art. Much coarser interpretations of *pied-de-boeuf* (and hide-and-seek) turn up in the print tradition. In one version, with particularly rustic, doltish participants, the accompanying inscription describes the situation: "Colin, playing with Lisette, knows well how to take his pied-de-boeuf. And I think that to the game of Love and such, he seems not exactly new." Colin covers his lap with his hat and draws the hand of his partner, Lisette, toward it.

Adults too sometimes played *pied-de-boeuf,* as in an engraving by Bernard Picart, where a young lady has claimed the hand of her choice, or in Jean-François de Troy's 1725 rendition, in which a gallant has seized his lady's hand and gazes longingly at her. But Lancret's children, on the edge of adulthood, explore their future in the harmless flirtation of an innocent game.

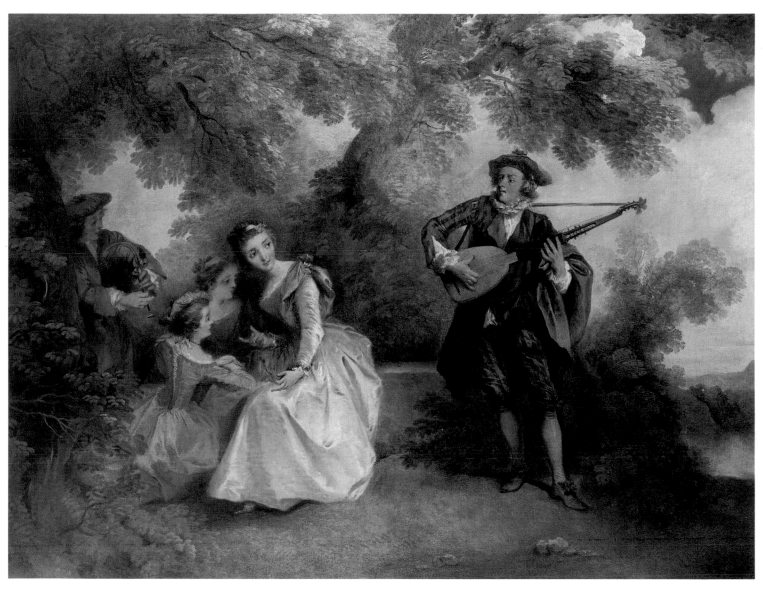

PLATE 24b. Lancret. *The Outdoor Concert.*

PLATE 25 CATALOGUE NUMBER 21

The Peepshow Man.

1743. Oil on panel, 52 x 77.5 cm.
Private collection.
Provenance: Frederick II; Peter Nathan,
Switzerland.
Bibliography: F. Nicolai, *Description des
villes de Berlin et de Potsdam,* Berlin, 1769,
p. 482; Oesterreich, no. 579; F. Rumpf,
*Beschreibung der aussern und innern Merkwür-
digkeiten der königlichen Schlösser in Berlin,
Charlottenburg, Schönhausen,* Berlin, 1794,
p. 264; P. Seidel, *Les Collections d'oeuvres d'art
français . . . ,* 1900, no. 42; Wildenstein,
no. 544.

Lancret's art always contained an element of robust naturalism that distin-
guished it from the more delicate images of the mature Watteau or Pater. In the
last eight years of his life he began to explore this aspect more fully. Though
idealized works remained the mainstay of his production, paintings began to
appear regularly that, in subject and treatment, exhibit a naturalism akin to that
of early Watteau (compare *The Country Dance* in the Indianapolis Museum of Art)
and to seventeenth-century Flemish painting (for example, the work of David
Teniers, who was highly popular in eighteenth-century France). Lancret's twelve
illustrations for the *Tales of La Fontaine,* a commission begun by Pater and picked up
by Lancret upon his death in 1736 (compare pls. 40, 41), reveal this trend clearly in
their broad humor and more realistic faces. The peasant festivities of the artist's
1737 *Wedding Meal* done for Fontainebleau (Musée des Beaux-Arts, Angers) are
equally robust and jolly.

The bawdy comedy of *The Peepshow Man* is firmly in this same spirit. At a
country fair, with tents and performers visible in the background, a group of village
girls gathers around a dark Savoyard, curious to view the exotic scenes inside his
magic peepshow box. Ignoring these maids, the licentious Savoyard concentrates
instead on a smiling coquette standing with hands on hips. As they leer at one
another across the box, a loutish youth, her discarded lover or husband, gapes at
them across his donkey's saddle, the symbol of his cuckolded state. Lancret's zest for
this amorous byplay recalls his scene of *Old Age* in London (fig. 5b), where an old
man takes his chance with a much younger girl while his virtuous wife sleeps at a
spinning wheel.

Savoyards appear frequently in eighteenth-century art, with and without
peepshow boxes. These itinerant natives of Savoy wandered across Europe, making
their living at a wide variety of jobs. As entertainers at fairs, they featured
performing marmots, hurdy-gurdy music, and the peepshow box. Watteau drew
and painted them with marmots, and Boucher included a peepshow box in his 1736
designs for the Beauvais tapestry works, part of the *Italian Village Fêtes.* Drouais'
1758 portrait of the noble Choiseul children in The Frick Collection shows them
costumed as Savoyards, again displaying a peepshow box. And Greuze portrayed
them in several drawings. The peepshow itself typically contained changing scenes
of faraway places, battles, or theatrical performances.[1]

The Peepshow Man holds a special significance within Lancret's oeuvre, as it is a
close variant of the painting Ballot de Sovot says the artist was working on when he
died, and which Lancret claimed was the only one that ever truly pleased him. That
version, according to Ballot, included marmots, but his overall description resem-
bles this painting very clearly. *The Peepshow Man* is another in the large collection of
Lancret's works that belonged to Frederick the Great.

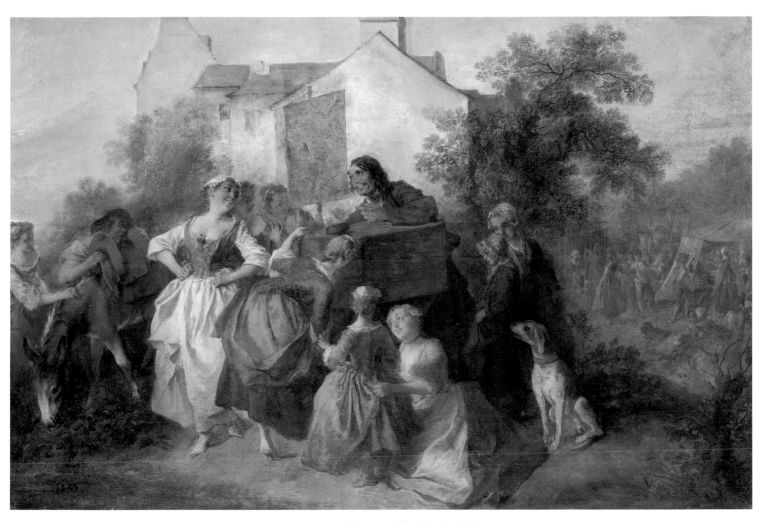

PLATE 25. Lancret. *The Peepshow Man.*

Lancret's Drawings

Like most eighteenth-century artists, Lancret was a prolific draughtsman. Some two thousand of his own drawings were found in his private collection at the time of his death, and to modern eyes his drawings are among his most beautiful works. In Lancret's day, drawing was considered indispensable both in the training and in the practice of art. Students at the Académie drew from the nude (so-called academic figures), drew copies of Old Master paintings, drew sculpture, drew in the open air, drew what were termed expressive heads, and drew their own invented compositions. In addition, virtually every eighteenth-century painter used drawings as an essential preliminary to his final work, developing compositions, landscapes or other settings, and full or partial figures. We also find drawings done for their own sake, with no particular finished product in mind; Gabriel de Saint-Aubin, for one, was primarily a draughtsman, and few paintings by him exist. By the eighteenth century, drawing had become valued as an art form in its own right, and connoisseurs were building impressive drawing collections.

Ballot de Sovot describes Lancret's avid drawing habits and relates Watteau's advice to the young Lancret: "He urged him to go

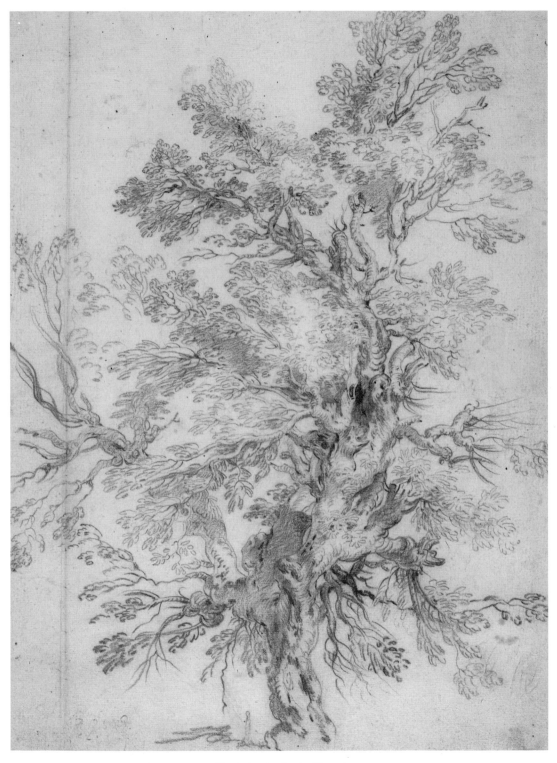

PLATE 26. Lancret. *Study of a Tree.* c. 1730.
Red chalk. British Museum, London.

sketching landscapes on the outskirts of Paris, then to draw some figures, and to combine them to form a painting of his own choice and imagination."[1] Ballot further notes, "All he saw on his walks were potential models; and it often happened that he would abandon his friends and go off to some vantage point to draw, to capture the overall look of a group or a figure that appealed to him."[2]

Of Lancret's surviving early drawings, little can be firmly tied to his studies at the Académie, despite the fact that over thirty academic nudes were catalogued in the sale of his collection held after his widow's death in 1782.[3] Such studies are notoriously difficult to attribute, and Lancret's are probably hidden away under some other artist's name, or in a box labeled "Eighteenth-century miscellany." Later in life, Lancret himself taught drawing at the Académie.

The vast majority of Lancret's extant drawings are—like Watteau's—figure studies, and many can be related to paintings. It was Lancret's practice to work on one or two figures in a drawing, often isolating a hand or head at one side for further reference. He rarely drew compositional studies, preferring to detach individual figures or couples. He did, however, occasionally use oil sketches to develop complete compositions, and several of these survive—among them the *Lit de Justice* (pl. 5) and *Concert in a Salon with Architectural Decoration* (pl. 6). Some sketches develop figures or heads that appear in more than one painting, a common enough practice of Lancret's day; Boucher too reused figures many times. Aside from figure studies, Lancret left little else. The British Museum's *Study of a Tree* (pl. 26) is the closest we have to a landscape drawing, despite the fact that the 1782 sale catalogue listed many others; though Lancret was not a painter of pure landscape, he did like to draw outdoors, and we should expect more from him in this vein.

Lancret's drawing medium and style have much in common with those of Watteau. Like his mentor, Lancret preferred chalk to pen-and-ink or pencil; his drawings are in red chalk, black chalk (often with white highlights), or, less frequently, in *trois crayons*—the three colors red, black, and white. Chalk is a subtle and adaptable

medium. Working with the sharp end allows great precision and delicacy, while the rounded end produces wonderful ranges of softness. Chalk can be smudged as well, and even its color can be varied by changing the pressure of the hand, from the palest light line to the darkest slash. Lancret mastered the full range of these capabilities. He would often sketch the first impression very delicately, then go over certain areas, especially the clothes, with much thicker, bolder strokes. His strokes tend to be broader and more angular than Watteau's, his figures heavier. When using *trois crayons*, he followed the customary practice of doing the flesh tones in red and using black and white elsewhere. Though his drawings often show more than one figure, or several parts of a figure, there is never the sense we have with Watteau that he is arranging the elements on the page for a specific compositional effect. Lancret simply moves over from the last image, finds an empty spot, and starts drawing again. Like Watteau, he rarely used blue paper; he preferred neutral paper colors such as ivory or cream, gray or light brown.

In drawing as in painting, Lancret quickly mapped out a distinctive territory for himself. While his drawings are often misattributed to Watteau or Pater, a close study finds them easily identifiable. The heads have Lancret's characteristic facial traits — wide eyes with heavy lids, broad cheekbones — and the flickering lines defining fingers and feet reveal the attenuated shapes familiar from his paintings. Most of all, however, it is in the bold and lively strokes that his authorship is revealed. Lancret drew with great vigor and enthusiasm. In much the same way that his paintings can be dated on stylistic grounds, his drawings can be placed in approximate chronological order by a general tendency away from the busy, more atmospheric approach of the early work of the 1720s toward a greater efficiency of line and simplicity of shading — his new mastery requiring fewer and fewer strokes to define a figure. Some of Lancret's later drawings, such as the *Kneeling Woman* (pl. 41), are almost stark in comparison with the flurry of strokes that created the *Gilles Embracing Columbine* of the early 1720s (pl. 29).

The Drawings

PLATE 27 CATALOGUE NUMBER 22

Study of Magistrates.

c. 1724. Red chalk on cream paper, 15.2 x
18.6 cm. The Snite Museum of Art, Uni-
versity of Notre Dame, Notre Dame,
Indiana, on extended loan as a promised
gift from Mr. John D. Reilly.
Provenance: A. Mouriau (Lugt 1853);
sale, Sotheby's, Monaco, December 2, 1989,
lot 160, to Cailleux.
Bibliography: None.

This study for Lancret's early *Lit de Justice* (pl. 5) reveals the softer side of red chalk.
With only a few dark accents, the drawing is done mostly in soft, round strokes,
creating a lush, velvety rose color perfect for the grandeur of the scene. The
emphasis is on the elaborate red robes lined in ermine and the lavish wigs of the
magistrates, who appear seated to the King's left in the final painting. A scene with
so many figures probably required a great many drawings; another one for these
figures is in San Francisco.

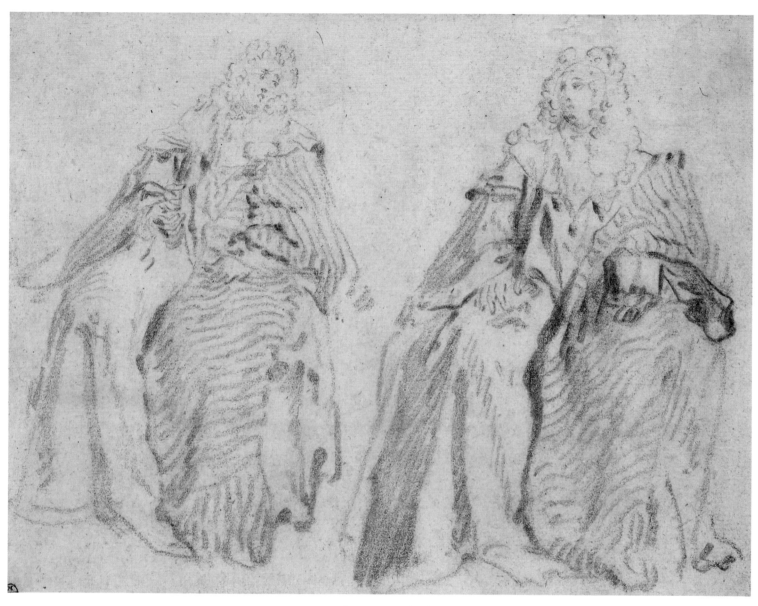

PLATE 27. Lancret. *Study of Magistrates.*

PLATE 28 CATALOGUE NUMBER 23

Couple Seated on the Ground, Looking at a Songbook.

c. 1720–25. Black and white chalk on light
brown paper, 25.4 x 33 cm. Mrs. A. Alfred
Taubman, New York.
Provenance: O. LeMay; private collection,
Switzerland; private collection, New York;
sale, Sotheby's, New York, January 13, 1989.
Bibliography: William H. Schab
Gallery, New York, 1987, *Important Old
Master Drawings and Two Paintings*, no. 16.

This unusual drawing is a perfect example of Lancret's ability to contrast texture and
stroke. The delicacy of the female figure — her head and torso sketched with the
lightest of touches, her skirt a silky cloud of white — plays against the tense, angular
strokes used for the anxious young man. Though the couple cannot be found in any
known painting, people looking at songbooks are frequent inhabitants of Lancret's
scenes — compare, for example, pl. 8.

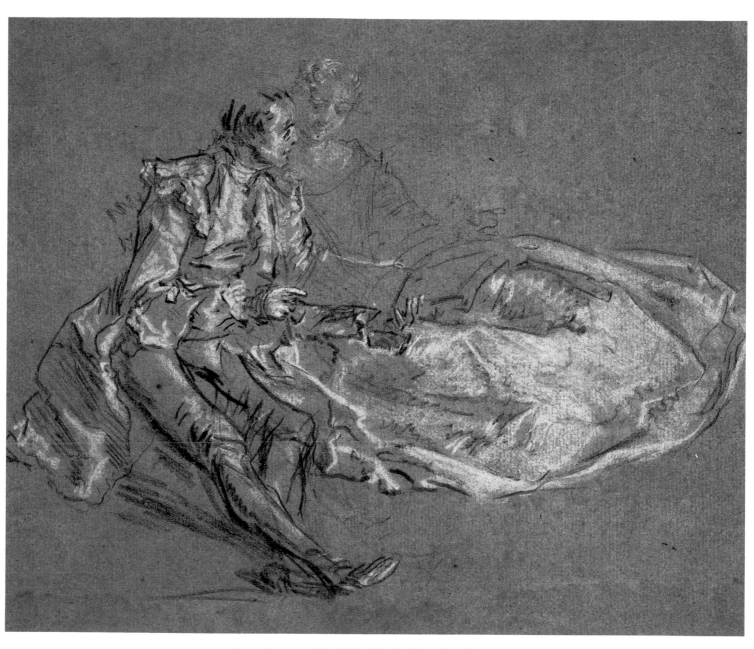

PLATE 28. Lancret. *Couple Seated on the Ground, Looking at a Songbook.*

PLATE 29 CATALOGUE NUMBER 24

Gilles Embracing Columbine, with Studies of His Head and Hand.

c. 1720–25. Black chalk with highlights in white and with touches of red on the study of the head, 19.2 x 20.9 cm. Patrick Perrin, Paris.
Provenance: A. Beurdeley (Lugt 421); his sale, Galerie Georges Petit, Paris, March 13–15, 1905, lot 118; Lehmann sale, Paris, June 8, 1925, lot 159; sale, Sotheby's, Monaco, December 2, 1989, lot 184, to Perrin.
Bibliography: Wildenstein, under no. 9.

Lancret's study for the couple seated on a bench in *Autumn* (pl. 10) is an excellent example of the busy, atmospheric style of his early work, perhaps as early as 1721. Long sweeping lines cover Columbine's gown, while a myriad of small strokes define her neck and Gilles' arm. The pose of Gilles is very close to that which Watteau employed for his *Mezzetin* in the Metropolitan Museum of Art, New York, and Lancret might well have been inspired by that figure. Watteau's painting is usually dated 1718–20.

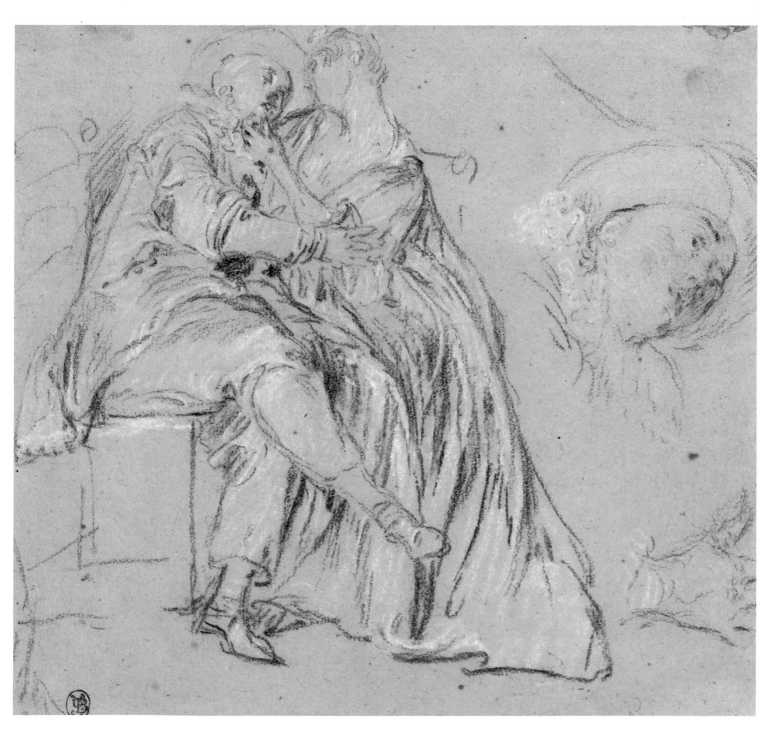

PLATE 29. Lancret. *Gilles Embracing Columbine, with Studies of His Head and Hand.*

PLATE 30 CATALOGUE NUMBER 25

Two Studies of a Guitar Player in Turkish Costume.

c. 1728. Red chalk on buff laid paper, 22 x 30.8 cm. The Art Institute of Chicago, Helen Regenstein Collection, no. 1971.530. Provenance: Andrea Kruger, Potsdam; Andreas Ludwig Kruger, Potsdam; Carl Kruger, Potsdam; Adolphe Stein, Paris. Bibliography: H. Joachim, *Liber Amicorum Karel G. Boon*, Amsterdam, 1974, pp. 102–03; H. Joachim, *The Art Institute of Chicago: French Drawings and Sketchbooks of the Eighteenth Century*, Chicago, 1977, no. 1F8.

This study of one of Lancret's favorite and most famous characters, the Amorous Turk (compare pl. 8), is typical of his early drawing style. The artist gave the exotic costumes his closest attention, going over them with layers of chalk, accenting and embellishing; in comparison, the small heads are only delicately indicated. Lancret experimented here with two poses for the Turk — the more common one, with his guitar hanging unplayed and arms akimbo, and the rarer depiction of the Turk actually strumming the guitar. None of the painted versions shows the instrument being played.

This drawing and the Chicago *Two Small Girls* (pl. 36) come with an interesting history, having been owned by three generations of the Kruger family in Potsdam. Andreas Ludwig Kruger (1743–1822), an architect and painter, lived from the age of nine with his uncle Andrea, an associate of Georg Wenzeslaus von Knobelsdorff (1699–1753), the architect and adviser to Frederick the Great. It has been suggested that the drawings were originally owned by Knobelsdorff, whose estate Andrea inherited, and that Knobelsdorff had also obtained certain Lancret paintings for the King, who was one of Lancret's most enthusiastic patrons. From Andreas the drawings passed to his son Carl (1776–1828), who recorded them as works of Watteau.

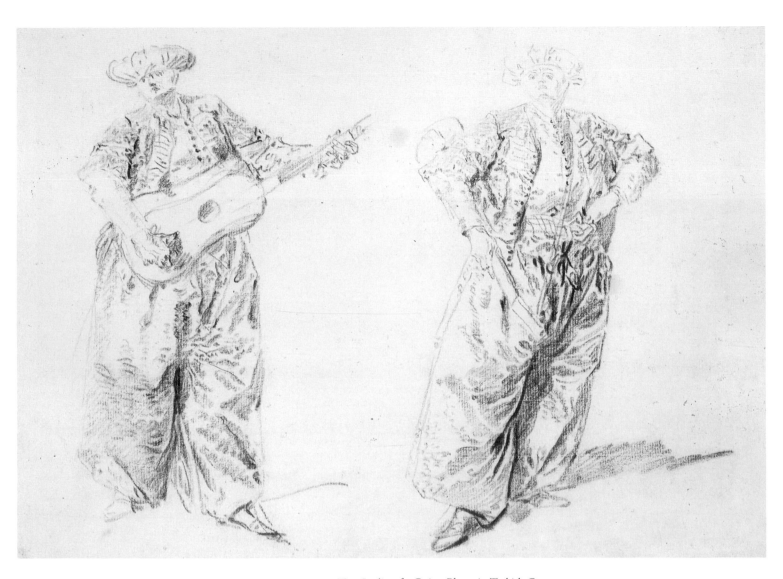

PLATE 30. Lancret. *Two Studies of a Guitar Player in Turkish Costume.*

PLATE 31 CATALOGUE NUMBER 26

Guitarist in Turkish Costume.

c. 1728. Red chalk with traces of pen and
brown ink on ivory paper, 21.5 x 16.8 cm.
Musée du Louvre, Paris, Département
des Arts Graphiques, inv. 27.539.
Provenance: Collector's mark of F. Rénaud
(Lugt 1042); Saint-Morys; seized by the
State.
Bibliography: Wildenstein, under no. 684;
Musée du Louvre, Paris, Cabinet des
Dessins, 1987, *Dessins français du XVIIIe
siècle de Watteau à Lemoyne,* no. 139.

In this splendid study of a Turk, Lancret imbues a potentially static figure with
swagger and brio through the turn of the body and the tilt of the head, and by a
blanket of dense red chalk-strokes typical of his production in the 1720s. He often
reworked parts of his drawings, using thick, aggressive strokes to emphasize details
and add intensity to shadows. The lines are short and terse, unlike the supple,
rounded ones we see in Watteau.

The Louvre drawing is related to the figure called the Amorous Turk who
appears in several paintings by Lancret — for which see pl. 8. It has been suggested
that this drawing and a similar sheet in the Art Institute of Chicago are linked most
closely to one of Lancret's earliest versions of the figure, in his decorations for the
salon of the Hôtel de Boullongne, Paris (now in the Musée des Arts Décoratifs).
However, as Lancret's painted Turks have mustaches and their guitars are not played
but simply hang from a strap, it is difficult to connect these drawings to any of the
painted versions.

The Louvre drawing has been attributed at various times to Watteau and then
to Pater, but both attributions are equally unlikely.

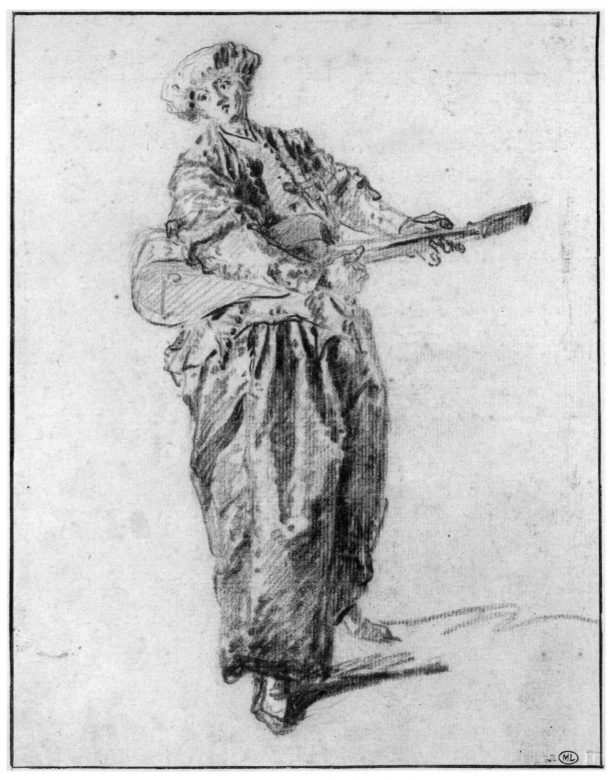

PLATE 31. Lancret. *Guitarist in Turkish Costume.*

PLATE 32 CATALOGUE NUMBER 27

Seated Figure and Standing Figure.

c. 1720–25. Black, red, and white chalk
on cream paper, 18.3 x 29.5 cm. National
Gallery of Art, Washington, D.C., gift of
Myron A. Hofer in memory of his mother,
Mrs. Jane Arms Hofer, no. 1944.9.1.
Provenance: Goncourt sale, Hôtel Drouot,
Paris, February 15, 1897, lot 146;
Frédéric Villot.
Bibliography: Metropolitan Museum of
Art, New York, 1959, *French Drawings
from American Collections*, no. 63.

This elegant early drawing of two women costumed *à la grecque* is not related to
Lancret's development of his stock character the Beautiful Greek as an isolated
figure, but to two paintings where she joins others in a *fête galante*. The standing
figure is very close to the Beautiful Greek in the Rohatyn painting (pl. 8), except that
her arms are gesturing in the opposite direction. The seated woman is preparatory
to a painting in the Fitzwilliam Museum, Cambridge, where the Beautiful Greek is
accompanied by two men, not by the customary Amorous Turk.
There is a similar drawing, with one seated figure of the Beautiful Greek, in the
Boston Museum of Fine Arts; both drawings have the softer, more atmospheric
touch of Lancret's work in the first half of the 1720s. The Washington drawing was
engraved by Jules de Goncourt.

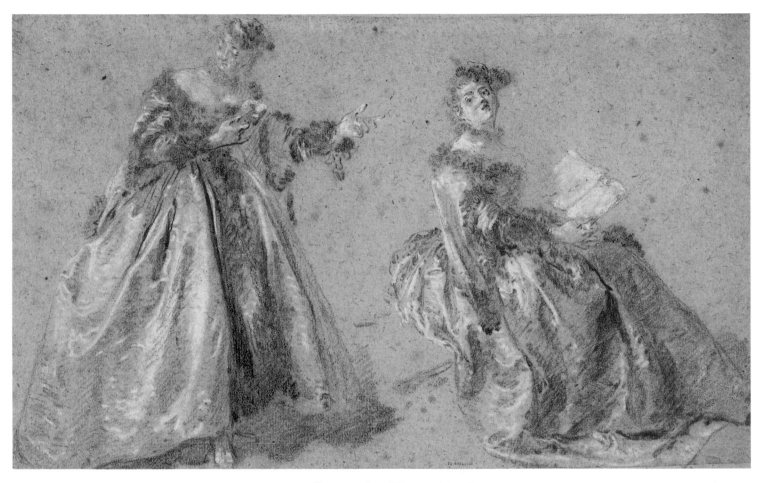

PLATE 32. Lancret. *Seated Figure and Standing Figure.*

PLATE 33 CATALOGUE NUMBER 28

The Skater.

c. 1730. Red chalk on cream paper, 20.6 x
12.9 cm. The Fine Arts Museums,
San Francisco, Achenbach Foundation for
Graphic Arts Purchase, 1964.133.
Provenance: William Pitcairn Knowles,
Rotterdam and Wiesbaden (Lugt 2643);
probably Jacques Doucet sale, Hôtel
Drouot, Paris, May 16–17, 1906, lot 29, as
one of two studies framed together;
Schaeffer Gallery, New York, 1964.
Bibliography: Baltimore Museum of Art,
1959, *The Age of Elegance*, no. 60; University of California at Los Angeles Art
Gallery, 1961, *French Masters, Rococo to
Romanticism*, no. 20; University Art
Museum, Berkeley, 1968, *Master Drawings
from California Collections*, no. 12; E.G.
Troche, "Some Recent Acquisitions of the
Achenbach Foundation for Graphic Arts,"
*Bulletin of the California Palace of the Legion of
Honor*, XXII, nos. 7–8, November–
December 1964, n.p.; P. Hattis, *Four Centuries of French Drawings in the Fine Arts
Museums of San Francisco*, 1977, no. 70.

Hattis suggests that *The Skater* is a study for the man helping a woman to her feet in the *Winter* scene of the *Four Seasons* done for the King's hunting lodge at La Muette (now in the Louvre). This is unlikely; not only is the action different, but the man in the drawing is dressed in very plain clothes, far from the fur-trimmed aristocratic garments worn by the skaters in *Winter*. This fellow would not fit in. Furthermore, the figure style, marked by an extremely small head and wide hips, indicates an earlier date, around 1730. At the start of his career, around 1720, Lancret painted two scenes showing a man pushing a sled, but those figures are in near profile, unlike the frontal view we see here. In *The Skater*, Lancret has isolated the figure, which is typical of his drawing method; he very rarely includes much context, preferring to study the movement of the figure by itself.

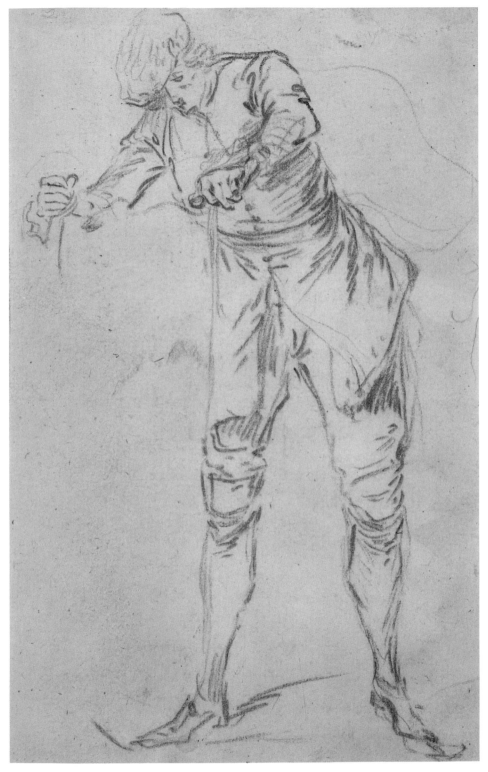

PLATE 33. Lancret. *The Skater.*

PLATE 34 CATALOGUE NUMBER 29

Man with a Bagpipe, and Two Studies of a Hand.

c. 1725–30. Black chalk on gray
paper, 23.7 x 16.7 cm. Private collection,
New York.
Provenance: Paul Weis, New York.
Bibliography: None.

Though it has not been connected to a particular painting and bears no date, this drawing appears to be a work of the late 1720s, resembling *The Skater* (pl. 33) in its figural treatment and in its style. Both men have the small heads and wide hips typical of Lancret's transitional period, and in the use of chalk the drawings fall between his soft and busy early manner and his stark late style. The handling is deft and sure, neither overworking the figure nor stripping it so bare as in the later drawings. Men playing bagpipes recur frequently in Lancret's painted work, but none appear to relate directly to this drawing.

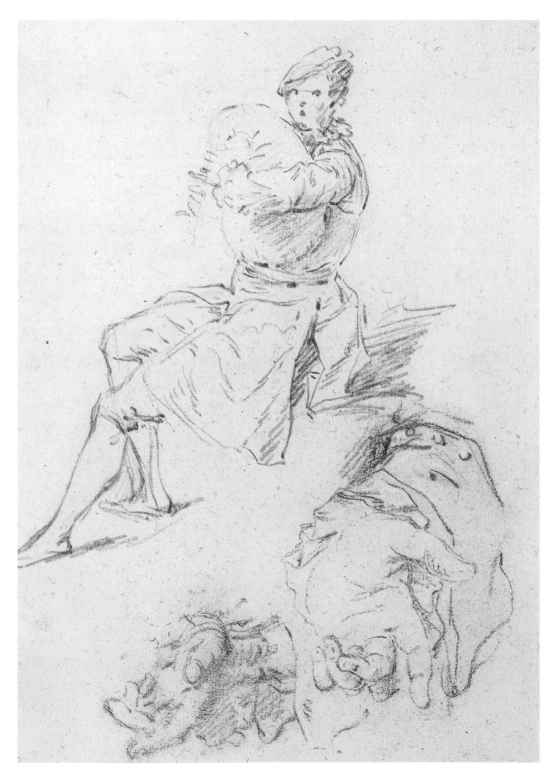

PLATE 34. Lancret. *Man with a Bagpipe, and Two Studies of a Hand.*

PLATE 35 CATALOGUE NUMBER 30

Study for the Picnic after the Hunt.

c. 1725–30. Black chalk heightened with
white on gray paper, 15.9 x 14.2 cm.
Bibliothèque Municipale, Rouen.
Provenance: Hédou bequest (Lugt 1253).
Bibliography: Musée des Beaux-Arts,
Rouen, 1929, *Exposition d'art du XVIIIe
siècle*, no. 140; Bibliothèque Municipale,
Rouen, 1970, *Choix des dessins anciens*, no.
20; P. Rosenberg and F. Bergot, *French
Master Drawings from the Rouen Museum
from Caron to Delacroix*, 1981, no. 63.

This elegant study is in preparation for the reclining foreground figure in the
Picnic after the Hunt (pl. 13). In the painting the man offers a biscuit to a dog,
but here Lancret characteristically omits the animal. The position of the man's arm
has been slightly changed. A drawing of great confidence, this sheet dates from
the late 1720s.

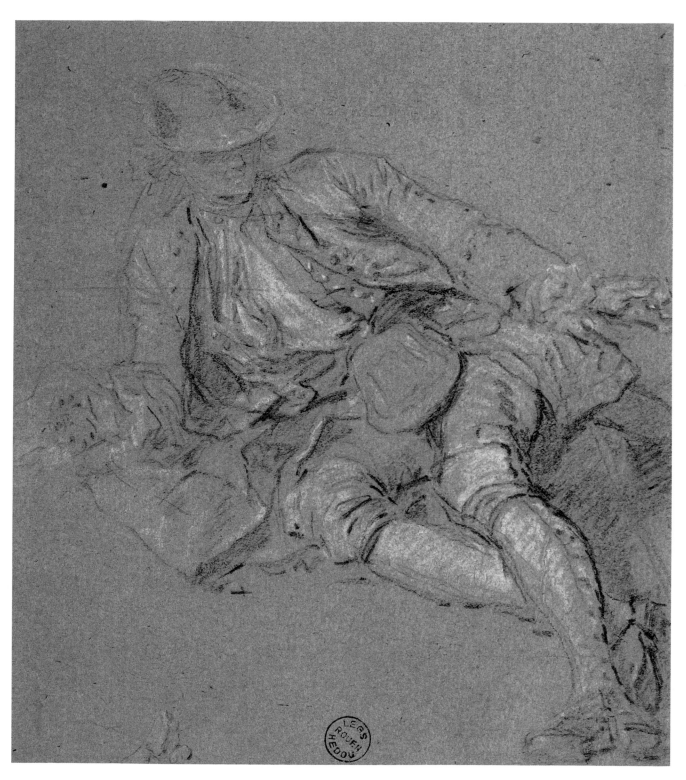

PLATE 35. Lancret. *Study for the Picnic after the Hunt.*

PLATE 36 CATALOGUE NUMBER 31

Two Small Girls.

c. 1725. Red chalk on ivory paper, 20 x
24.4 cm. The Art Institute of Chicago,
Helen Regenstein Collection, no. 1971.527.
Provenance: Same as for pl. 30.
Bibliography: Musée du Louvre, Paris,
1976–77, *Dessins français de l'Art Institute of
Chicago de Watteau à Picasso*, no. 5.

One of Lancret's most engaging drawings, the Chicago sheet exhibits a perfect
harmony between delicate chalk-work and charming subject matter. It is a
preparatory sketch for the two little girls in the foreground of the Dresden *Dance
between Two Fountains* (pl. 12).

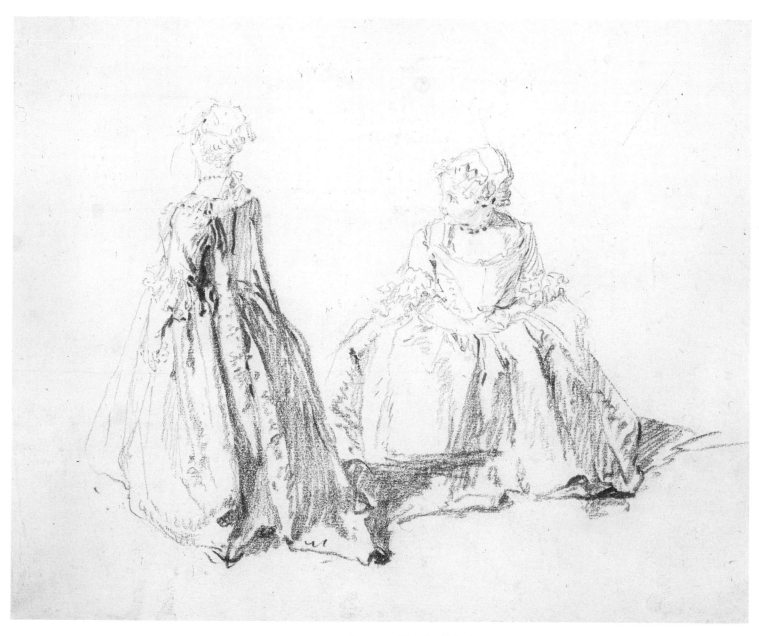

PLATE 36. Lancret. *Two Small Girls.*

PLATE 37 CATALOGUE NUMBER 32

Two Studies for the Luncheon with Ham.

c. 1735. Red chalk on cream paper, 18.6 x
25.2 cm. The Pierpont Morgan Library,
New York, purchase, bequest of
Mrs. Herbert N. Strauss, no. 1985.11.
Provenance: Defer-Dumesnil sale, Paris,
May 10–12, 1900, lot 168; H. Haro sale,
Paris, February 3, 1912, lot 44; Walter Burns
sale, Sotheby's, London, March 22, 1923,
lot 8; Mrs. D.C. Stralem, New York.
Bibliography: Wildenstein, no. 73; Metro-
politan Museum of Art, New York, 1959,
French Drawings from American Collections,
no. 62; Grasselli, 1986, p. 385.

These studies for the *Luncheon with Ham* (fig. 1) and *Luncheon Party in the Park*
(pl. 14) provide further examples of Lancret's maturing drawing style, with its spare
angular strokes and omission of superfluous elements. In describing the man with
his foot on the table, for example, Lancret uses only the smallest notation to indicate
the table top. Grasselli has compared its efficient style to that of another sheet in The
Pierpont Morgan Library, the *Hurdy-Gurdy Player*, one of Lancret's rare drawings on
blue paper. The present studies are remarkably expressive of the group in the
painted composition: the seated man spreads out in an expansive triangle of huge
napkin and widely set legs, vividly evoking ease and good humor, as the standing
man pours wine from his precarious perch on a chair.

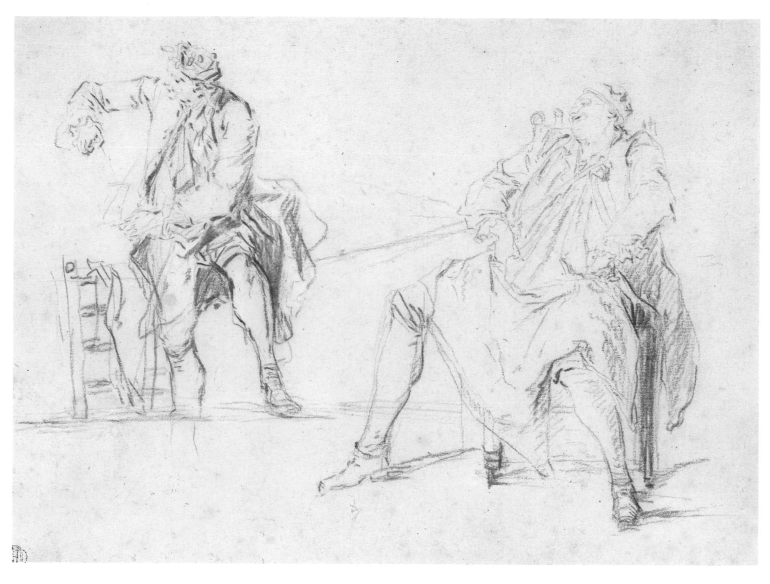

PLATE 37. Lancret. *Two Studies for the Luncheon with Ham.*

PLATE 38 CATALOGUE NUMBER 33

Three Studies of the Head of a Turbanned Black Man.

c. 1720. Black and red chalk with stump-
ing, heightened with white chalk, on pale
brownish-gray laid paper, 17.5 x 27.7 cm.
The Art Institute of Chicago, restricted gift
of the Regenstein Foundation, no. 1987.58.
Provenance: Sale, Sotheby's, New York,
January 16, 1985, lot 95.
Bibliography: None.

This fine drawing, so compelling in its focus on the head, is a preparatory study for a painting entitled *The Negro and the Kitchen Maid* (formerly Wildenstein, Paris). Lancret's successful adoption of the *trois-crayons* method was never put to more effective use. Though we might expect the black skin of the subject to be rendered in black chalk, Lancret used red for the flesh, relying on the features to indicate the man's ethnic heritage. It is instructive to compare this sheet with drawings by Watteau of black subjects, such as the famous one in the Louvre. Both portray the same head in three positions, and both employ *trois crayons*. Lancret, in keeping with his general drawing style, uses a static and straightforward placement on the sheet, unlike Watteau's rhythmic arrangement. Watteau's application of the chalk is more lush and uses a great deal of black for the skin color. Lancret's technique is tighter and more angular, tending to flatten the form; his heads appear less rounded than Watteau's.

A drawing by Lancret of the same model, shown full-length from two viewpoints, was in the Hermitage Museum (sale, Boerner, Leipzig, April 29, 1931, lot 145), and a replica of the Chicago drawing is in the Staatliche Museen, Berlin-Dahlem.

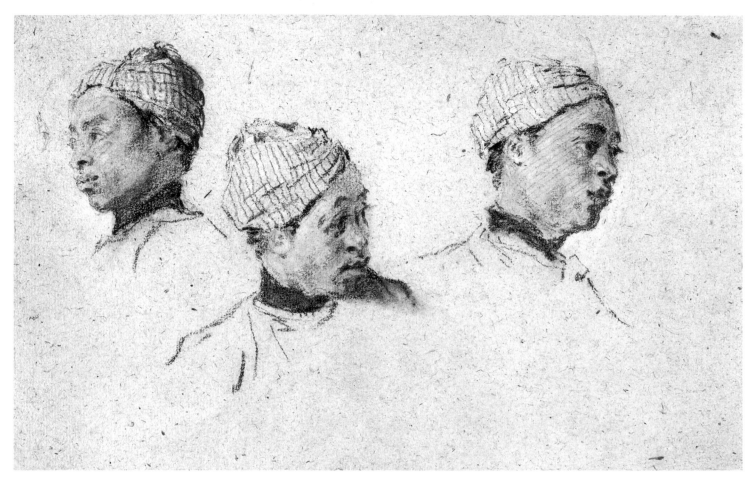

PLATE 38. Lancret. *Three Studies of the Head of a Turbanned Black Man.*

PLATE 39 CATALOGUE NUMBER 34

Seated Woman.

c. 1739. Red chalk on cream paper, 16 x
14 cm. Private collection, New York.
Provenance: Cythera Fine Arts,
New York, 1982.
Bibliography: None.

This drawing for the seated figure in the *Midday* scene of the London *Four Times of Day* (pl. 20b) is remarkable for the delicate precision with which the artist uses his red chalk. Lancret deftly indicates the shadows cast on the woman's face and in the folds of her clothes. In its masterful and efficient handling, the drawing typifies his late style. The finished painting shows a fan in the woman's hands and slightly alters the positions of her arms.

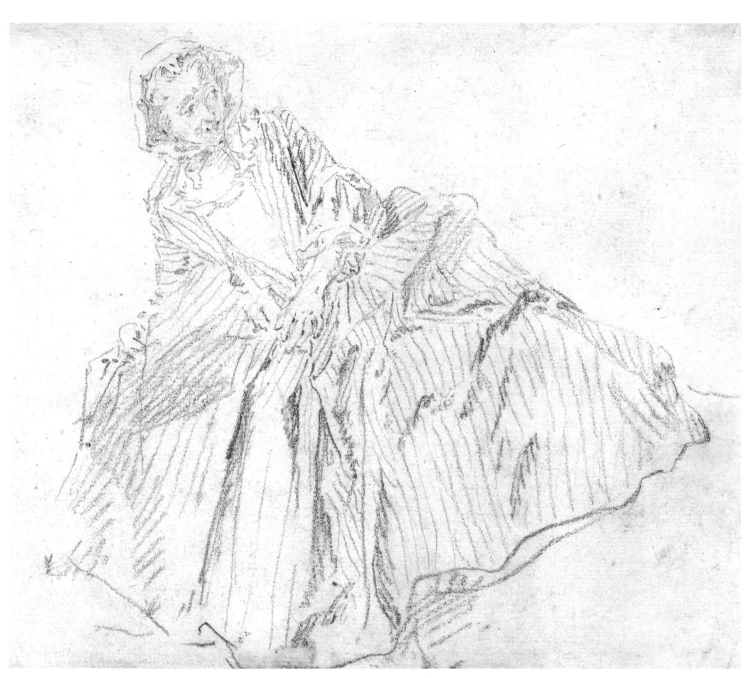

PLATE 39. Lancret. *Seated Woman.*

PLATE 40 CATALOGUE NUMBER 35

Two Studies of a Nun.

c. 1737–39. Black, red, and white chalk
on tan paper, 26.4 x 29.8 cm. Musée
du Louvre, Paris, Département des Arts
Graphiques, inv. 27.541.
Provenance: Saint-Morys; seized by
the State.
Bibliography: Wildenstein, under no. 652;
Musée du Louvre, Paris, Cabinet des
Dessins, 1987, *Dessins français du XVIIIe
siècle de Watteau à Lemoyne,* no. 140.

Lancret did a brilliant group of drawings in preparation for his twelve paintings of
scenes from the *Tales of La Fontaine.* He began the illustrations in 1736 or 1737, to
complete a series started by Pater and left unfinished on the latter's death in 1736.
This scene, of a nun flogging a man who broke into her convent, is from the twelfth
story of Book IV. Another study for the scene, showing the figure of the man tied to
a tree, is in the Boymans-van Beuningen Museum, Rotterdam.

One of the most impressive of Lancret's later drawings, this example is typical
in the masterful brevity with which he describes the figures, using no extraneous
lines.

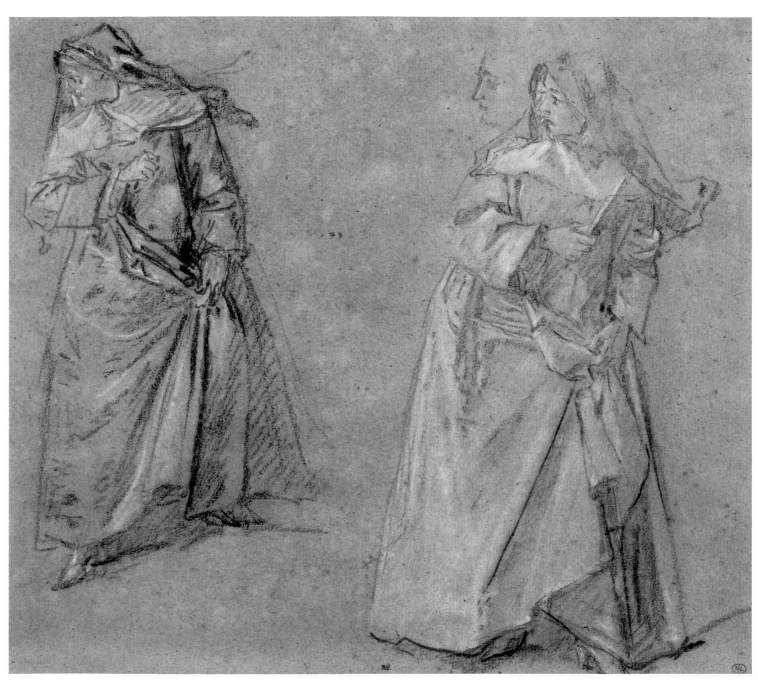

PLATE 40. Lancret. *Two Studies of a Nun.*

PLATE 41 CATALOGUE NUMBER 36

Study of a Kneeling Woman.

c. 1739. Red chalk on ivory paper, 12 x
16 cm. Private collection, France.
Provenance: Unknown.
Bibliography: None.

This sensitive study of an older woman resembles, in the delicate touch used on the face, Lancret's studies for the sleeping woman in the London *Old Age* (see fig. 5b). The clothes and hands are emphasized with his typical angular dark strokes, employed here to enhance the crumpled effect of the woman's skirt as she kneels. Another in the group of preparatory drawings done for Lancret's illustrations to La Fontaine, this one is impressive in its simplicity and in the incisive sureness of its line; we see here not the soft atmospheric chalk of the 1720s — compare the *Magistrates* (pl. 27) — but clear lines of great precision.

The tale to which the drawing relates, the thirteenth story of Book III, is set in Mantua and involves Argie, wife of the departed Anselme, who receives her lover Atis in the guise of a pilgrim. The two are aided in this liaison by the fairy Manto, who has taken the form of a spaniel capable of producing jewels and coins when it shakes itself. Lancret's finished painting, in which our figure appears as Argie's maid, is now in the Wallace Collection, London. Another drawing for the same painting, showing a girl stringing beads, is in the Fogg Art Museum, Cambridge.

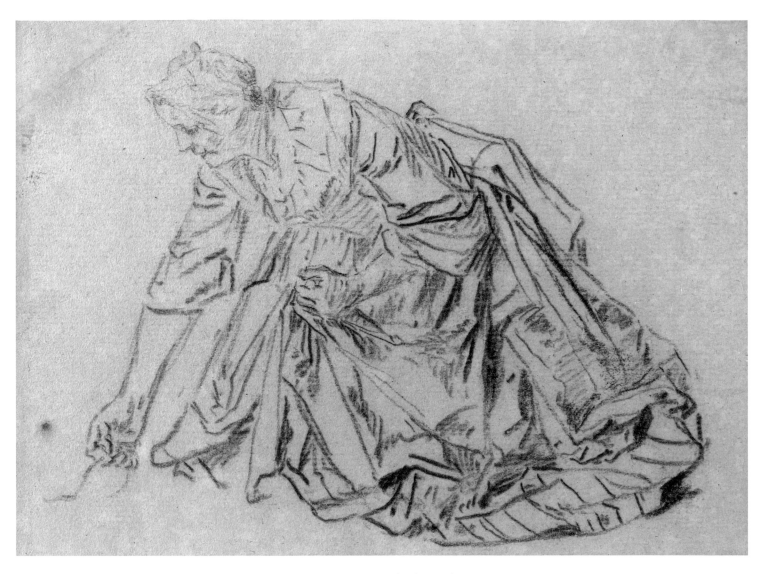

PLATE 41. Lancret. *Study of a Kneeling Woman.*

PLATE 42 CATALOGUE NUMBER 37

Studies of an Actor.

1739. Black, red, and white chalk on gray
paper, 26.4 x 21.7 cm. The Fine Arts
Museums, San Francisco, Achenbach
Foundation for Graphic Arts Purchase,
Georges de Batz Collection, 1967.17.4.
Provenance: Jacques Mathey, Paris;
de Batz Collection; Achenbach Foundation
purchase 1967.
Bibliography: Chevalier de Neufville de
Brunabois Montador, *Description raisonnée
des tableaux exposés au Louvre, 1739, Lettre à
Mme la Marquise de S.P.R.*, Bibliothèque
Nationale, Collection Deloynes, p. 187;
P. Hattis, *Four Centuries of French Drawings
in the Fine Arts Museums of San Francisco,*
1977, no. 71.

The subject of this drawing has been identified as the actor Grandval, the pose
and costume seeming to relate it to Lancret's portrait of him (pl. 21). As Hattis
suggests, however, the figure is much closer to another depiction of an actor by
Lancret, one included in a scene from a contemporary production of the play
Le Glorieux by Destouches. Lancret did three such paintings, the others being
from Thomas Corneille's *Comte d'Essex* and Destouches' *Philosophe marié* (the latter
work a pendant to *Le Glorieux*, with which it was exhibited in the Salon of 1739).
The painting of *Le Glorieux*, showing a moment from the third scene of Act 3, is
known today only from the engraving by Nicolas-Gabriel Dupuis. The San Fran-
cisco drawing relates to the man standing at the left, turned slightly with one hand
outstretched. The position of the hand, the hat held under the arm, and the tied-back
hair clearly mark the drawing as preparatory for that figure — who is, of course,
reversed in the engraving.

A contemporary observer, seeing the painting of *Le Glorieux* in the Salon,
insisted that all the actors could be identified. According to his account, this figure
portrays the actor Abraham-Alexis Quinault (called Quinault-Dufresne), while the
central figure in the painting represents Grandval.

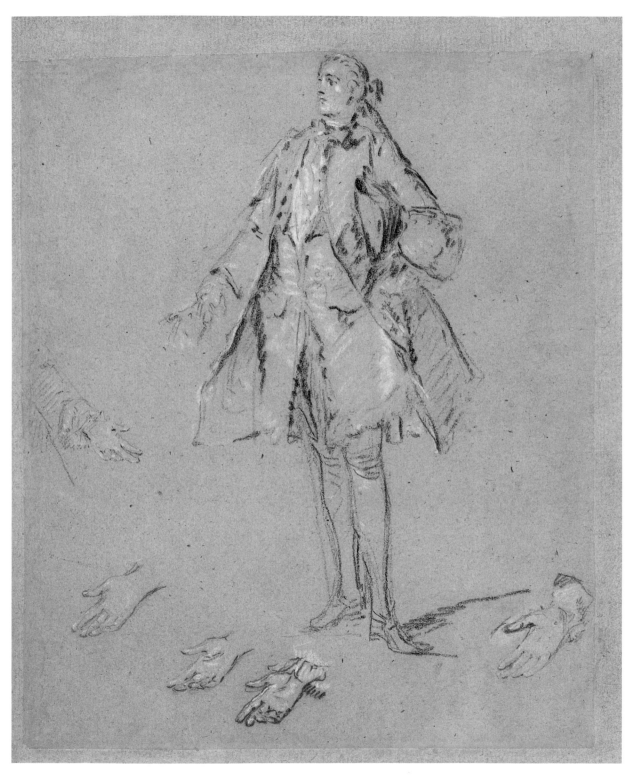

PLATE 42. Lancret. *Studies of an Actor.*

Notes to "Lancret and His Time"

1. J. and E. de Goncourt, *L'Art du Dix-huitième Siècle,* Paris, 1880 (3rd ed.), I, pp. 38–39, 52.

2. Levey, p. 23.

3. See Grasselli, Rosenberg, and Parmentier, p. 40.

4. On this see Engerand, pp. xliv–xlix. Engerand lists the following commissions for Lancret: 1727, *The Accident at Montereau;* 1735, *The Luncheon with Ham* (see our fig. 1); 1736, *The Tiger Hunt* (our pl. 15); 1736, two pastorals for the *petits cabinets* of the Queen at Versailles; 1737, *The Four Seasons* for the King's hunting lodge at La Muette; 1737, three pastorals for Fontainebleau; and 1743, four *fêtes galantes* and pastorals (actually five) for Versailles. See also Engerand's pp. 262ff. Dézallier d'Argenville, 1762, IV, p. 234, notes a further commission: "The King also ordered from him the paintings that decorated his dining room at Versailles and five others, including a representation of *The Fair at Bezons* and *The Four Corners of the Earth.* His Majesty afterwards presented these last paintings to the late M. le Comte de Toulouse." In the 1765 edition of his book Dézallier adds (p. 291) the following: "The King, who liked his style, ordered from him four overdoors, which are the rustic subjects that can be seen today in the Galerie d'Apollon. . . ." However, it is possible that by 1765 these paintings had simply been moved to the Galerie d'Apollon from another location, and that they do not represent an additional commission.

5. Much of this huge body of material can be found in the Cabinet des Estampes of the Bibliothèque Nationale, Paris, catalogued under the printers' names or collected in *Costumes du siècle de Louis XIV* (Oa 56 to 57 petit folio) and *Livre curieux des modes sous Louis XIV* (Oa 61 to 78 petit folio). Scholarship on these prints includes: A. Blum, *Abraham Bosse et la société française au dix-septième siècle,* Paris, 1924, and *L'Oeuvre gravé d'Abraham Bosse,* Paris, n.d.; F. Courbin, *Histoire illustrée de la gravure en France,* Paris, 1923; Louvre, Cabinet Edmond de Rothschild, *Modes et costumes français 1574–1815: Gravures et dessins,* Paris, 1966; V. Mayer, *L'Oeuvre gravé de Daniel Rabel,* unpublished master's thesis for the Sorbonne, Paris, 1979; M. Préaud, Bibliothèque Nationale, *Inventaire du fonds français; Graveurs du XVIIIe siècle,* Paris, 1980; J. Thuillier, "Poussin et ses premiers compagnons français à Rome," *Actes colloque Nicolas Poussin,* Paris, 1958, I, pp. 71–116; Versailles, Musée de Versailles, *Charles Le Brun 1619–1690: Peintre et dessinateur,* 1963, p. xxxx; R.A. Wiegert, *Bonnart: Personnages de qualité 1680–1715,* Paris, 1965.

6. See Mariette's *L'Été,* Cabinet des Estampes, Bibliothèque Nationale, Oa 76.

7. On this see E. Goodman-Soellner, *"Le Miroir Ardent:* An Emblematic Image of Love," *Simiolus,* XIII, no. 3–4, 1983, pp. 218–24.

8. Bibliothèque Nationale, Cabinet des Estampes, Trouvain, Oa 69.

9. Jal, p. 734.

10. Ballot de Sovot, p. 15; Jal, p. 734.

11. Jal (p. 734) identifies this master with Lancret's brother François-Joseph, who had

a studio on Rue de la Calande.

12. Ballot de Sovot, p. 15.

13. Dulin in fact studied not with Le Brun but with Sébastien Le Clerc, Bon Boullogne, and Friquet de Vauxrose. He won the Prix de Rome in 1696, was admitted to the Académie in 1707, and became adjunct professor in 1726. In 1710, he designed a tapestry depicting the *Establishment of the Invalides* for the series *The History of King Louis XIV.* His principal patron was the Duc de Richelieu. There is a useful essay on him by H. Hulst in L. Dussieux, *et al., Mémoires inédits sur la vie et les ouvrages des membres de l'Académie royale de Peinture et de Sculpture,* Paris, 1854, II, pp. 250–54. See also G. Janneau, *La Peinture française au XVIIème siècle,* Geneva, 1965, pp. 251, 270.

14. Illustrated in the catalogue *Trésors des Musées du Nord de la France IV: La Peinture française aux XVIIe et XVIIIe siècles,* Dunkerque–Valenciennes–Lille, 1980, p. 170.

15. See especially Janneau, p. 270.

16. Ballot de Sovot, p. 16.

17. Wildenstein, p. 45.

18. Montaiglon, IV, p. 69.

19. *Idem,* p. 70.

20. *Idem,* p. 76.

21. *Idem,* p. 124: "April 8, 1711 — Selection of the students who will compete for the Grand Prizes — Lancret, L'Eveillé, Le Moyne, Nepveu, De Laistre painters, Bourlot sculpt." The subjects were the story of Ruth and Boaz or the piety of Tobias. The judgment was on August 29, and Lemoyne won. On this competition, see J.-L. Bordeaux, *François Lemoyne (1688–1737): His Contribution to Illusionistic Ceiling Painting,* unpublished doctoral dissertation, University of California, Los Angeles, 1971, pp. 23–24. Bordeaux discusses Lemoyne's victory and asserts that "his closest competitor [was] Lancret." The Académie minutes state that the second prize went to "Adnet," which

is quite possibly a misspelling of Lancret's name — a common occurence; there was no Adnet listed in the competition. See also P. Grunchec, *The Grand Prix de Rome: Paintings from the École des Beaux-Arts 1793–1863,* Washington, 1984, pp. 25–27; the author thanks William Barcham for drawing this catalogue to her attention.

22. Gillot is today recognized chiefly as an artist who created a new theme but lacked the imagination to carry it to genius; he lived to see Watteau accomplish that. A native of Langres, Gillot had moved to Paris by 1695 and trained with the history painter and engraver Jean-Baptiste Corneille *le jeune.* He was *agréé in* 1710 and *reçu in* 1715 as a history painter. The bulk of his work, however, comprised theater scenes, costume and set designs, arabesque decorations, and book illustrations. Few paintings by him survive, the most famous being *The Two Carriages* and *The Tomb of Maître André (fig.* 6), both *commedia* scenes now in the Louvre. It has been pointed out by Dieckmann (M. H. Dieckmann, "Claude Gillot interprète de la Commedia dell'Arte," *Cahiers de l'Association internationale des Études françaises,* CXCVI, 1962, pp. 207–08) that Gillot sought to depict theatrical scenes as if they were set on stage, with the equivalent of flat backdrops. Populus *(passim)* indicates that Gillot made use of *commedia* themes primarily between 1704 and 1718, finding much inspiration at the Spectacles de la Foire after the expulsion of the Théâtre Italien in 1697. Gillot was ruined in the collapse of the Mississippi Scheme in 1720 and died in poverty in 1722. Though there has been a recent revival of interest in him, the principal sources of information on Gillot remain the 1930 monograph of Populus and É. Dacier's 1928 essay in Dimier *(op. cit.,* I). More recent information on Gillot, on his interest in the theater, and especially on his relationship to Watteau can be found in: Atlanta, High

Museum of Art, 1983, *The Age of Rococo*, no. 42; Bordeaux (see preceding note), pp. 43ff., nos. 132–134; and Eidelberg, 1973, pp. 232–39.

23. Dacier (in Dimier, I, p. 161) summarizes the remarks of Jullienne, the Comte de Caylus, and Gersaint on the date of the relationship between Watteau and Gillot, which Jullienne and Caylus place around 1710. Twentieth-century opinion varies: Populus (p. 21) suggests 1704–05 to 1708, while Mosby, in "Claude Gillot's Embarkation for the Isle of Cythera, and its Relationship to Watteau," *Master Drawings,* XII, 1974, p. 52, suggests 1703 to 1708. See also Eidelberg, 1973, pp. 232–39. Most recently, Posner (p. 47) places the beginning of the relationship in 1706–07 and notes that Watteau probably did not stay with Gillot for long. The two did not part as friends, and Watteau next joined the atelier of Claude III Audran.

24. Ballot de Sovot, p. 17.

25. Dézallier d'Argenville, p. 289.

26. Wildenstein, p. 10.

27. Mathey, pp. 175–76. According to Populus (pp. 22–23): "Some time later, perhaps around 1708, another artist, Lancret, came knocking on Claude's door, and this new pupil, like Watteau, would borrow from the painter... a taste for Italian comedy. The master's influence on the new pupil was no less than that on Watteau; but Lancret, too, would later enlarge the genre borrowed in this workshop and would take up especially the 'fête galante' that issued from the Italian comedy." Levey (p. 22) says Lancret became a pupil of Gillot around 1712–13.

28. C. Saunier, "Lemoyne," in Dimier, I, p. 63; Conisbee, p. 17.

29. Posner (pp. 33–38) points out that Watteau painted military scenes for three or four years beginning in 1709 or 1710. The earliest recorded example, *Return from the Campaign,* was sold to the dealer Sirois, who then com-missioned a pendant, *The Bivouac* of about 1710. "Through these pictures, seen in Sirois' shop," notes Posner, "Watteau's name started to be known and his works began to sell." *The Jealous Ones* of 1712, according to Posner, "announces a new phase in Watteau's career, when he become a painter of *fêtes galantes,* and when military scenes along with scenes of everyday life quickly disappeared from his work." Posner further states that "After 1712, he was increasingly busy meeting the demand for his work," and that by around 1715–16 "the reputation of the special genre Watteau had developed became widely established."

30. In 1962, Cailleux *(loc. cit.)* was able to assert: "All historians of Watteau agree that the paintings submitted... for approval by the Académie were: *Les Jaloux, Pierrot Content, Harlequin Jaloux,* and *La Partie Quarrée.*" And in 1970, Rosenberg and Camesasca (nos. 80–83) gave the same list. However, in the 1979 catalogue of the Thyssen-Bornemisza loan exhibition in Washington, Rosenbaum stated (no. 51) that *Pierrot Content* was not part of this group, but instead a close variant of *The Jealous Ones,* done on the heels of the success of the latter at the Académie. According to Posner (p. 65), "Among the drawings and paintings Watteau presented for judgement were *Retour de campagne* and *Le Camp volant,* which he would have borrowed from Sirois for the occasion, and *Les Jaloux.*"

31. Though Cailleux and Rosenberg and Camesasca include *The Foursome* among the presentation paintings (see preceding note), Posner (pp. 56–57) suggests it is one of three variants of the popular *The Jealous Ones,* and slightly later in date.

32. The engraving was announced in the *Mercure de France* for April of 1729 (p. 752): "M. Crépy *fils,* the printmaker on the Rue Saint-Jacques, recently engraved a very pretty subject entitled *The Joys of the Theater,*

after a small horizontal painting by M. Lancret showing eight figures with a landscape background." Wildenstein (no. 281) knew only the engraving. The treatment of the figures, their flat, weightless quality, and their awkward poses mark this painting as a very early work.

33. Posner (p. 13) provides some useful background on the new taste for genre painting around 1700: "Military victories and economic expansion had given way to defeats and hard times, and many people began to muse on the virtues of a modest, undemanding existence. . . . Sophisticated city dwellers liked to imagine the supposed happiness of their opposites, the country folk; hence the popularity at the time of pastoral poetry and pictures of rural life. Ancient writers, modern Italian and native French poets like Fontenelle could fill the needs of the literary imagination, but around 1700 it was still mainly Dutch and Flemish paintings and their imitations that pictured the rustic life. Many not so sophisticated people were also attracted to Netherlandish genre pictures." See also: O. Banks, *Watteau and the North,* New York, 1977, chaps. 1–3; A. Brookner, *Greuze,* London, 1972, chap. 3; and E. Snoep-Reitsma, "Chardin and the Bourgeois Ideals of his Time," *Nederlands Kunsthistorisch Jaarboek,* XXIV, 1973, pt. I, pp. 148–51, 158–62.

34. See Janson, I. The 1673 Salon had a modicum of landscape and still-life painting.

35. *Idem.* There were a few figural genre scenes in each Salon.

36. This Salon is often referred to as the "pseudo" Salon, as it is not listed in the records of the Académie and it lasted only ten days. However, it was sponsored and financed by the Académie, all the exhibitors were Academicians, and it was arranged by the *premier peintre,* Louis Boulogne *le jeune.* For further information and a reprint of the livrets, see *Salon de 1725, passim.*

37. Another member of Gillot's circle, Pierre-Antoine Quillard, has been characterized as Watteau's assistant from 1712 to 1714 by Eidelberg (1970, pp. 39–40). Mathey *(loc. cit.),* using as evidence a drawing for a figure in Gillot's famous *Two Carriages* that he asserts was done by Lancret from the model at the same time as Gillot was working towards the painting, suggests: "It is possible that Lancret had a hand in executing the picture; the quality of the painting, above all its coloring, argues in favor of this possibility." Mathey's position assumes an early date of about 1708 for Lancret's tenure with Gillot, as *The Two Carriages* is usually dated between 1707 and 1709.

38. Ballot de Sovot, p. 18; Gersaint, p. 192. Lancret heeded Watteau's advice. Ballot tells us (pp. 25–26) that he drew all the time, sometimes leaving his companions during walks to go off and sketch a figure that pleased him. He continued to draw from the model at the Académie even in winter, until it threatened his health. He then sketched in the theater, using actors and dancers as models. His passion for draughtsmanship is attested to by the great many of his own drawings that remained in his collection after his death—some two thousand. Lancret was *agréé* on February 26, 1718, with "several paintings in a particular genre" (Montaiglon, p. 261).

39. Lancret was *reçu* with a painting "representing a *fête galante"* (Montaiglon, p. 280). That painting was engraved in 1743 by J.-P. Le Bas for the latter's own *morceau de reception,* and the engraving reproduces the *Conversation Galante* in the Wallace Collection (pl. 2). The measurements of the London canvas do not match those given in the *Mercure de France,* but it is possible that the latter were incorrect or that once again Lancret replicated one of his own works. In any case, the composition and style are the

same. See: Wildenstein, no. 285; Ingamells, no. P. 422.

40. Ballot de Sovot (p. 19) describes the breakup: "M. Lancret exhibited in the Place Dauphine, on a certain day of the year when it is still the practice to do so, two paintings in the style of Watteau, which people believed were by Watteau himself and on which several of his friends complimented him. Such is what M. Lancret learned later, and it was only to this that he could attribute the cold reception Watteau gave him shortly afterward. All relations between them were broken off at that moment; and things remained on this footing until Watteau's death." Bellier de la Chavignerie omits any mention of this exhibition, which suggests that it predated the scope of his entries, begun in 1722. In his notes to Ballot's text *(loc. cit.),* Guiffrey questions the truth of this tale.

41. *Mercure de France,* June 1723, p. 1175. Eidelberg (1970, p. 63) suggests that Lancret was in fact Watteau's pupil: "Although we know little of the circumstances, it is quite probable that Lancret was also a pupil in his studio." The present author knows of no evidence to support this supposition.

42. De Troy was from an artistic dynasty. His father, François, was a successful portraitist under Louis XIV, and he himself worked as a portraitist as well as a history and genre painter. A prominent Academician, he served as Director of the French Academy in Rome from 1738 to 1752. See: G. Brière, "De Troy," in Dimier, II, pp. 1–74; and P. de Troy, *Une Famille de peintres aux 17e et 18e siècles: Les Detroy,* unpublished doctoral dissertation for the University of Algiers, 1955.

43. De Troy's *Game of Pied-de-Boeuf* was exhibited in the Salon in 1725 and engraved by C.-N. Cochin. A copy is in The National Gallery, London. It is interesting to note, without giving it undue weight, the choice of these two painters to decorate the dining room of the *petits cabinets* at Versailles, and the contrasting assignments they were given — Lancret providing the country debauch, and de Troy the city revelry; the contrast neatly reflects their varied talents.

44. De Bar was born about 1700 and died in 1729. When he was *reçu* in 1728, one of his submissions was the *Fair at Bezons* now in the Louvre, an attractive synthesis of the *fête galante* with Northern village fêtes like those of Teniers. De Bar was sponsored by Leriget de la Faye, one of Lancret's most important early patrons, and the two artists probably knew one another. De Bar died in Leriget's home. See: A. Valabrègue, "Petits Maîtres du XVIIIe siècle, Bonaventure de Bar," *Chronique des arts et de la curiosité,* 1905, n.p.; G. Huard, "Debar," in Dimier, I, pp. 295–300; and Levey, p. 25.

45. Octavien was *agréé* in 1724, was *reçu* in 1725 (also with a *Fair at Bezons* now in the Louvre), and died in 1740. Only eight paintings by him are listed by J. Messelet in the catalogue of his works published by Dimier (II, pp. 335–40). See also R. Rey, *Quelques Satellites de Watteau,* Paris, 1931, pp. 101–31, and Ingersoll-Smouse, p. 11.

46. Quillard, who was born in 1704 and died in 1733, has inspired a certain amount of interest owing to the continued confusion of his works with those of Watteau. The tentative attribution to him of two paintings in the Louvre traditionally given to Watteau — the *Planting of the Maypole* and the *Village Dance* — gave rise to a flurry of articles in the 1920s and 1930s. There is also confusion over two paintings in the Prado, Madrid — the *Contract* and the *Gathering before a Fountain of Neptune.* Quillard, who may well have known Lancret, seems to have made little impact in France; he left in 1726 to become court painter to John V in Lisbon, where he died. For a bibliography on Quillard see Eidelberg, 1970, and for a

recent appraisal see Grasselli, Rosenberg, and Parmentier, nos. P. 21, P. 22. Rosenberg is working on his drawings.

47. Chantereau is discussed by Rey (see note 45 above).

48. Mercier was born in Berlin in 1689 and trained under Antoine Pesne. He spent much of his working life in London and died in 1760. See Kenwood, Iveagh Bequest, Great Britain Arts Council, 1969, *Philip Mercier,* text and catalogue by R. Raines and J. Ingamells.

49. Gersaint, p. 197. The main source of information on Pater, including a catalogue of his works, is Ingersoll-Smouse.

50. Ingersoll-Smouse, p. 3.

51. *Idem,* p. 27. Pater's reception piece was the *Soldier's Merrymaking* of 1728, now in the Louvre (no. 397).

52. *Idem,* p. 7. Pater's only royal commission, and indeed his only painting owned by the Crown, was the *Chinese Hunt,* for which see pl. 15 of the present catalogue.

53. March 1728, p. 552, in an announcement of a sale of prints after Lancret.

54. *Mercure de France,* June 1730, p. 1184.

55. Ballot de Sovot, p. 21.

56. *Mercure de France,* August 1736, p. 1165.

57. For listings of the works on view at the Exposition de la Jeunesse as they were published in the *Mercure de France,* see Bellier de la Chavignerie. A good discussion of the Exposition, and of exhibition opportunities in general at the time, can be found in Conisbee, pp. 22–23.

58. A possible earlier entry is a small, circular painting on wood, *A Scene of the Italian Comedy,* which Wildenstein (no. 326) catalogues as signed and dated 1721. It was formerly in the collection of M.J.P. Heseltine, London, and the author has seen only a poor reproduction.

59. For which see Ingamells, no. P. 448.

60. For information on the Lit de Justice ceremony, see: F.-J.-B. Barbier, *Journal histo-*

rique et anecdotique du règne de Louis XV, Paris, 1847, I, pp. 166–67; and E. Lavisse, *Histoire de France illustrée,* Paris, 1911, VIII, pt. 2. For background on the Order of the Saint-Esprit, see Helyot, *L'Histoire des ordres religieux,* Paris, 1719, VIII.

61. T. Crow, *Painters and Public Life in Eighteenth Century France,* New Haven, 1985, pp. 40–41.

62. A contemporary copy of the letter in which the Duc d'Antin ordered the painting from Lancret in September of 1725 was found and published by P. Mantz ("Copie sur l'original envoyé par M. le duc d'Antin au Sr. Lancret," *Archives de l'art français,* I, 1851–52, pp. 301–03). Lancret received payment on October 10, 1727 (Engerand, pp. 262–63). See also A. Valabrègue, "Nicolas Lancret: Un Tableau commandé par le Duc d'Antin," *Nouvelles Archives de l'Art français,* 3e série, VIII, 1892, pp. 271–72.

63. Bellier de la Chavignerie, p. 16; Mariette, p. 55.

64. Ingamells, no. P. 488; Wildenstein, no. 137.

65. For more on this Salon, see note 36 above. Other useful information, including background on the rivalry of de Troy and Lemoyne, can be found in: C. Saunier, "Lemoine," in Dimier, I, pp. 73–74, nos. 31, 40, 47, 51; G. Brière, "De Troy," in Dimier, II, pp. 6–7; M. Florisoone, *Le Dix-huitième Siècle,* Paris, 1948, p. 42; Conisbee, p. 77; and J.-L. Bordeaux, in *The Rococo Age,* High Museum, Atlanta, 1983, p. 15. Lancret did not participate in the Concours of 1727.

66. *Salon de 1725,* pp. 46–47; Wildenstein, nos. 48, 156, 157, 447, 569.

67. *Salon de 1725 ,* pp. 48–49.

68. *Idem,* pp. 39–40.

69. Wildenstein (nos. 143, 156) has proposed that the Dresden *Dance between Two Fountains* can be identified with the 1725 *Dance in a Landscape,* though the measurements do not correspond. For the *Pleasures of the Bath*

now in the Louvre, which was once owned by Lancret's important early patron the Marquis de Béringhen, see M. T. Holmes, *Revue du Louvre*, 1991, no. 1, and Wildenstein, no. 433; *The Luncheon in the Forest* is Wildenstein's no. 444, and the *Portrait of a Man Playing the Cello* is his no. 578.

70. Ballot de Sovot, p. 26. Nougaret (II, pp. 224–25) phrases it similarly: "Lancret's sole dissipation was going to the theater."

71. Though Lancret is not mentioned as a visitor to this salon, we can assume that he was, on the basis of his friendship with Ballot, his interest in the theater and music, and his acquaintance with many of the principals in attendance. G. Cucuel, in *La Poupelinière et la musique de chambre au XVIIIe siècle,* Paris, 1913, discusses the establishment of the salon and provides much information on the visitors. Ballot's attendance began around 1730–31 (pp. 61ff.), the same time that Voltaire started appearing. Voltaire's letters mention Ballot frequently, calling him "Ballot l'Imagination," and attest to his liaison with Mlle. Sallé (*The Complete Works of Voltaire,* Geneva, 1969, II, letter to Thièriot, July 15, 1735).

72. Cucuel, pp. 63ff.; letter from Voltaire to Thièriot, April 14, 1732: "Yesterday M. Ballot came to see me and took me to M. Lancret's, where I saw a very pretty painting of the prettiest priestess of Diana who ever appeared on the stage. The portrait of Mlle. Sallé is what it should be, better than that of Camargo."

73. Jal, p. 274, *s.v.* Edme Boursault.

74. The two frontispieces had been known only through engravings (Bocher, nos. 72, 81; Wildenstein, nos. 711, 712), but one has been located in a private collection in the United States; both are for harpsichord compositions by Jean-François Dandrieu, organist of the King's chapel, and one is dated 1734. For the opera scenes, see Wildenstein, nos. 269, 763.

75. For the Comtesse de Verrue, who owned a *Pied-de-Boeuf* probably by Lancret, see: her sale catalogue, Paris, March 27, 1737, lot 45bis (catalogue reproduced and annotated by C. de Ris, Paris, 1863, p. 31); B. Scott, "The Comtesse de Verrue: A Lover of Dutch and Flemish Art," *Apollo*, 97, 1973, pp. 20–21; Wildenstein, no. 246. For the Prince de Carignan, who owned a *Ball* and a *Dance,* see the catalogue of his sale, Paris, 1743, lot 64. The Comte de Vence owned *The Undecided Shepherd,* according to the catalogue of his sale, February 9, 1761, lot 134; see also Wildenstein, no. 470. M. and Mme. Gaignat owned a *Dance in a Garden,* listed in their sale, Paris, February 14, 1769, as lot 55; see also Wildenstein, no. 189, and, for two portraits said to represent the couple, Wildenstein, nos. 570, 571. Mariette claimed that Jean de Jullienne owned two Lancrets, a *Ball* and a *Dance*; Wildenstein also lists two portraits, nos. 572 and 573, as representing Jullienne, and a further portrait, no. 574, as representing Jullienne with his wife. La Roque owned a Lancret kitchen scene with figures, listed in the Gersaint catalogue of his 1745 sale as lot 55 (Wildenstein, no. 535), and a "gallant subject" and its pendant, *Thieves Robbing a Traveler,* which appeared as lot 156 (Wildenstein, nos. 423, 560). Cottin favored Lancret's theater scenes and figures, including versions of *La Camargo* and *Mlle. Sallé* as well as *Le Glorieux* and *Le Philosophe Marié* (his sale, Paris, November 27, 1752). The Quentin de l'Orangère sale, Paris, March 4, 1744, included a "dance after Lancret" (lot 4; Wildenstein, no. 211) and "A large painting, a gallant subject, after the same" (lot 5).

76. Count Brühl owned *Women Bathing* (see: *Recueil d'estampes d'après les tableaux de la galerie de S.E.M. le comte de Brühl,* 1754, XXXVI, engraved by Moitte; Wildenstein, no. 429). The Elector of Cologne owned a set of twelve paintings that decorated an

entire salon (see *Catalogue de tableaux ... la plus grande partie venant de la vente de feu S.A. Electeur de Cologne,* December 10, 1764, Paris, lot 57). Catherine the Great owned *The Kitchen* (Wildenstein, no. 529), *The Gallant Valet* (Wildenstein, no. 530), a version of *La Camargo* (Wildenstein, no. 584), and *An Outdoor Concert* (Wildenstein, no. 336), all now in the Hermitage Museum. Louisa Ulrica owned *Fastening the Skate* (Wildenstein, no. 19), the *Game of Colin-Maillard* (Wildenstein, no. 229), and a version of *The Swing* (Wildenstein, no. 233), all now in the Nationalmuseum, Stockholm. For Frederick II, see the exhibition catalogue *La Peinture française du XVIIIe siècle à la cour de Frédéric II,* Louvre, Paris, 1963, nos. 7–15.

77. See note 4 above.

78. Ballot de Sovot, pp. 29–30; Dézallier d'Argenville, 1762, IV, p. 438.

79. See Janson, II, p. 129.

80. For the illustrations to the *Tales,* also known as the Larmessin Suite after one of their principal engravers, see: Ingersoll-Smouse, pp. 74ff.; Wildenstein, p. 19, pp. 113 ff.; A. Hédé-Hauy, *Les Illustrations des Contes de la Fontaine,* 1893, Paris.

81. Ballot de Sovot, p. 25.

82. Gersaint, p. 192. Dézallier d'Argenville (1745, p. 190) also commends his character: "A superiority of talent, a great love for his Art, and a lifetime of labor produced the quantity of works we have from his hand; his sincere and affable character and the simplicity of his ways won him the esteem of all fairminded people."

83. Mariette, III, p. 55.

84. Ballot de Sovot, p. 21.

85. Documents concerning the suit of June 25, 1731, and the award in favor of Lancret on March 17, 1732, are published in Wildenstein, pp. 50–52. When the pendant *Mlle.*

Sallé was published, the *Mercure de France* for April 1733 (p. 773) noted that it too was "highly successful, and gives viewers a great deal of pleasure."

86. The *Mercure de France* points this out repeatedly. To take but two examples: in July of 1735 (pp. 1612–14) it notes that the prints after Lancret's *Four Ages of Man* "are selling with great success"; and of the print after *Le Glorieux,* "which was exhibited at the Salon of 1739 to public applause," we are told (March 1741, pp. 567–68), "This print is selling well, and it deserves to." Mariette, X, p. 68, adds that the most popular prints in the mid eighteenth century were after Lancret, Chardin, Teniers, and Wouwerman.

87. According to a letter of March 30, 1744, from Count Rothenburg to Frederick II detailing the purchase, for which see "Correspondance de Frédéric le Grand, relative aux arts," *Revue universelle des arts,* V, 1857, pp. 174–78. Wildenstein (pp. 14–15) provides further information on Lancret's prices, noting that "Among his contemporaries, Lancret could with good reason pass for an 'expensive' painter."

88. Mariette, III, p. 55.

89. See Jal, p. 274, *s.v.* Edme Boursault.

90. The catalogue is reproduced in Bocher, *loc. cit.*

91. Roland-Michel, 1969.

92. *Idem,* p. iv.

93. Ballot de Sovot, pp. 23–25.

94. *Idem,* pp. 23–24.

95. *Idem,* pp. 27–28.

96. See Posner, pp. 8–9.

97. *Idem;* see also Conisbee, pp. 148–51.

98. Posner, p. 199.

99. Quoted in full by A. Michel, *François Boucher,* Paris, 1906, p. 7.

100. Cabinet des Estampes, Bibliothèque Nationale, Ed III, tome I, p. 8.

Notes to "The Paintings"

Plate 5

1. Bibliothèque Nationale, Cabinet des Estampes, Pd53 fol.

2. Florisoone, pp. 138-39.

Plate 6

1. See Roland-Michel, 1969, p. vi, note 5.

2. *Idem.*, p.v.

3. F. Watson, "Choiseul's Gold Box," Charlton Lecture on Art, Newcastle-upon-Tyne, 1963.

Plate 7

1. These paintings can be identified almost certainly with a set formerly in the collection of Mr. and Mrs. Deane Johnson; see their sale, Sotheby's, New York, December 9, 1972, lot 81.

2. Posner, pp. 61-62.

Plate 8

1. Bibliothèque Nationale, Fr. Manuscript 9312, no. 1306, probably dating from 1695-1712, the dates of the two bordering plays bound with it.

2. Posner, p. 208.

Plate 9

1. Grasselli, 1986, p. 385, suggests that the Washington painting was done first, and dates it 1727-28.

2. Laurent Cars' engraving, announced in the *Mercure de France* for July 1731, was probably done after the Wallace Collection version.

3. Sale, Christie's, New York, June 3, 1987, lot 90.

4. *Mercure de France*, January 1732, n.p.

5. In the announcement of the publication of the print after Sallé, *Mercure de France,* April 1732, p. 819.

6. Bibliothèque Nationale, Cabinet des Estampes, Oa 69 pet. fol., published by Trouvain.

Plate 10

1. The announcement that prints after the La Faye paintings were soon to appear was made in the *Mercure de France,* June 1730, p. 1184, and permission to engrave them was obtained on August 6, 1730, at the same time as that for the engraving of *Mlle. Camargo.* Each of the four paintings was engraved by a different artist: *Autumn* by N. Tardieu; *Spring* by B. Audran; *Summer* by G. Scotin; and *Winter* by J.-P. Le Bas.

2. *Winter* might be identified with a painting now in a private collection, Paris.

3. A. Rochas, *Nouvelle Biographie universelle,* Paris, 1853, XXVIII, n.p.

4. J. Le Rond d'Alembert, *Histoire des membres de l'Académie française,* Paris, 1787, IV, p. 432.

5. *Idem.*

6. Ballot de Sovot, pp. 19-20; see also Dézallier d'Argenville, III, p. 290.

Plate 11

1. It had been thought that this painting and its pendant, *The Swing,* were purchased by Count Tessin, Louisa Ulrica's emissary to France, in 1745 for the Queen. However, it is now clear that they were purchased by Tessin for his own collection in 1728, taken to Stockholm in 1729, and sold to the Queen, together with the rest of his collection, in 1750. See Moselius, p. 95.

2. This interpretation of the painting is supported by its pendant, which portrays another aspect of the story of love—its inconstancy. Seen together, the games of blindman's buff and swinging form a commentary on the perverse ways of love—on the one hand, its blindness, and on the other, its fickleness.

Plate 12

1. For other instances of this influence, see M. Eidelberg, "Watteau, Lancret, and the Fountains of Oppenort," *Burlington Magazine,* CX, 1968, pp. 447-56.

Plate 13

1. It is difficult to determine just how many of these hunt picnics Lancret actually painted, as many are lost. A celebrated *End of the Hunt* was formerly in the Tabourier collection, Paris. A sketch in the Detroit Institute of Arts was probably done for the *Lunch in the Forest* now at Sans Souci.

2. For example, J. Cailleux has identified the seated woman in the Tabourier *End of the Hunt* as the Maréchale de Luxembourg ("Invalids, Huntsmen, and Squires," *Burlington Magazine,* CVI, February 1964, supp. p. iii).

Plate 14

1. *Mémoires du Duc de Luynes sur la cour de Louis XV,* ed. L.-E. Dussieux and E. Soulié, Paris, 1860, I, p. 69, II, p. 202.

Plate 15

1. Bruzen de la Martinière, *Le Grand Dictionnaire . . . ,* Paris, 1741, VI, part 2, pp. 101-02.

2. F. H. Hazlehurst, "The Wild Beasts Pursued: The 'Petite Galerie' of Louis XV at Versailles," *Art Bulletin,* LXVI, 1984, pp. 224-36.

Plate 19

1. Grasselli, Rosenberg, and Parmentier, no. D113.

Plate 23

1. For more on this subject in Lancret's work, see E. Goodman-Soeller, *"L'Oiseau pris au piège:* Nicolas Lancret's *Le Printemps* (1738) and the *Prisonnier volontaire* of P. Ayres (c. 1683-1714)," *Gazette des Beaux-Arts,* March 1986, pp. 127-30.

Plate 24

1. H. R. d'Allemagne, *Récréations et passetemps,* Paris, n.d., p. 206.

Plate 25

1. For more on this subject, see E. Munhall, "Savoyards in French Eighteenth-Century Art," *Apollo,* LXXXVII, February 1968, pp. 86-94.

Notes to "Lancret's Drawings"

1. Ballot de Sovot, p. 18.
2. *Idem*, p. 26.
3. One exception is a drawing of the Belvedere torso—a frequent classical substitute for a real nude model—done on the back of an early study of hands and heads now in Frankfurt. P. Ettesvold, who was preparing a dissertation on Lancret's drawings, attested to the existence of several more studies in a telephone conversation with the author on January 11, 1984.

Bibliography of Works Cited In Abbreviated Form

S. Ballot de Sovot, *Éloge de Lancret, peintre du Roi*, ed. J.-J. Guiffrey, Paris, n.d.

E. Bellier de la Chavignerie, "Notes pour servir à l'histoire de l'Exposition de la Jeunesse," *Revue universelle des arts*, XIX, 1864, pp. 38–67

É. Bocher, *Les Gravures françaises du XVIIIe siècle*, Paris, 1875–77

J. Cailleux, "A Rediscovered Painting by Watteau: 'La Partie quarréc,'" *Burlington Magazine*, CIV, 1962, supp. pp. i–v

P. Conisbee, *Painting in Eighteenth-Century France*, Ithaca, 1981

A.-J. Dézallier d'Argenville, *Abrégé de la vie des plus fameux peintres*, Paris, 1745, III, 1762, IV

L. Dimier, ed., *Les Peintres français du XVIIIe siècle*, Paris, 1928

M. Eidelberg, "P. A. Quillard, An Assistant to Watteau," *Art Quarterly*, XXXIII, 1970, pp. 39–70

M. Eidelberg, "Watteau and Gillot: A Point of Contact," *Burlington Magazine*, CXV, 1973, pp. 232–39

F. Engerand, *Inventaire des tableaux commandés et achetés par la direction des Bâtiments du Roi (1709–1792)*, Paris, 1900

E.-F. Gersaint, *Catalogue raisonné des diverses curiosités du cabinet de feu M. Quentin de Lorangère*, Paris, 1744

M. M. Grasselli, "Eleven New Drawings by Nicolas Lancret," *Master Drawings*, XXIII–XXIV, 1986, pp. 377–89

M. M. Grasselli, P. Rosenberg, and N. Parmentier, *Watteau: 1684–1721*, Washington, 1984

M. T. Holmes, "Lancret, décorateur des petits cabinets de Louis XV à Versailles," *L'Oeil*, no. 356, 1985, pp. 24–31

M. T. Holmes, "Deux Chefs-d'oeuvre de Nicolas Lancret, 1690–1743," *Revue du Louvre*, no. 1, 1991, pp. 40–42

J. Ingamells, *The Wallace Collection Catalogue of Pictures III: French, before 1815*, London, 1989

F. Ingersoll-Smouse, *Pater*, Paris, 1928

A. Jal, *Dictionnaire critique de biographie et d'histoire*, 2nd ed., Paris, 1872

H. W. Janson, comp., *Catalogues of the Paris Salons, 1673 to 1881*, New York-London, 1978

M. Levey and W. Kalnein, *Art and Architecture of the Eighteenth Century in France*, London, 1972

P.-J. Mariette, *Abécédario*, ed. P. de Chennevières and A. de Montaiglon, Paris, 1851–53

J. Mathey, "Lancret, élève de Gillot, et la 'Querelle des carosses,'" *Gazette des Beaux-Arts*, XLV, 1955, pp. 175–78

A. de Montaiglon, *Procès-verbaux de l'Académie royale de Peinture et de Sculpture 1648–1793*, Paris, 1883

L. Moréri, *Le Grand Dictionnaire historique de Moréri*, Paris, VI, 1759

P.-J.-B. Nougaret and N.-T. Leprince, *Anecdotes des beaux-arts*, Paris, 1776–81

M. Oesterreich, *Description de tout l'interieur des deux Palais de Sans Souci, de ceux de Potsdam, et de Charlottenbourg*, Potsdam, 1773

B. Populus, *Claude Gillot (1673–1722): Catalogue de l'oeuvre gravé*, Paris, 1930

D. Posner, *Antoine Watteau*, London, 1984

M. Roland Michel, in *Watteau et sa génération*, Gallerie Cailleux, Paris, 1968

M. Roland Michel, "Observations on Madame Lancret's Sale," *Burlington Magazine*, CXI, 1969, supp. pp. i–vi

A. Rosenbaum, *Old Master Paintings from the Collection of Baron Thyssen-Bornemisza*, National Gallery of Art, Washington, 1979

P. Rosenberg and E. Camesasca, *Tout l'Oeuvre peint de Watteau*, Paris, 1970

Salon de 1725: Compte-rendu par le Mercure de France de l'Exposition faite au Salon carré du Louvre..., Paris, 1924

G. Wildenstein, *Lancret*, Paris, 1924

Index

NOTE: Numbers in **boldface** indicate pages with illustrations.

PHOTOGRAPHIC CREDITS

Most of the photographs have been
supplied by the lenders. However, special
acknowledgment is due to the following
photographers and sources: Bibliothèque
Nationale, Paris; British Museum, London;
Bulloz, Paris; Charlottenburg, Berlin;
Documentation de la Réunion des Musées
Nationaux, Paris; Galerie Cailleux, Paris;
Giraudon, Paris; Her Majesty Queen
Elizabeth II; Landesbibliothek, Deutsche
Fotothek, Dresden; Richard di Liberto,
The Frick Collection, New York;
National Galleries of Scotland, Edinburgh;
The National Gallery, London; National
Gallery of Art, Washington, D.C.;
Nationalmuseum, Stockholm;
The Pierpont Morgan Library, New York;
Eric Pollitzer, New York; Thyssen-
Bornemisza Foundation, Lugano; Wallace
Collection, London.

DATE DUE